7.11 6 3/11

The Art of
small things

John Mack

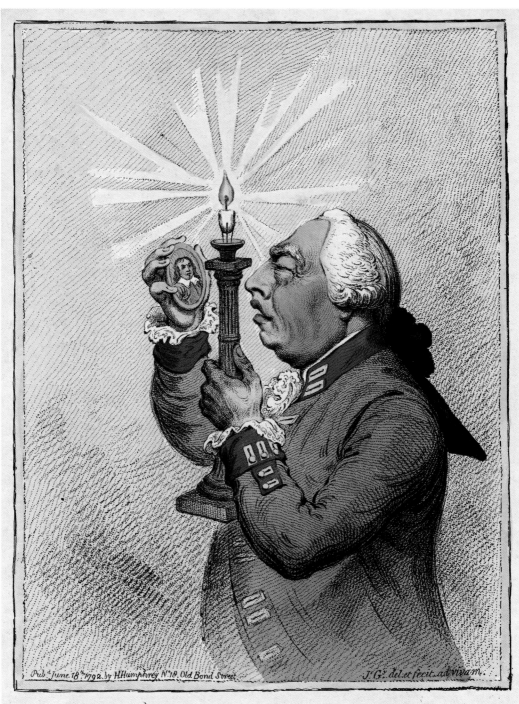

Pub.d June 18.th 1792. by H.Humphrey N.o 18. Old Bond Street

J.s G.s del.et fecit ad vivam.

A CONNOISSEUR examining a COOPER.

The Art of
small things

John Mack

HARVARD UNIVERSITY PRESS

Cambridge, Massachusetts

© 2007 The Trustees of the British Museum

John Mack has asserted his moral right to be identified as the author of this work

First published in 2007 by The British Museum Press
A division of The British Museum Company Ltd

Library of Congress Cataloging-in-Publication Data

Mack, John.
 The art of small things / John Mack.
 p. cm.
 ISBN-13: 978-0-674-02693-3 (alk. paper)
 ISBN-10: 0-674-02693-4 (alk. paper)
 1. Small art works. I. Title.
 N7437.M33 2007
 701'.8--dc22
 2007015343

Designed by Carla Turchini at Turchini Design
Printed in Singapore by C.S. Graphics Pte Ltd.

Frontispiece: Hand-coloured etching by James Gillray. British, 18 June 1792.
The print is entitled 'A Connoisseur examining a Cooper'; the connoisseur is King George
III, who is holding a miniature by Samuel Cooper (1609–72) showing Oliver Cromwell.
H. 32 cm, W. 23.8 cm

Contents

Illustration references

Unless otherwise stated, all photographs are © The Trustees of the British Museum and references are British Museum registration numbers. Photography of British Museum objects is by British Museum Photography and Imaging.

Frontispiece PD 1868,0808.6215
p. 4 PE 1978,1002.407. Donated by Professor John and Anne Hull Grundy
p. 6 PD 1861,1012.46. Donated by Henry W. Martin
p. 8 Asia 1881,1210.04
p. 9 Asia 1980,0225.02.03. Donated by Robert G. Sawers
p. 12 (above) AOA Am1849,0629.9; (below, left) AOA Am1856,0422.93. Donated by Lady Webster; (below, right) AOA Oc,TAH.133
p. 13 Asia 1945,1017.634. Bequeathed by Oscar Charles Raphael
p. 14 PE 1858,0428.1
p. 15 (above) PE 1979,1101.1; (below) AOA Am1940,11.2. Donated by the National Art Collections Fund
p. 16 PE 1949,0702.1
p. 17 AOA Af1900,0427.44
p. 18 (left) AOA Am1936,L3.15; (right) ME 1897,1231.7. Bequeathed by Sir A.W. Franks
p. 20 PE WB27 (Waddesdon Bequest)
p. 21 PE WB28 (Waddesdon Bequest)
p. 23 PD 1912,0717.1. Donated by Peter Gellatly
pp. 24–5 PE SLMisc.1778 (Sloane Bequest)
p. 26 PE WB167 (Waddesdon Bequest)
p. 27 (above) CM M6903; (below) CM 1844,0425.24
p. 28 Asia 1920,0917.02
p. 29 Asia 1998,1005.1
p. 30 PD 1895,0915.1275
p. 33 PE 1990,0710.1
p. 35 (above) PE 1904,1126.1-32; (below) PE 1991,1107.1
p. 36 PE 1978,1002.407. Donated by Professor John and Anne Hull Grundy
p. 39 © Wellcome Trust
p. 41 ©Wellcome Trust
p. 45 © British Library (BL 435.e.19 xxxiv)
p. 46 Asia 1962,0418.1; 1880,3490; 1919,0709.2
p. 51 PE 1831,1101
p. 52 PD 1868,0808.7206
p. 53 PD 1851,0901.1128. Donated by William Smith
p. 57 GR Sculpture 1726
p. 58 GR Jewellery 1670-71
p. 61 Asia 1869,0503.7
pp. 62–3 Asia 1793,0511.1. Donated by Charles Marsh
p. 65 AOA Am2006,Drg.54
p. 67 GR 1824,0301 (box of impressions)
pp. 70-71 PE 1866,1030.1. Donated by Octavius Morgan
p. 73 Asia 1991,0328.1
p. 74 Asia 1939,04.1-37 (selection)
pp. 76, 78 PE WB235/6 (Waddesdon Bequest)
p. 79 PE WB232 (Waddesdon Bequest)
p. 81 Asia 2001,1123.1
p. 82 PE 1985,0708.1-12
p. 85 PD 1938,0502.21 (12)
pp. 86–7 Asia 1943,0215.30. Bequeathed by Marjorie K. Coldwell
pp. 88-9 Asia 1889,0306.4
p. 90 Asia 1986,0412.1
p. 91 Asia 1991,1028.2
p. 92 Asia 1937,0710.0212. Bequeathed by Charles Shannon
p. 95 © British Library (BL Add. MSA 28681, f.6)
p. 96 © British Library (BL Harl. MS 2660, f.37)

p. 99 © British Library (BL MS Royal 6.C.1, f.108 (v))
p. 101 PD H.4.65
p. 102 PD 1845,0825.411
p. 105 Asia 1880,4081
p. 109 EA 32141
pp. 110-11 AOA Af1946,04.1
p. 113 AOA Af1939,11.1
p. 114 AOA Af1932,0514.1-53. Donated by Mrs L.S. Tucker
p.117 EA 32141
p. 118 ME 92668
p. 120 AOA Af1905,0525.4, Af1949,46.280
p. 121 AOA Af1905,0525.6
p. 124 AOA Af1910,0513.1
p. 127 AOA Oc,LMS.19. Christy Collection
p. 128 AOA Oc,LMS.169. Christy Collection
p. 129 AOA Oc1919,1014.1
p. 130 PE 1952,0404.1
p. 131 © British Library (BL 1856.g.16.4)
p. 132 (left) GR 1824,0424.1. Bequeathed by Richard Payne Knight; (right) PD 1975,1025.27
p. 133 AOA Am1938,0706.1. Donated by the National Art Collections Fund
p. 134 AOA Af1910,0513.1
p. 135 AOA Am1913,1212.1. Donated by the Earl of Plymouth
p. 137 Asia 1940,0713.0.51. Donated by Mrs A.G. Moor
p. 139 PD 1851,0308.113
p. 142 AOA Am1921,0721.1
p. 143 AOA 1862,0611.4. Donated by William Bollaert
p. 145 PE 1825,1112.1
p. 147 PD 1880,0710.865
p. 148 PD 1988,1105.80. Donated by L.C. Velluet (© The Estate of Edward Bawden)
p. 150 Asia 1998,0218.019
p. 151 Asia 2001,1129.1,2
p. 153 AOA Af1969,09.1-2
p. 154 (left) AOA Af1954+23.3580. Donated by the Wellcome Historical Medical Museum; (right) AOA Af.8006. Christy Collection, donated by R.G. Whitfield
p. 156 AOA Af1951,12.233-4
p. 159 Asia 2005,0702.1. Donated by Tamaya Shōbei IX
p. 160 PD 2003,0531.96
p. 164 PE 1925,0610.1+
p. 166 CM M8007
p. 167 CM 1882,0704.15. Donated by H.B. Morse
p. 168 CM 1881,0602.1
p. 169 (above) Asia SL.am. 1, 6, 7, 9, 10, 15; (below) Af1940,23.1
p. 171 PE 1902,0210.1. Donated by George Salting
p. 174 (left) EA 24787, (right) EA 29222
p. 175 (clockwise from top left) EA 26230, EA 59500, EA 14696, EA 7876, EA 48667
p. 176 (left) PE 1855,0305.1; (right) PE 1862.6-13.35
p. 177 PE various
p. 178 PE 1867,0507.739
p. 182 PE 1885,1201.231
p. 183 PE WB158 (Waddesdon Bequest)
p. 184 PE 1891,0217.16
p. 185 PE AF.1432. Bequeathed by Sir A.W. Franks
p. 186 PE AF.1439. Bequeathed by Sir A.W. Franks
p. 187 (above) GR 1867,0508.527 (Jewellery 1390); (below) PE 1912,0610.1
p. 189 (above) Asia F994. Donated by Sir A.W. Franks; (centre) Asia 1953,1217.11. Bequeathed by Miss Helen Epstein; (below) Asia F1084. Donated by Sir A.W. Franks
p. 190 Asia HG348. Donated by Professor John and Anne Hull Grundy

p. 191 Asia 1945,1017.405, 403. Bequeathed by Oscar Charles Raphael
p. 192 Asia 1945,1017.586. Bequeathed by Oscar Charles Raphael
p. 193 Asia 1979,0702.8
p. 194 Asia 1945,1017.521. Bequeathed by Oscar Charles Raphael
p. 195 (left) Asia 1930,1217.62. Bequeathed by James Hilton; (right) Asia HG11. Donated by Professor John and Anne Hull Grundy
p. 196 Asia 1981,0203.116. Donated by Capt. Collingwood Ingram
p. 199 (top left) AOA Af1949,08.1; (bottom left) AOA Af1922,1027.458. Donated by T.R.O. Mangin; (right) AOA 1947,13.138. Donated by Capt. Robert P. Wild
p. 202 (clockwise from top left) AOA 1910,0420.446, 442, 445, 443
p. 203 (left) AOA Af1951,34.2; (right) AOA Af.4573
p. 204 PE 1828,1111.1. Bequeathed by Hon. Mrs Anne Seymour Damer
p. 207 (left) PE SLRings19 (Sloane Bequest); (right) PE 1978,1002.1071 (HG 1071). Donated by Professor John and Anne Hull Grundy

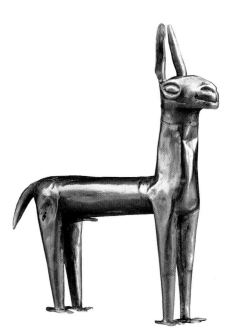

Hammered gold llama. Inca, Peru, 1400–1500. See p. 142.

Preface

The ideas that set in motion the writing of many books probably have no obvious or single starting point. This one, however, certainly has paternity: it follows my earlier volume, *The Museum of the Mind: Art and Memory in World Cultures*, about the conditions of memory and the place of objects in constructing pasts, which was published in 2003 to coincide with the 250th anniversary of the founding of the British Museum. An associated exhibition was one of several moments of 'commemoration' in the Museum's year of celebration (as well as a reflection on why commemoration is itself one of the defining features of human cultures).

That book covered a wide field, but among the most potent techniques of memorizing discussed was that of identifying iconic images that précis larger ideas. Recalling a series of such objects enables the remembrance of much more complex sequences of thought. The description of this technique of memory is most explicit in the western tradition and has clear roots in classical thought. Yet in many cultures, western and non-western, past and present, this is not simply a matter of mental gymnastics but is objectified in physical artefacts, and these act as the starting point for narratives that can be of potentially epic proportions. Indeed, the capacity of an object to achieve this exaggerated significance is, arguably, a prerequisite of identifying an image as 'iconic' in the first place. From that discussion was born an increasing awareness that the processes of creating small things are not simply technologies for reducing scale but also imply a corresponding exaggeration of content. The description of the miniature as an object of allure, or of awe, is far from exhausting its potential significance. The making and manipulating of the miniature consitute not just the product of a technology of the aesthetic but also a cultural process, and both these aspects provide the themes of this book.

Yet there is also another, more anecdotal, starting point to the train of thought pursued here. In Madagascar there are two major symbolic sites at the heart of Imerina, the historic kingdom in the centre of the large island. One is the Rova, or palace complex, on the top of one of the hills overlooking the capital, Antananarivo. This was the place where the Merina court had its public face during the nineteenth century, where royal proclamations (*kabary*) were addressed to the people, where the army paraded and where foreign visitors were received. Visible in the distance from the hill on which the Rova stands is a second site, Ambohimanga, the so-called 'summer palace' of the Merina royalty. This is identified as the original homeland of the small fiefdom whose expansion in the late eighteenth and early nineteenth centuries created the kingdom that came to rule central Madagascar, and much of the rest of the island besides. The

capital moved to Antanarivo, but royalty continued to be buried at Ambohimanga and some of the most powerful charms of Imerina were fashioned there. It became the major site of ancestral blessings.

In the 1980s, when I was doing fieldwork in Madagascar, Ambohimanga was an interesting place to visit on return trips to the capital. During one of these visits I became aware of a rumour, which was becoming quite widespread in the area, that the then president of the post-independence island, though not himself from Imerina, went there sometimes – always stealthily, and as far as possible anonymously – to consult an *ombiasy*, a traditional healer. The *ombiasy*, it emerged, held healing sessions at a small shelter erected over a pool issuing from the bottom of the hill on which Ambohimanga stood. The pool was a river source but also had red fish swimming around in it – red being a colour associated with potency and authority. It seemed to follow that rain landing on Ambohimanga and filtering through the earth of this important hill might create a pool of enhanced sacredness, and the goldfish or carp merely endorsed this perception of the spring as a source of special *hasina*, ancestral blessings. In effect the substance of the sacred hill was concentrated at this particular point of issue.

Had I found the opportunity to work on this further, it could possibly have led to making some contribution to the burgeoning literature on the significance of landscape. That it has contributed to what follows may be partly attributed to the fact that I am more of an ethnographer and art historian by background than an archaeologist. Many of the themes that have subsequently emerged in the writing of this book are imminent in those original, if random, Sunday-afternoon thoughts: the notion that condensation and concentration are aspects of the cultural field within which miniaturization takes place, the idea of essences as reductions charged with potency, even the observation that engagement with miniature worlds is a secret and often intensely personal activity. Visiting a sacred pool in Madagascar may seem a long way perhaps from the experience of fighting for the space to admire small Elizabethan portraits in a western museum, which is what the English usage of the term 'miniature' most readily brings to mind. But there are connections to explore; and I strongly believe that, to begin to understand some of the responses we have to these small gem-like creations of human skill and ingenuity, it helps to think in a wider cross-cultural context about the circumstances in which such works are executed and viewed.

The research I was engaged in while in Madagascar was part of my work as a curator in the British Museum, and the initial development of this book also took place while employed at that remarkable institution with the encouragement of Neil MacGregor and assistance from Antony Griffiths and Julie Hudson in particular. However, it has been seen through to completion after a move sideways into the

academic world at the University of East Anglia. I have many colleagues in the two institutions to thank, and have presented much of the material that is embodied in this book in seminars and lectures in both places, and elsewhere; I have benefited significantly from observations made by a wide range of colleagues on those occasions, notably Sandy Heslop, John Onians and John Mitchell. The fullest discussion of the issues, however, has been with Richard Maguire, whom I thank for his incisive comments. The British Museum's in-house publishing team have, as in the past, helped me balance the requirements of monograph and catalogue, of scholarship and public accessibility. Finally, I have to thank my family for tolerating several 'holidays' that were spent in the rather single-minded pursuit of a topic that is by its very nature conducive to obsession.

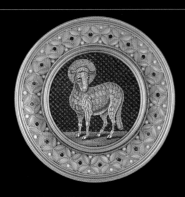

1. Small is Beautiful

The phrase 'small is beautiful' was coined in 1973 by the influential economist Ernst Schumacher to refer to the immediacy and vitality of local contexts of reference in the face of globalizing economies. Yet the aphorism has attained a wider resonance. It is repeated in numerous other contexts and appears in dictionaries of quotations not just as a historic rallying call in the emerging tension between local aspiration and international agency, but also because it seems on other accounts to be true. Small is, indeed, very often, and by common consent, beautiful. Speaking of works of art, the anthropologist Claude Lévi-Strauss remarked in an apparent aside that 'all miniatures seem to have an intrinsic aesthetic quality'.[1] This chapter introduces the theme of smallness by exploring the background to this perception.

In western aesthetic vocabulary the terms for smallness often endorse these perceptions. It is hard to imagine an English word like 'exquisite' being used of the gigantic. Small is, by convention, understood to be 'beautifully formed'. Even classical tastes with their propensity for the colossal concur. Although he considered large proportions as essential for true beauty, *kalloi*, and for greatness, Aristotle nonetheless regarded smallness in a positive light – he commented that smallness in people brought with it qualities of *symmetroi*, being well proportioned, and of *asteioi*, elegance.[2] People relating to newly born babies find the experience of having their immense sausage-like fingers gripped by minute hands riveting. In literature, as much as in lived experience, the hand is, in fact, often at once the measure and the container of the miniature. Things that 'would fit in the palm of your hands' are, by definition, small. In the case of the baby's grasp, it is surely not just some unworthy instinct of dominance that is at work – a physical expression of a child's dependency – more charitably, it is also a perception that differentials of scale have an aesthetic aspect. As Gulliver observes to the giant King of Brobdingnag in Jonathan Swift's famous *Gulliver's Travels* (1726), the smaller 'animals, bees and ants had the reputation of more industry, art and sagacity, than many of the larger kinds'.[3] Edmund Burke, in his *Philosophical Enquiry into the Origins of our Ideas of the Sublime and Beautiful* (1757), notes that objects of affection are very often spoken of in the

Opposite
Micro-mosaic brooch showing the Lamb of God by the Castellani firm. Italian, c.1860.
See p. 36.

diminutive in many languages, such as by the use of the suffix '-ling' in English, as in 'darling'. He extends the observation into the animal kingdom:

> In the animal creation, out of our own species, it is the small we are inclined to
> be fond of; little birds, and some of the smaller kind of beasts. A great beautiful
> thing is a manner of expression scarcely ever used; but that of a great ugly thing,
> is very common.[4]

The diminutive is the suffix of choice for describing children and pets, and a resource in the vocabulary of the patronizing remark. There is an almost mathematical equation to be discovered that links the degree of reduction to the sense of artistic achievement: the smaller, the more beautiful. To represent ordinary things on an ever-reducing scale is, arguably, to render them more powerful in visual terms.

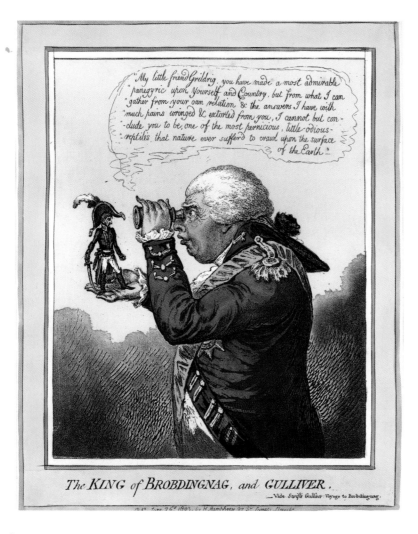

The KING of BROBDINGNAG, and GULLIVER.

_ Vide Swift's Gulliver. Voyage to Brobdingnag.

Hand-coloured etching by James Gillray. British, 26 June 1803.
A series of political satires in early 19th-century Britain exploited Dean Swift's *Gulliver's Travels* with its differentials of scale to lampoon political ambitions. Napoleon Bonaparte was the most familiar target, especially during the period when the threat of invasion was at its height. Here George III is figured as the King of Brobdingnag and Napoleon as Gulliver. The accompanying text ends with the words: 'I cannot but conclude you to be one of the most pernicious, little odious reptiles that nature ever suffer'd to crawl upon the surface of the Earth.' H. 35.7 cm, W. 25.6 cm

6

The mathematics of the miniature

In addition to Swift, another Irish master of the surreal, the pseudonymous Flann O'Brien, also explores the world of the small, in his case that of the infinitesimal. In *The Third Policeman* (1967) one of their number, Policeman MacCruisken, produces a tiny casket that he has confected when not pursuing an obsessive interest in bicycles. The commentator remarks:

> Never in my life did I inspect anything more ornamental and well-made. It was a brown chest like those owned by seafaring men or lascars from Singapore, but it was diminutive in a very perfect way as if you were looking at a full-size one through the wrong end of a spy glass. It was about a foot high, perfect in its proportions and without fault in workmanship.

Indeed, so convincing is it, that it is described as having 'the dignity and the satisfying quality of true art'. It is 'nearly too nice … to talk about it' – so good, it is 'unmentionable'.[5] Yet this turns out to be but the product of two years' manufacture when Policeman MacCruisken was yet a lad. He then turned to wondering what to keep in his miniature chest: letters, his studs and enamel badge, a present from Southport, his razor, his certificates, perhaps his cash – or a picture of Peter the Hermit? Finally he comes to the only viable conclusion – another chest 'of the same make but littler in cubic dimension'. And then another, and another, and so on, each taking years in the making. Thirteen chests are laid out, the last opened with a diminutive key 'like a piece of hair'.

But this was not the end of it. The continuing diminution in the size of the chests becomes mind-boggling. 'I could almost hear my brain rattling in my head when I gave a shake as if it was drying up into a wrinkled pea.'[6] Further chests, each representing an investment of time stretching over the years, emerged from MacCruisken's expert, compulsive hand. Fifteen years ago he had made number twenty-two. Thereafter he was making one a year, each a reduction in scale on its predecessor. He must by that calculation be working on number thirty-six. Number twenty-eight had already become so small that 'it looked like a bug or a tiny piece of dirt'. Number twenty-nine looked like 'something you would take out of a red eye on a windy dry eye'.[7] It is becoming exasperating, unthinkable, challenging the very boundaries of the experiential. 'I shut my eyes and prayed that he would stop while still doing things that were at least possible for a man to do.'[8] But no. By the last five, they have become so tiny that no magnifying glass is sufficient 'to make them big enough to be regarded truly as the smallest thing ever made'. Indeed, no one can see MacCruisken making them because his tools are now so small that they too are invisible. The one he is working is 'nearly as small as nothing. Number One would hold a million of them at the same time and there would be room left over for a pair of woman's horse breeches if they were rolled up.'[9]

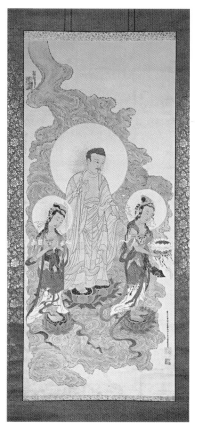

Hanging scroll (and details) with imagery composed of miniature writing. Japanese, 1796. This scroll shows a scene known as 'The Descent of the Amida Trinity'. Its extraordinary feature is that the whole scene is depicted using minute characters that quote passages from sacred Sutras. Its very conception and realization (by an obscure Edo-period official) might be regarded as itself an act of dedicated piety. H. (excluding mount) 132.3 cm, W. 38.2 cm

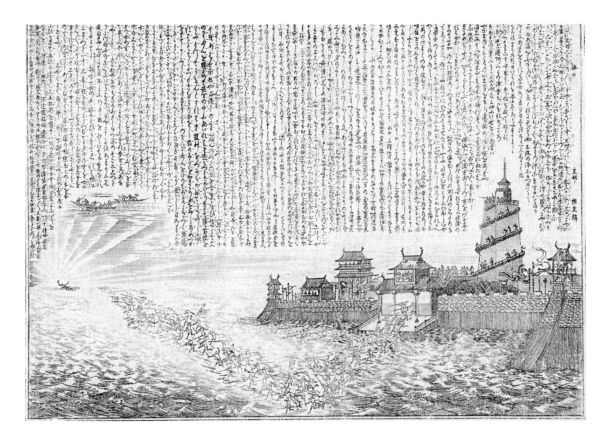

Where MacCruisken seeks to go in a fictional context, others have sought to tread in reality. There is a well-known Greek story about an artistic competition with the aim of creating the smallest marks that it was possible to make by human hand. It concerns the painter Apelles who, on a visit to Protogenes of Rhodes, sought to mark his presence by inscribing a line of infinite fineness on a surface as a kind of signature. Protogenes, seeing the line, sought to surpass it himself with a line that was still finer, transecting the one already inscribed. When Apelles later returned, he was embarrassed to have been thus outdone and added a third line of yet more fineness, to the point of it being barely visible. Pliny talks of the resulting panel with its three lines being among the most prized treasures in the imperial collections in Rome until it was later destroyed by fire. The Greeks, known rather more for their interest in the massive, were not beyond being intrigued by the truly tiny: like the fictional MacCruisken's obsession, there was an identifiable interest in the exploration of the outer limits of visual perception and technical precision. This in its turn led to the direct incorporation of miniaturized imagery on larger sculpture, not just cupids but also figures of gods otherwise known in large format but portrayed in their infancy.

Copperplate engraving of *Warriors on the Sea* by Mizuhili Shōshitsu in Kyoto. Japanese, c.1860–8.
The topic here appears to be a military chronicle. Its most outstanding characteristic is the miniature writing with which the whole of the upper register of the image is composed. It has been estimated that it contains up to 1,000 characters in the equivalent of a square inch (6.5 sq. cm). H. 8 cm, W. 10 cm

The makers of miniature things are well aware that the evaluation of their skill is linked to an observer's sense of the impossibility of what they are trying to achieve. MacCruisken, Apelles and Protogenes are not alone. At times, there is a distinct air of competitiveness to some of the experimentation. In more recent years *The Guinness Book of Records* has come into play as a register of success in these border-lands of human creation. The aspiration to create the smallest book in the world is an accolade that printers and publishers have been pursuing since at least the seventeenth century. Sometimes skill has taken precedence over content. One of the first contenders was also one of the longest lived. The book is *Bloem-Hofje*, an otherwise unremarkable Dutch poem by one C. van Langeby. It was issued in 1674 by Benedikt Smidt, a printer who had at that point just moved to Amsterdam and, it has been suggested,[10] was looking to advertise his arrival with a sensational demonstration of his abilities. Van Langeby's work was rendered and published at a size little different from a fingernail. The book was beautifully presented, gilt-tooled on red leather and with a minuscule and finely chased gold clasp. For two centuries it remained the smallest book known. When it was exceeded in smallness, it was by a work associated with a thinker of an altogether more magisterial significance: it was a version of *Galileo a Madama Cristina di Lorena* (1615), issued in 1897 at a serious length of 206 pages but measuring only $\frac{3}{4}$ by $\frac{1}{2}$ an inch (1.9 x 1.3 cm).

In 1932 a translation of *The Rose Garden of Omar Khayyam* by Eben Francis Thompson was published in a printing of 250 by the Commonwealth Press of Worcester, Massachusetts. As was increasingly the case, the tiny book was beautifully bound and encased in a box, which also contained a magnifying glass. A bibliography was included under the title 'A Thimbleful of Books'. Its size was a mere $\frac{3}{16}$ by $\frac{7}{32}$ of an inch (4.8 x 5.6 mm). By 1971 an East German printer had produced a book measuring $\frac{1}{8}$ by $\frac{3}{32}$ of an inch (3.2 x 2.4 mm), Egon Pruggmayer's *Bilder ABC. Das kleinste Buch der Welt*, but with only fourteen leaves; and then in 1978 the Gleniffer Press near Glasgow in Scotland brought out a version of the nursery rhyme *Three Blind Mice*, which was pronounced the smallest book in the world at the time by *The Guinness Book of Records*. It measured 2.1 millimetres square. However, in the following year the major Japanese printers Toppan Printing Co. produced its 'Toppan Ultra Micro Trio' consisting of three books – *Birth Stones, Language of Flowers* and *The Zodiacal Signs and their Symbols*. Each 'volume' is 2 millimetres square, so small that, as the collector and enthusiast of miniature books, Louis Bondy, reports:

I recently had the terrifying experience when breathing against the case (in which the book is bought and needs to be kept) to see one of the books take off like a speck of dust and it was nothing short of a miracle that I managed to find it again and replaced it in its allotted space.[11]

The books are not only issued in a brass case with a magnifying glass but also come with a slightly larger 'Mother Book', itself only 2 centimetres square – small enough

to render all the more remarkable, by comparison, the technical miracle that produced the tiny particles of the three books. By 1981 the Toppan Micro Books series had a further companion volume at 1.4 millimetres square, *The Lord's Prayer*. The current *Guinness Book of Records* cites Anatoly Konenko's printing of Anton Chekhov's *Chameleon* published in a limited edition of one hundred at Omsk in Siberia in 1996. Each book has thirty pages and contains three colour illustrations with eleven lines of text to the page. It is bound in gold, silver and leather. The book is truly at the dimensions of a dust speck measuring 0.9 by 0.9 millimetres – less a work of literature than a microbe. A general concern for the effects on the eyesight of working in such micro-worlds is not misplaced. In 1878 the brothers Salmin who worked in Padua developed a micro-type known as 'fly's eye type' specifically for an edition of Dante's *Divine Comedy*. It is reported that the work 'seriously injured the eyesight of both the compositor and the corrector. It took one month to print 30 pages.'[12]

In the hands of MacCruisken, Toppan Printing Co. and others, who seek to create things in the dimensions of the micro-world, the ineffably beautiful is turning into the mathematically unimaginable as sight alone is insufficient to give access to these minuscule things. Policeman MacCruisken is rehearsing in the guise of the miniaturist a phenomenon that mathematicians have wrestled with for centuries: the problem of infinitesimals, the status of numbers that get increasingly closer to zero as they are divided and subdivided ever downwards. Bishop Berkeley (1685–1753) called such infinitesimals 'the ghosts of departed quantities'. If, as Brian Clegg explains, we imagine the smallest number there can be – call it a 'ghost' – and then divide it by two, we end up with a number that is bigger than zero (because two of them added together make a 'ghost'), yet it is still smaller than the imagined infinitesimal, which was otherwise the smallest number we could think of.[13]

Embedded in this reductive thinking is a mechanism that challenges our experience of the material world through eye and mind. While in literature such thinking is called the absurd, in mathematics, when the theoretician Abraham Robinson came to a resolution in the early 1960s, it became known as 'non-standard analysis'. Yet, interestingly, while the vocabulary detaches the surreal from the real, it retains a connection to human experience; similarly, non-standard analysis acknowledges that infinitesimals are not the same as real numbers, but in Robinson's inspired analysis they are treated as having the same characteristics as their big brothers and may be subjected to the same mathematical rigour. Both the infinitesimally tiny and the infinitely large stretch the limits of our imagination. We are at a frontier that the theoretical physicist, the astronomer and the religious thinker seek to probe, a world that is not supposed to be occupied by man-made things, but a world nonetheless in which the technician and the artist with their different skills and motivations seek to create material artefacts. It is hard to escape the conclusion that small is beautiful at least in part because of the combination of skill and imagination that they represent. For them to exist at all as humanly created things occupying the outer margins of

scale, they have – almost by definition – to approach the realization of physical perfection. Our next questions, then, must be about those who aspire to create art in these challenging dimensions and especially about their technical prowess. We begin with an introductory survey of the materials that are used by the miniaturist.

Materials

Gulliver remarks that the 'fair skins of our English ladies' are a stark contrast to the pitted visage of the giants of Brobdingnag. Enlargement magnifies imperfection; reduction diminishes it. One aspect of the miniature is that it erases such physical defects and resolves them, in the eye of the beholder, into a fragile beauty. This sense of fragility is one that preoccupies makers and viewers alike. The implication is that hardness is a desirable, indeed to some degree unavoidable, quality in small-scale sculpture. It is revealing, for instance, that in a comprehensive review in his *Materials of Sculpture* Nicholas Penny illustrates his chapter on the hardest stones used by sculptors exclusively with miniatures and figurines, while chapters on softer stones are articulated around discussion of sculpture in larger format.[14] That said, hard stone is also extensively exploited by carvers of the colossal. After all, it is not just figurines that are fashioned from hard rocks: the massive sculpture of Ancient Egypt was largely created from granitic rock, one of the hardest igneous stones. Marble like-

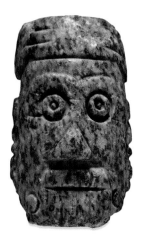

Jade head. Mixtec, Mexican, 1200–1521.
Jade is a hard gemstone, which is not so much carved as abraded – a slow and demanding process. This small head represents Tlaloc, the rain god.
H. 8.3 cm

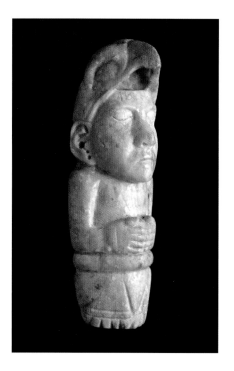

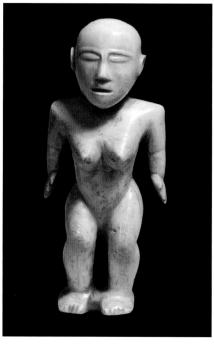

Far left
Jade torso of an eagle warrior. Aztec, Mexican, 1300–1521.
As most figurative jades have to be worked by processes of grinding, making too many complex facets or deep incisions is usually avoided. Here, however, the eagle helmet stands out by being acutely undercut. H. 14.5 cm

Left
Ivory figure. Tongan, Polynesia, 18th or early 19th century.
By comparison with bone carving, ivory carving like this has a much more rounded three-dimensional form. The figure is thought to represent a goddess.
H. 12 cm

wise lends itself to the life size and the massive. It is partly the scale on which the material is found in nature. As Penny remarks of igneous rocks, 'it is the stuff of which whole mountains are made'. But hardness is certainly a helpful quality to the carver in miniature: such dense materials offer resistance to the sculptor's tools, making any of the inadvertent slips that may easily occur when working at such limits of visibility less disastrous.

Detail is easier to achieve on harder woods, although a lively sense of the qualities of flesh cannot be readily created; softer wood, which is simpler to carve, takes a deeper cut but makes fineness of line and ornamentation more complicated to achieve in the scale of the miniature. Hard woods are also more durable, which is important where a utilitarian as well as an ornamental purpose is intended. For this reason Japanese *netsuke*, the toggles used to suspend small possessions from the sash of a kimono, tend to be made of hard materials. However, one of the most influential of *netsuke* carvers, the Osaka-based artist Yoshimura Shuzan, who worked in the early eighteenth century, preferred to use the soft wood of the Japanese cypress because it took painted colour readily and, when it wore down, turned to a striking and distinctive mottled patina. He was otherwise renowned for carving larger-scale Buddhist images, for which Japanese cypress was also his preferred wood.[15]

Ivory presents other problems and opportunities. Unlike bone, it has none of the grooving or tendons that either appear as blemishes on the surface or need to be concealed on the back or underside of any sculptural form. Where there are natural

Wood and ivory *netsuke* by Kagetoshi. Japanese, Edo period, early 19th century.
The subject of this detailed miniature carving is taken from a Chinese fable. It concerns Chao Lu Sheng (Rōsei in Japanese), who dreamed of fame and wealth only to wake up and realize the temporary nature of mortal things. He is shown among a series of tiny sleeping figures in a large palace. Kagetoshi (died c.1843) was renowned for his complex and elaborate miniature carving.
L. 4.5 cm

whorls in the grain of ivory this can sometimes be incorporated into the detailing of a finished piece. Ivory is generally an expensive material. In Japan it began to be introduced in the early seventeenth century from India by way of China and Korea. It was the material for making the plectrums used to play the Japanese musical instrument, the *samisen*. Gradually, however, it became one of the favoured materials, with wood, for the carving of *netsuke*. To minimize waste, these were initially carved from the triangular sections left over when the piece used for making the plectrum had been shaved off, and many retain this general shape, avoiding in the process sharp projections that would break off or get snagged on clothing. The *netsuke* also needed to be balanced so that it lay correctly against a sash when being used to suspend decorative containers. Too rounded a shape would tend to slip and not sit well against a sash, so most *netsuke* are carved in a broadly triangular or oval form. As with some types of wood, the hardness of ivory and the closeness of its grain are an advantage in carving fine detail, and the harder inner core is often preferred for what would be the outer surface when the *netsuke* is in use as a toggle.

Being broadly oval in shape, *netsuke* also feel good when cupped comfortably in the palm of the hand, and artists paid attention to qualities of touch and texture in carving them. In the case of ivory this had an additional benefit. Ivory cracks readily, especially when it is allowed to dry out as it does with ageing. Regular contact with oil or moisture, such as that on the palm, is a useful preventive measure. If it did split, small metal staples were inserted to bridge the crack. As ivory gets older, it also tends to take on a brownish patina, while exposure to light encourages the retention of its whiteness. Either quality may be desirable. In Japan colour was preferred and many methods of staining ivory were employed by different *netsuke* artists. In Congo, on the other hand, the whiteness of small miniature masks worn as pectorals by initiated men was a desired quality and obtained by regularly washing them in sandy river water – with the effect of wearing down the surface decoration.

Apart from carving, casting in metal is the other major technique for creating miniatures, especially through the so-called 'lost wax' process. This is a simple method, or at least it is simply described. Firstly, an image is modelled in wax and, once finished and hardened off, a clay mould is built up around it. Next, a small hole is made through the mould (or alternatively a wax rod is attached to the wax body

Ivory figure of St Margaret of Antioch. French, 1325–50.
The subject of this figurine is St Margaret emerging from a dragon and refers to a popular medieval miracle. This relates how through prayer she was delivered from the belly of a dragon that had swallowed her. The mass of the carving makes it difficult to avoid naturally occurring cracks, which are here concealed by the gold decorative work.
H. 14.5 cm

Bronze brooch. Anglo-Scandinavian, second half of the 11th century.
This brooch has been cast in bronze and then gilded on both sides. It shows a snake with rounded eyes biting an unidentified four-legged animal that in turn bites itself. It style shows an intermingling of Viking and Anglo-Saxon design features. It is known as the Pitney Brooch after the village churchyard in Somerset where it was found.
D. 3.9 cm

Gold lime-container. Quimbaya, Colombia, AD 500–600.
This virtuoso casting uses the lost-wax technique and is in two parts, which have been soldered together at the torso. Lime was chewed with coca leaves as an aid to contemplation.
H. 14.5 cm

**Cast-gold elephants.
Asante, Ghana,
18th–19th century.**
This delicate ornament
has been modelled in wax
before being cast in gold.
Goldsmiths worked at the
behest of the Asante court
with the direct patronage
of the Asantehene, or
king. L. 9.5 cm

and also encased in the clay mould). This is then heated so that the clay hardens and the wax melts and can be drained out of the mould. This leaves a cavity in the shape of the original wax image. Molten metal can then be introduced through the hole in the mould and left to cool and solidify. Finally, the mould can be broken open and the metal casting removed and tidied up. Control of temperatures and of the viscosity of materials comes with experience, but the whole procedure is made possible by the malleability of the wax and the skill in creating the mould.

Among the Asante of Ghana, who use this technique to cast in both brass and gold, the model is built up by combining pieces of wax cut into strips and shaped by a range of methods – with the fingers, with a spatula, a thin blade, a needle or a rod. The wax and the tools may be heated periodically to aid malleability, or the tools may be dipped in cold water to harden off the wax. Pieces may be joined by touching points of contact with a hot blade and fusing the two. To retain the fineness of the detail, the wax model is first covered with a fine clay paste mixed with charcoal. When the first coating is dried, others are gradually added. In this way brass weights for weighing gold dust were made in their thousands, and gold jewellery and decoration were produced for chiefs and royalty.[16] Similar techniques seem to have obtained in antiquity. The Oxus Treasure in the British Museum, dating to the fifth and fourth centuries BC, is the most impressive collection of Achaemenid metalwork known and is made by the same casting techniques that are still in use in West Africa today. A gold miniature model of a chariot bearing two figures and pulled by four ponies, and a gold bracelet furnished with terminals in the form of winged 'griffins' with ibex

Opposite
**Silver brooch. Anglo-
Saxon, mid-9th century.**
The basic material of the
brooch is silver, though its
richness is enhanced by an
extensive use of gold. The
pattern shows a series of
dog-like animals. A black
inlay makes the design
stand out and blue glass
emphasizes the eyes of
the animals. Dots punched
into the surface give it
sparkle. It is known as
the Strickland Brooch
after the family to which
it is thought to have
originally belonged.
D. 11.2 cm

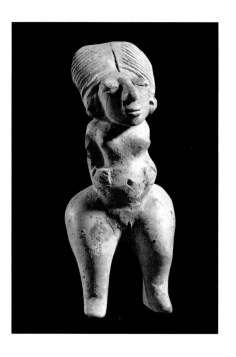 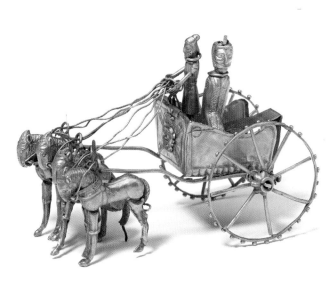

horns are the best known. It is speculated that the bracelets may have been gifts of honour and that the gold from which they were made was used as currency throughout the region, but their subject matter and iconographic significance remain frustratingly difficult to interpret.[17]

Painting in miniature is as exacting a physical and technical process as sculpting and involves a careful assembling of precisely identified materials with particular desired qualities. These are considered in the following section.

The miniaturist

In the 1980s, while undertaking anthropological fieldwork in south-eastern Madagascar, I attempted to reconstruct something of the life of a shadowy but accomplished local Taimoro sculptor called Fesira. One of his works, a complex of commemorative sculptures generally referred to as the 'Tomb of Ramaria', is relatively well known, as it stands by the roadside on the route from the port of Tolenaro (formerly Fort Dauphin) to the nearby nature reserve of Berenty. Ramaria is sculpted as a single figure wearing a cross and carrying a Bible, referring to the fact that she was the first Catechist in her family. A more complex sculpture at the same site shows a boat full of people and commemorates an accident that took place in 1928 when a canoe sank and its occupants were drowned. In the course of research other virtuoso sculpture in remoter villages came to light.[18]

Above left
Pottery female figurine. Panuco valley, Veracruz, Mexico, 900 BC–AD 300.
In Mesoamerica figurines modelled in clay survive in burials from early periods. This example is from the Formative or (Preclassic) period when a well-developed agricultural practice emerged. It has been modelled by hand and its incised features applied while the clay was still wet. The emphasis on the hips and on sexual attributes may have some link to ideas of regeneration. The elongated head is thought to possibly represent cranial deformation, which was common. H. 8.4 cm

Fesira himself was active in the 1930s. Little is formally recorded of his origins, his training or the circumstances of his various commissions. Some details, however, seemed to have become consistently embedded in local lore: he is recalled as having preferred to carve alone at night and often, it is said, naked. It is hard at this distance of time to know how to interpret these details, especially the last. They seem to point to a common acknowledgement that his talents were regarded as wholly exceptional and his creations to have a miraculous, revelatory quality in a region that otherwise lacked either artists' ateliers or indeed any established tradition of figurative carving. His sculptures were not portraits done from life but commemorative pieces, sometimes of people he could not have known. There is in his carving an emphasis on biographical scenes rather than physiognomy: Fesira was in a sense giving birth, through sculpture, to memory.

His work, though significantly smaller than life-size, would hardly count as miniaturization at some of the scales we discuss in this book. But there are remarkable similarities between the oral descriptions of Fesira's working practices in a remote part of Madagascar and those of the miniaturists and micro-miniaturists working in the western tradition. The miniature is at once a radiant wonder of creation and a testament to physical discipline. The well-researched essay accompanying a display of micro-miniatures at the Museum of Jurassic Technology in Los Angeles introduces us to the world of Hagop Sandaldjian, 'one of the four or five living practitioners of micro-miniature, a Slavic speciality that is understandably rare because it demands unthinkable physical precision'.[19] Sandaldjian's speciality was carving minute figures – such as Napoleon, Snow White and the Seven Dwarfs, Goofy, Pinocchio, Donald Duck and Mickey Mouse – and mounting them in the eye, and sometimes on the point, of a needle. The catalogue essay by art historian Ralph Rugoff describes the discipline this demands:

> The micro-miniaturist must work with a patience that saturates the artist's every finger, instilling a profound response in each cell. And it is not only his hands that are involved – the micro-miniaturist must learn to make his decisive movements between breaths, even between heartbeats, and he must work in monastic solitude, in the nocturnal quiet of a small clean room.[20]

Micro-miniatures are not creations forged in a ferment of artistic inspiration; they are, rather, intense acts of concentrated precision, produced against an almost fetishistic backdrop of order and tidiness. One slip of the carving instrument, a lapse of concentration, and the whole work is destroyed. For these reasons it is often asserted that it requires a more disciplined approach to conception, an impeccable attention to detail in preparing materials, and a great deal more skill in execution to work in smaller scales. And the results at an ever reducing scale are increasingly satisfying.

Modern British miniaturists are rare. However, a contemporary British artist, Willard Wigan, has exhibited such technical triumphs as the creation of an image of

Opposite right
Cast-gold model chariot. Achaemenid Persian, Tadjikistan, 5th–4th century BC.
This delicate casting is one of the most remarkable survivals from Near Eastern antiquity. The chariot is shown with two figures dressed in the style of the Medes from the centre of the Achaemenid empire in Iran. On the front of the chariot is the image of the Egyptian dwarf-god Bes, a popular protective deity. L. 18.8 cm.

the Statue of Liberty in the eye of a needle, a work that has been exhibited inside its gigantic subject for the benefit of visitors, and the successful representation of a herd of elephants on a pinhead. He uses diamond-tipped tools to effect such micro-sculpture, which he paints with, among other things, eyelashes. In discussing the technical requirements of working at such a miniature scale, he has pointed to two features.[21] One is patience, an ability to work more calmly and slowly than an artist working on a grander scale. There is simply not enough base material to rapidly pre-pare the intended object in rough, as a sculptor would in blocking out a larger work in less fragile materials and circumstances. The other observation again concerns the physical discipline required. Wigan has talked of the need to control the nervous system, to train himself to work directly on the materials being sculpted only in the *middle* of a heartbeat. However expressed, whether in terms of the control of breath-ing or of the activity of the nervous system, the ability to perform concentrated physical acts in the execution of supremely precise incisions has a whole, bodily context.

The word 'miniaturist' as applied to the artists who create miniature images has an unlikely source. Initially, it was not a reference to scale but to the medium in which an artist worked. The Latin word *minium* means 'orange or red lead', which in medieval times was the medium in which hand-written initials were painted; the verb

Painted casket panel by Pierre Raymond. French, *c.*1550.
The subject here draws on the classical story of the Rape of Helen, who in this depiction is accompanied by Paris.
H. 7.4 cm, W. 12.6 cm

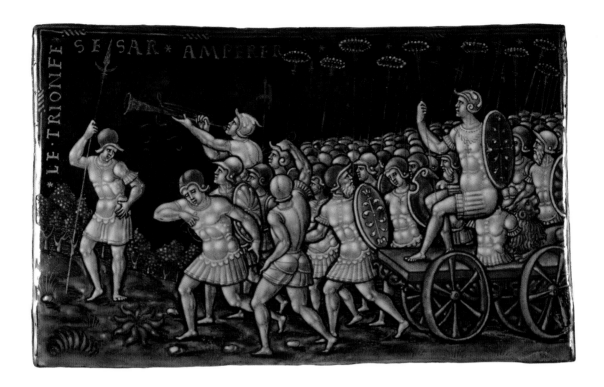

Painted casket panel by Pierre Raymond. French, c.1550.
Depicted in this scene is the Triumph of Caesar, sitting on a carriage surrounded by soldiery and being trumpeted. H. 7.6 cm, W. 12.5 cm

miniare referred to the process of painting (initials) in red, and *miniator* to the person who did the painting. It was therefore originally connected with a form of calligraphy using red paint.[22] When it slipped into meaning someone who works on a small tableau is not clear, but it is linked to illumination, referring to the process of embellishing a letter or document with colour. 'To illuminate' and 'to paint' have an uncertain but related history. Both refer to the activity of painters, but illuminators were originally those who worked in tempera and on parchment, while a painter worked in oil and on wood panel. Illuminators were known at the time as 'limnists' or 'limners'. In Flemish usage the two were members of different guilds, just as in England into Elizabethan times limners were distinguished – though not formally – from other kinds of painters. In practice the scale on which the artist and the limner worked could be the same and, despite their lexical and even legal distinction, the level of overlap and of mutual influence was significant.[23]

The fullest record of what is involved in the production of miniature paintings is found in the work of one of the greatest of limners, Nicholas Hilliard (1547–1617/18). His father had been a goldsmith, and his whole background and training lay in the making of jewel and gem settings; it was to be one of his lifelong preoccupations. Hilliard was also an engraver and an expert calligrapher, whose signature alone was immensely well crafted. But he was undoubtedly best known as a

miniature painter – indeed, in that role he is arguably the first English painter of whose work and life we have a significant account. We learn about his techniques, and about the influences on him, both from the works authoritatively associated with his name, from those attributed to his hand and – most definitively – from a remarkable document that Hilliard was encouraged to write, recording for the benefit of successors and for posterity the intricacies of his trade. This was his *Treatise on the Art of Limning*, which was written sometime between 1597 and 1603 (though it is only known from a manuscript dating to 1624). Hilliard's description of the discipline to which the limner or miniaturist must subject himself prefigures what has been said of the Malagasy carver Fesira, and the Slavic micro-miniaturists. The limner should 'sleep not much, watch not much, eat not much, sit not long, use not violent exercise in sports' – only a little dancing and perhaps the odd game of bowls are recommended. 'Discreet talk or reading, quiet mirth or music, offendeth not, but shorteneth the time and quickeneth the spirit, both in the drawer and he which is drawn.' And, at all costs, the limner must 'avoid anger, shut out questioners or busy fingers'.[24]

In addition to the observation of those disciplines, the physical circumstances in which the limning is produced are no less exacting. Firstly, as to the medium to be used, Hilliard recommends vellum, following the practice of Hans Holbein, his inspiration in the field of miniature portraiture. But it was not just any vellum that was required. It must be 'virgin parchment, such as never bore hair, but young things found in the dam's belly'. It must be 'most finely dressed, as smooth as any satin, and pasted, with starch well strained, on pasteboard well burnished, that it may be pure, very smooth and white'. The pigments employed must also be carefully selected and prepared. They could be bought from the apothecary, but needed to be stored in a small box of ivory or of shell. They were mixed with water and gum arabic, but the water should be 'distilled from the water of some clear spring, or from black cherries, which is the cleanest that ever I could find and keepeth longest sweet and clear'. For use as a palette, pieces of mother of pearl were recommended, and for the brush, the hairs taken from a squirrel's tail, first fixed on a quill and then mounted on wood or ivory sticks. The studio should benefit from a northerly or easterly light so that direct sunlight is excluded. Finally, the limner himself must prepare for his work meticulously. Hilliard recommends that he should preferably wear the finest silk 'such as sheddeth least dust or hairs'. He must take the greatest care never to touch his work with his fingers, 'nor even to breathe on it in cold weather'. The limner at his work was akin to the modern surgeon in his operating theatre: scrupulously neat and clean, his tools meticulously prepared and the physical circumstances in which he performs his artistry, calm, quiet and intense.

Hilliard's insistence on using pure, unsullied materials evokes the miniaturist's sense of needing to work in an unpolluted ambience. In many societies this is both a physical and a ritual prescription, for it is not just cleanliness and the avoidance of rowdy behaviour that is necessary, but other forms of abstinence, including sexual

Drawing of Queen Elizabeth I for the Great Seal of Ireland by Nicholas Hilliard. British, c.1584.
Like other portraits of Elizabeth I, even those from the end of her reign, she is portrayed in a youthful pose. Beside the queen are two shields, with on the left a harp adopted as the official arms of Ireland. The seal design, however, was not used.
D. 12.3 cm

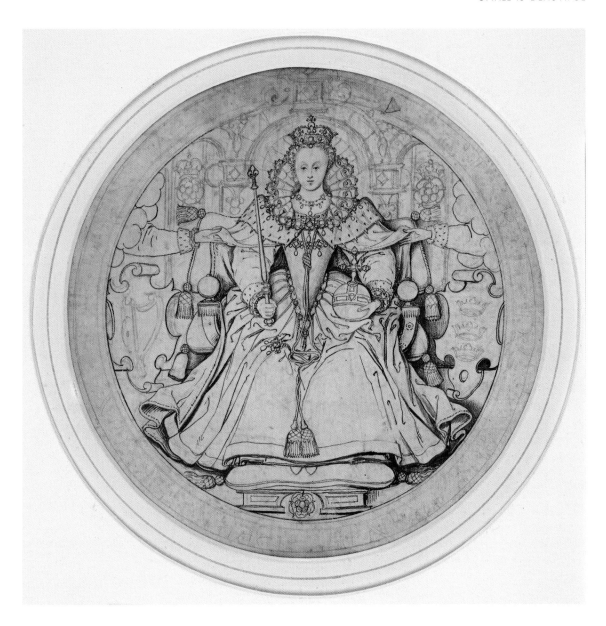

prohibitions. Acts of creation in one context imply taboos on acts of procreation in another. Yet materials present their own opportunities and challenges depending on their physical characteristics. Clearly much depends on the techniques being used, but many miniatures, especially sculpted ones, are made in a single piece and thus a single material. Qualities such as unblemished surfaces, colour and susceptibility to taking patina or paint, pliability, durability and ability to resist cracking are all important.

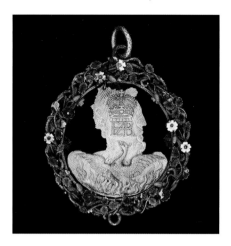

The high art of the Elizabethan miniaturist was not just evident in the production of a likeness of the sitter or of a signature with immense flourish, the identifying characteristics of both the patron and the maker in this reduced medium. Among the most noted details was the ability to represent lace ruffles convincingly. It was the painting of lace as part of a miniature of Elizabeth of Austria by the French miniature painter François Clouet that led Lévi-Strauss to his reflection on the aesthetics of the miniature (see p. 5). Hilliard and his sometime protégé and later competitor, Isaac Oliver, specialized in the portrayal of lace, made all the more difficult by being in shades of white. In some pictures, for example Hilliard's portrait of the Countess of Pembroke (*c.*1590), the lace occupies over 75 per cent of the surface of the miniature. Reproducing the already fragile tracery of lace in this reduced medium provided the miniaturist with an opportunity to show off his skills.

Much of this is obviously a matter of practical necessity. It is hard to imagine a gifted miniaturist with dandruff or with dirt under his or her fingernails. Miniatures are the product of sustained, sacrificing effort (as the French poet and philosopher Paul Valéry put it).[25] Yet the monastic circumstances of their production also added lustre to the final work. Hilliard himself talked of the art of limning as producing jewel-like results, something so enriched that it seemed to be the 'work of God not of man'. Gems, jewels and miniature pictures were linked both by their luminosity and the fact that they could be worn. 'Here,' Olivia says in Shakespeare's *Twelfth Night*, 'wear this jewel for me, 'tis my picture.'[26]

Many of the comparisons between the massive and the miniature assume that the large came first. The miniaturist, in this formulation, was a copyist. Such an assumption is at work in establishing the chronology of large Greek sculpture and miniature representations of the same subject in jewellery. In Europe the copying of easel paintings, especially portraits, commonly led to the creation of miniature versions. The art historian and museum director John Pope-Hennessy regarded Hilliard's earliest attempts at the miniature as 'reduced, full-scale portraits'.[27] As we shall see,

Reverse *(above)* **and obverse** *(opposite)* **of a gold pendant containing a miniature portrait of Queen Elizabeth I, attributed to Nicholas Hilliard. British, 1570–80.** Known as the 'Phoenix Jewel' from the phoenix in flames on the reverse (above), this pendant formed part of the founding collection of the British Museum. The idealized portrait of the Virgin Queen (r. 1558–1603) is similar to one of the same subject by Hilliard dated to the 1570s. D. 4.6 cm

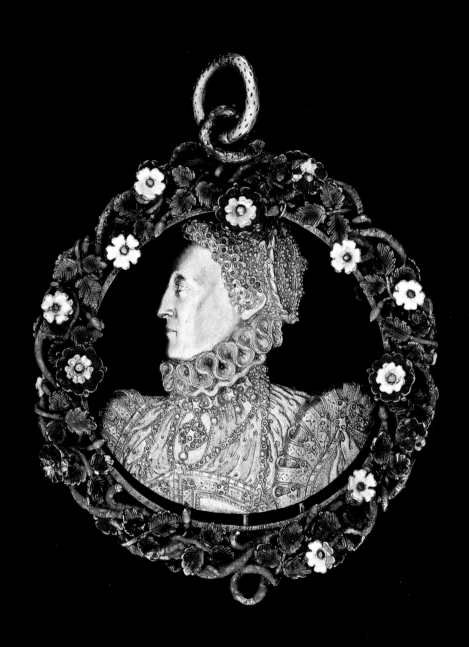

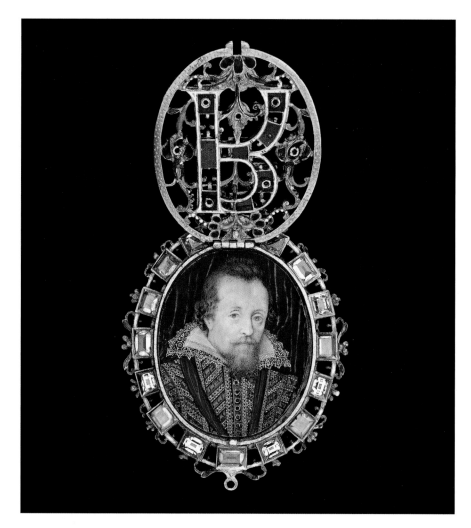

Enamelled gold locket set with diamonds containing a miniature portrait of King James I of England (VI of Scotland) by Nicholas Hilliard. British, 1610–11. Like many Elizabethan and Stuart miniatures, this has been set in a jewelled locket and was given as a royal gift to a member of the court. In this case James I (r. 1603–25) bestowed it on Thomas Lyte in appreciation for the latter's gift of a royal genealogy that seemed to prove that James was descended from the first king of the Britons. It bears the royal monogram 'IR', *Iacobus Rex*. H. 6.5 cm, W. 4.8 cm

micro-mosaics replicated large mosaics from earlier eras but at the scale of the minuscule. The chronology seems self-evident, even where the technical means are available to create objects at any scale. Yet there is no necessary reason why this should be so. One obvious exception is the Persian miniature, created originally for the illustration of narratives and later as a technique of portraiture. In Asia the small scale of illustrated manuscripts and albums dictated that for at least six hundred years from the thirteenth century the format of painting was an intricate detailed pictorial style. It was derived from a much older Arab tradition of illustrating books of fables and histories with painted scenes. The practice was only transformed when painting larger portraits in oils developed under external influence in the nineteenth and twentieth centuries, though even so the discipline of miniature painting has continued.

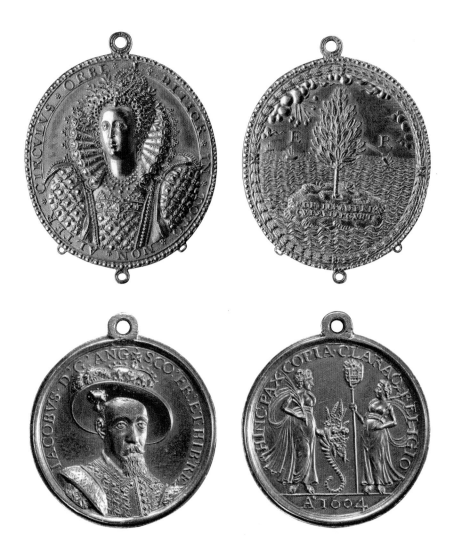

Gold medal of Elizabeth I by Nicholas Hilliard. British, 1589.
In addition to his fame as a miniaturist, Hilliard was also an accomplished medallist, a skill that he learnt during an earlier apprenticeship as a goldsmith, his father's trade. Medals, like miniature paintings, were used as gifts that the queen might confer on favoured courtiers or present to trusted allies. Elizabeth's portrait is supported by a laurel tree on the reverse that has the queen's monogram 'ER'.
D. 4.4 cm

Gold medal of James I of England (VI of Scotland) by Nicholas Hilliard. British, 1604.
Hilliard is largely known as an Elizabethan-period artist. However, he also executed works for James I, who in 1617 gave him the exclusive right to produce royal portraits. This medal was commissioned to commemorate the restoration of peace with Spain. The portrait of James is close to other painted miniatures of him by Hilliard while the reverse shows personifications of Peace and Religion.
D. 3.7 cm

Like the Elizabethan miniaturists, the Persian practitioners of the art also took infinite care in the preparation of their materials and, no doubt, were also meticulous about the physical circumstances in which they produced their works. The paper they used was made from linen strips, which were soaked in lime water, kneaded, pulped, bleached and cleaned – again in pure water. It would then be pounded until smooth and moulded.[28] It could then be sized to render a clean flat surface made even finer by burnishing. There is a Persian equivalent of Hilliard's commentary on limning by a sixteenth-century author, Sadiqi Beg, and entitled *The Canons of Painting*. Squirrels' tails were, as in England, the recommended quarry of the Persian brush-maker, though the hair from Persian cats was also deemed viable. The evident brilliance and luminosity of Persian miniatures, even after many centuries, stem from the meticulous preparation of the pigments, the skill in their application and the

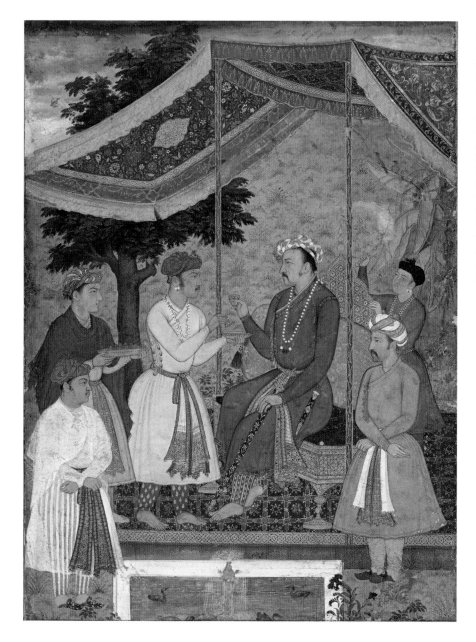

Mughal miniature painting on paper by Manohar of Emperor Jahangir in private audience. Indian, c.1610. The Mughal school of miniature painting was centred in northern India and flourished in the 16th and 17th centuries under the patronage of emperors Akbar, Jahangir and Shah Jahan. This picture painted in the early years of Jahangir's reign shows him seated on a gold throne receiving wine from one of his sons. H. 21 cm, W. 15.5 cm

choice of binding materials. Gold, silver and lapis lazuli, which gives ultramarine, were among the most lustrous sources of colour. Indigo, malachite and azurite provided further blues. Malachite also produced a green, an easier source than the alternative that involved dipping copper plates in vinegar and then burying them for a month. Cinnabar, mercury and sulphur, when heated up together, and red lead, all produced different reddish hues. Yellow was obtained from the mineral orpiment, and

black from carbon boiled up with gall nuts. A pen was made from a reed of medium dimension, neither too thick nor yet too thin, neither too firm nor too soft, proportioned so that it could be readily manipulated – neither too long nor short – and preferably tawny in colour, not black. As in Elizabethan painting, everything had to be 'just so'. Sheila Canby remarks: 'When the kings and princes of Iran wished to patronise the visual arts, they could and did command the most talented artists and craftsmen, who in turn were provisioned with the finest paper, most brilliant pigments and subtlest brushes imaginable.'[29]

Many commentators emphasize the interaction between different traditions of illumination in Asia. Canby makes a point of noting the Chinese influences on Persian miniature painters, while Michael Rogers highlights the availability of European prints as a model in the Mughal courts.[30] Some of the interactions were more direct. Persian artists were recruited to the imperial workshops in India, notably during the Safavid period in the sixteenth century, inspiring Indian artists in the arts of the miniature. We know that in Mughal India during Akbar's reign (1556–1605) the quality of the materials used in miniature painting was also subject to strict control. The Mughal emperors themselves were instructed in painting as one of the arts that informed their education, and there are reports of their books being placed on stands and scrutinized closely using glass lenses to take in the detail of fine brushwork and density of detail. The emperor and his courtiers conducted weekly inspections of the output of the artists. The accusation that the artists were looking to challenge the wonders of God's creation by seeking after perfection was dismissed; the best of the artists could breathe life into their pictures figuratively, but only God had the creative power to do so literally.[31] Nonetheless, some of the artists were celebrated for their exceptional skill, notably Basawan: in 'designing, painting faces, colour-

Playing cards. Indian, 18th century.
These cards used for playing the game *ganjifa* have been made with lacquered cloth and then individually hand-painted in the Mughal style. Their subject is the court of Emperor Akbar the Great (1542–1605).

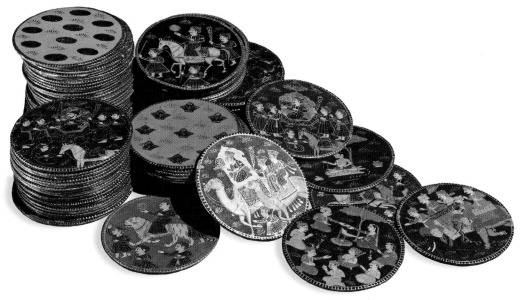

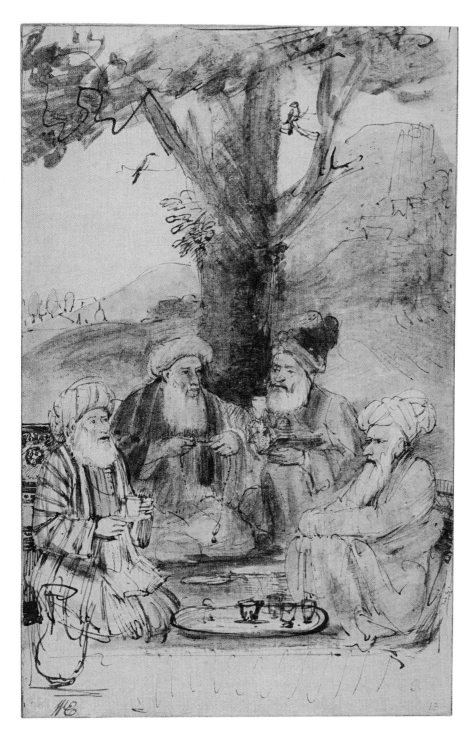

Four Orientals Seated under a Tree by **Rembrandt van Rijn. Dutch, after 1656.** An unusual Rembrandt drawing that is freely based on Mughal miniatures from India. It is well known that Persian and Indian miniaturists were influenced by European prints, but the reverse process is less widely discussed. The detailing of costume and turbans is typical of Rembrandt's better-known portraits.
H. 19.3 cm, W. 12.4 cm

ing, portrait painting, and other aspects of his art, Basawan has come to be uniquely excellent'.[32] Artists were well looked after in the imperial household, and some were born into the role, being the sons of renowned royal painters. Even so, they had no separate status but were simply *khanazad*, 'second-generation servants'.[33]

Micro-mosaics

The same sense of the radiance of small things pervades discussion of another arena of technical virtuosity, the micro-mosaic. A technique for making *mosaico in piccolo*, or 'micro-mosaics' – the term coined by Sir Arthur Gilbert (1913–2001), the creator of one of the most comprehensive collections of the form – was originally developed in the eighteenth century as a sideline by artists employed in the mosaic workshop of the Vatican. The minute individual tesserae were made of opaque enamel and came in a wide range of colours. They are of such minuscule dimensions that some have been estimated as containing over 5,000 individual pieces of enamelling in a square inch (6.5 sq. cm) – which compares favourably with the micro-mosaic created by the contemporary American artist, Laura Hiserote, one of whose creations was executed with just over 4,000 tesserae in a 2.2 cm-diameter image.[34]

These gem-like works of artistry were among the most prized souvenirs of the Grand Tour of the eighteenth and early nineteenth centuries. Frequently they would be miniature copies of classical busts or of paintings, similar in subject matter to the prints by Piranesi and others, which were resolutely in line with the neoclassical tastes of the period. And, like prints, the micro-mosaic would have been a welcome alternative to the task of transhipping large chunks of actual classical statuary across Europe. Micro-mosaics could come in the form of tiny free-standing pictures or they might already be incorporated as decorative additions on numerous types of small caskets, jewellery, inkstands and table tops. They were sold direct to visitors especially from workshops clustered in the streets around the Spanish Steps in Rome, although, increasingly into the early nineteenth century, they were exported or bought direct by jewellers elsewhere in Europe who incorporated the small plaques into their own settings.[35]

An example that illustrates well a familiar subject of the micro-mosaic artist is a miniature version of *The Doves of Pliny*, a second-century-AD Roman mosaic recovered in 1737 from Hadrian's villa near Tivoli. It is one of a number inspired by arguably the finest ancient mosaics but is among the earliest dated. The micro-artist was Giacomo Raffaelli (1753–1836), known in part as the organizer of what has come down to us as the first public display of micro-mosaics in 1775 – a rather elaborate claim, perhaps, when he was one of various makers who exhibited their products in their workshop-cum-commercial outlets in Rome. *The Doves* micro-mosaic is dated to 1779, a time when the original on which it was based was a celebrated and remarkable exhibit in the Capitoline Museum. Among the most renowned features of the

classical prototype were the stone tesserae, noted for their small size and unique in an ancient mosaic that was created well before the passion for micro-mosaics swept the Italian market in the eighteenth century. In 1847 the historian G. Moroni compared the Roman original with the later miniature versions:

> [A] mere square inch of this mosaic, described by Pliny and today in the Campidoglio, contains 163 tesserae. And now, the entire bowl with the four doves can be executed in less than a square inch. Even more remarkable, ladies now wear in tiny finger-rings the largest monuments of ancient and Christian Rome.[36]

The development of the technique of the micro-mosaic has an unusual origin within the context of the Vatican. Larger mosaics had been executed since about 1578 as adornments to the domes and chapels of St Peter's, and a mosaic workshop was established in Rome for the purpose of recruiting, initially, specialists from Venice, where St Mark's employed the leading exponents in Italy. However, within several decades of the completion of the basilica, the great Renaissance paintings that hung there began to be affected by dampness and showed signs of deteriorating. A plan was forged to replicate in mosaic several of the painted altarpieces that were at risk, thereby reproducing them in hard and durable form – creating what have been termed 'eternal pictures'. The success of these initial reproductions, their accuracy and radiance, encouraged the decision in the early eighteenth century to render all the great paintings in St Peter's in mosaic. Given this accomplishment on a large surface, the aspiration to achieve the effects using only the smallest tesserae of opaque enamelling grew. The requirement for increasing delicacy led to the creation of ever smaller – that is, thinner – glass filaments that could be broken into ever tinier tesserae. The developed technique of micro-mosaic was to lay out the minute strands of the tesserae enamels side by side like upright matchsticks on a slow-drying paste so that only the head would be visible on the finished object. Once done, the whole would be covered in wax and then polished, each step adding to the lustre of the result.

The fit between the tesserae in these micro-mosaics was often so exact that the joins between the minute pieces were not perceptible. Whereas Impressionist or Pointillist pictures appear as a mass of incoherent blobs when seen close to and only attain coherence when viewed from afar, micro-mosaics achieve such levels of luminosity that the individual pieces are difficult to identify with the naked eye, even on the closest inspection. Yet the shapes of these pieces contribute to the overall effect. Thus, tesserae arranged in different directions can create a sense of movement, while curved pieces set together can suggest flowing forms. With the production of multi-coloured tesserae, the artist was able to imitate actual brush strokes so that the micro-mosaics became true skeuomorphs, not only miniaturizing large pictures but even mimicking the detail of the painter's technique with all the attention of the faker seeking to deceive the eyes of the expert. The levels of skill attained are most readily seen in the representation of hair and fur, which achieved a high order of verisimilitude,

Micro-mosaic of *The Doves of Pliny* by Giacomo Raffaelli. Italian, 1779.
The original on which this micro-mosaic is based was recovered in 1737 at Hadrian's villa near Tivoli and is a 2nd-century-AD copy of a mosaic described by Pliny. It immediately attained celebrity and was viewed by many visitors in the house of its excavator, Cardinal Furietti, before being transferred to the Capitoline Museum. The original is 98 x 85 cm, the micro-mosaic version a mere 5.5 cm in diameter.

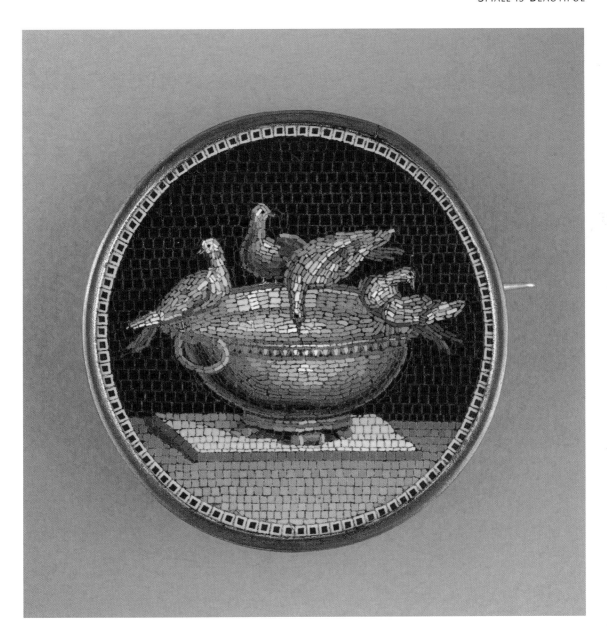

due to both the smallness of the mosaics and the wide range of colours that had
become available. Enamel production techniques had developed to such an extent
that by the mid-eighteenth century a palette of colour could contain as many as
28,000 different tints. Multicoloured filaments gave rise to speckled tesserae, which
could be employed to reproduce the effect of feathers.

All of this allowed the reproduction in miniature of major paintings. Marble
sculpture, however, posed a different set of challenges. The ability to overcome these
and suggest in a single colour the features of a sculpted bust attracted admiring com-
ment. The form of the subject could be conveyed by emphasizing its outline so that
it stood out from the background like a cameo. The master of the technique was
Clemente Ciuli, and his masterpiece, a reproduction of the head of Jupiter of Otricoli.
This miniature piece was chosen by Antonio Canova, the sculptor, for Pius VII to
present to Napoleon's brother, Prince Joseph, on the occasion of the emperor's coro-
nation in 1804. It, or one like it, was seen by the chronicler of Roman art and antiq-
uities, G.A. Guattani, who described its effects very fully:

> It is essential to record in these memoirs the name of another skilful practitioner
> of miniature mosaics, Signor Clemente Ciuli at no. 71, Piazza di Spagna. We
> have seen a work of his that may be described as non plus ultra of monochrome
> work, or mosaics of one colour. On commission he has made the head of the cel-
> ebrated colossal Jupiter … The minute scale, the uniformity and the invisible
> joining of pieces, suggests a drawing in chiaroscuro rather than a mosaic: and it
> should be noted that there could be no more difficult subject for a mosaic than
> such a Jupiter, in view of the difficulty of rendering that thick head of hair, and
> majestic beard, so well arranged, modelled and amassed by the ancient sculptor,
> that in this divine head is a masterpiece of human skill. Notwithstanding, the
> imitation made by Ciuli appears to be also of marble; nor can one understand
> how these marvellous tiny tesserae create the impression of the finest lines of the
> brush of a miniaturist.[37]

The mosaic artist is described at his easel with the colours arranged in compartments
just as a painter has his oil colours and mixes on his palette when at his easel. The
mosaic artist's tools may have been sharp pincers, but his effects were every bit as
subtle as those achieved with brush strokes. It is no discursive aside when Guatanni
compares the effects achieved by Ciuli with painters of miniatures. The art of the
micro-mosaicist has all the mystique of the miniaturist and likewise acquired the aura
of the wondrous in its reduction of large subjects to the disciplined space of a tiny
plaque. It was the nanotechnology of its day, something worked out on a scale that
barely seemed possible. It is almost irrelevant to the contemporary assessment that
the micro-mosaicist was far from an artist in his own right. They were technologists,
artisans, copyists from one perspective. In fact, most employed artists to lay out the
base design or recreate in the appropriate miniature format the outlines within which

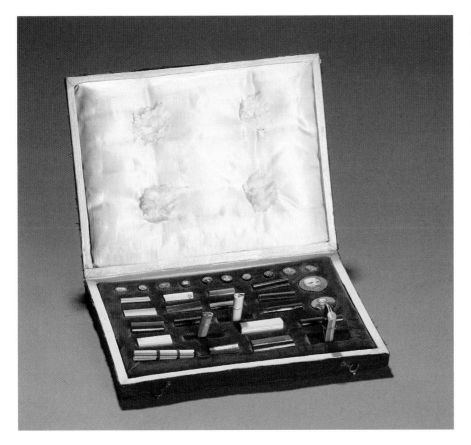

Millefiori **glass demonstration set. Italian, 19th century.** Coloured canes were fused, reheated and drawn out to make first the various parts of a face and then the complete portrait.

Micro-mosaic of a seated spaniel by Luigi Moglia. Italian, c.1830. Nowhere is the challenge to the micro-miniaturist's art more exacting than in the execution of works involving the portrayal of hair or feathers, each individual follicle of which needs to be suggested to give a combed appearance. For this purpose tiny curved tesserae are used producing a remarkable degree of naturalism in the best examples. The signature of the maker, 'LM', appears in the lower left corner.
H. 6.2 cm, W. 4.2 cm

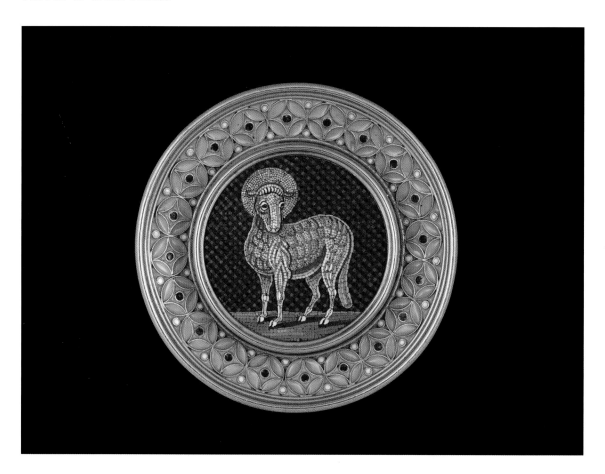

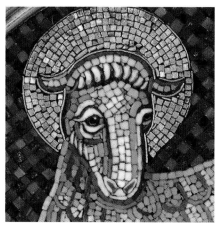

Micro-mosaic brooch showing the Lamb of God by the Castellani firm. Italian, c.1860.
This micro-mosaic combines a border copied from an 8th-century-AD piece of Italian jewellery with a representation of a large-scale mosaic from one of the churches in Rome. The tesserae that form the halo are made from gold rather than glass.
D. 5.3 cm

they placed their fairy filaments. Yet their art is not that of the faker, nor an art of deception, but one of enchantment. They, like the miniature painters of Elizabethan England or imperial Asia, were making and doing things that until then seemed beyond human capacity to create.

The microscopist

'The cleverer I am at miniaturizing the world, the better I possess it', as Gaston Bachelard remarked.[38] But what if the cleverness is in creating the instruments to investigate a world of small that is not of human creation? The world revealed to the eyes that first looked through the lens of a microscope held such ambiguity. And what they saw was a world that, in its smallness, had definitively not been made by man but was a tribute to the beauties of God's creations in miniature.

One of the first, and most interesting, questions to arise from the discoveries facilitated by the invention of the microscope was the perennial philosophical one as to the status of the world in small. For many at the time biblical understanding was ready to hand. Perception of this microscopic world had been forfeited with the Fall and the loss of both the knowledge originally available to Adam and the kinds of visual acuity that God had originally intended that Man should have. Paradoxically, one consequence of original sin was that the 'naked' eye seemed to have been reduced in its amplitude. The embarrassment that had led Adam and Eve to cover their natural condition extended to the world in miniature, which, in that instant, had receded from a subject of human contemplation into a now invisible condition. The enhanced vision that developments in the technology of lenses made possible were thus mechanisms to aid the recovery of that original knowledge, of which man, unaided, has now only a partial and blurred perception. In other words, the effect of the Fall was to reduce and restrict our understanding of the world that the Creator had intended should be known. Micro-technologies, as they were developing in Europe in the 1600s, seemed to offer the opportunity to restore this lost world – not just a lost innocence but a diminished understanding. Technology was indissolubly linked to theology in the vision it was beginning to open up into the world of diminutive things.[39] The microscope, Swammerdam proposed, could 'find wonder upon wonder, and God's wisdom clearly exposed in one minute particle'.[40]

Robert Hooke (1635–1703) has been called 'London's Leonardo',[41] at once an inventor and mechanic, a scientist with a 'law' named after him (that 'the Power of any Spring is in the same proportion as the Tension thereof'), an anatomist, an astronomer and meteorologist, a geologist, an architect and surveyor, and a talented illustrator. He was a man whose own achievements are momentous enough on their own, but who also assisted the work of some of the greatest figures of the seventeenth and early eighteenth centuries. Indeed, his reputation has suffered by comparison with a number of his illustrious contemporaries on account of his being a brilliant

experimenter who also theorized, rather than the other way round. Hooke was close-
ly involved with the experiments that led Robert Boyle to the formulation every
schoolchild now grapples with: Boyle's Law, the observation that the volume of a gas
is inversely proportional to its pressure. Hooke it was who perfected the air pump, so
constructed as to prevent leakage when creating a vacuum, thus enabling the accu-
rate tabulation of the variations in the relationship of pressure to volume. Equally, his
association with Christopher Wren (1632–1723) was close – so close, indeed, that
Hooke's diary, which records upwards of a thousand meetings between the two, is a
primary source on Wren's career.[42] The overlap in the interests of the two is evident
in the number of exploratory projects and innovations on which they worked togeth-
er. Hooke often saw through to completion projects initiated in common with Wren,
from the exploration of the laws of planetary motion and the perfecting of a weather
clock to his illustrated exploration of the world through the microscope,
Micrographia (1665), the book that first brought Hooke major public recognition.
Subsequent to the Great Fire of London in 1666, Wren was installed as one of the
royal appointees to the Commission for Rebuilding and Hooke was nominated by the
City of London to be one of their three Surveyors. In this capacity he was involved
with laying out a new alignment of the streets of London and in authorizing and
negotiating the new, privately sponsored rebuilding programme on behalf of the
City.[43] His restless interests extended readily into the field of the properties of build-
ing materials and methods of construction. Hooke was the architect of the Bethlem
(Bedlam) Hospital at Moorfields in the City of London and of the original Montagu
House in Great Russell Street – which became the first home of the British Museum
before the site was redeveloped.

Hooke's tally of achievements was most significantly racked up in his role as
Curator of Experiments at the Royal Society, and subsequently as Cutlerian Lecturer.
From these experiments, perhaps as many as three or four carefully worked out in
advance for weekly presentation to the meetings of the Royal Society, derive the
advances on which his reputation rests. He is known as one of the great figures of
experimental science and its philosophical articulation. He was conversant with
Euclid and with Descartes, and capable of engaging critically and creatively with the
propositions associated with both. He was a considerable designer and maker of
instruments (witness his air pump, among many), but he also had a less widely cel-
ebrated talent as an artist, or at least as an illustrator. And it is from this energetic,
precocious combination of scientific, technical and artistic talents that comparison
with the extraordinary achievements of Leonardo derives its appropriateness – an
acrimonious dispute with Newton notwithstanding.[44]

Hooke's magisterial examination of the microscopic world is documented in
Micrographia, a volume copiously illustrated with his own observational drawings.
The subtitle of the work suggests the technical and mechanical refinements that made
possible the experiments and observations on which the book is based: *Some
Physiological Descriptions of Minute Bodies Made by Magnifying Glasses with*

Observations and Enquiries thereupon. Optical instruments – microscopes and telescopes – provided the sights from which the 'insights' derive. Hooke used both compound and simple (or single-lensed) microscopes. However, he was not just viewing his subjects privately but illustrating them, both in his published book and in the public presentations of his experiments, albeit to the professionally attuned membership of the Royal Society. For both purposes illustrations were desirable. Additional refinements to commercially available microscopes were necessary to achieve this end. The principal one was an adequate illumination of the subject so that Hooke could see clearly what was going on. This he achieved using a condensing lens, whether a convex lens or a glass flask, to concentrate daylight or the light from an oil lamp. The conditions had to be carefully constructed. If relying on ordinary sunlight,

Illustration of a compound microscope from _Micrographia_ by Robert Hooke. British, 1665. Wellcome Library, London.

Hooke appropriately illustrated not just his 'discoveries' but the means of making them. The compound microscope is provided with an oil lamp and condensing lens to aid illumination. Hooke adapted to his own specifications microscopes that were already commercially available.

it should be filtered, whether through oiled paper or glass 'rubb'd on a flat Tool with very fine sand' to avoid glare.[45] We are reminded again of Hilliard's recommendations to limners (see p. 22), except that on this occasion the avoidance of dirt, dust and mites to provide ideal viewing conditions was designed to observe the things themselves – the mites, fleas and gnats – better. And here 'illumination' is not just coincident with 'illustration' in semantic terms, it literally precedes it in scientific and procedural terms.

A second issue was the act of illustration itself. Hooke was using his illustrations in *Micrographia* to record on a large scale things otherwise invisible to the naked eye, thereby reversing the procedures of the miniaturist. But his childhood background included some exposure to the techniques of the miniaturist painter. John Aubrey (1626–97), in one his 'Brief Lives', records a visit made to the Isle of Wight by John Hoskins, who was Charles I's miniaturist.[46] Charles I had fled to Carisbrooke Castle in the centre of the island in 1647, postponing his ultimate fate at the hands of Parliament and settling for a time near Freshwater, Hooke's home. Aubrey records that Hoskins made a visit to Freshwater and that the young Hooke, after watching Hoskins at work, decided that the techniques of painting were well within his grasp:

> *Mr. Hooke observed what he did, and, thought he, 'why cannot I doe so too?' So he gets him chalke, and ruddle (red ochre), and coale, and grinds them, and putts them on a trencher, gott a pencil, and to worke he went, and made a picture: then he copied (as they hung up in the parlour) the pictures there.[47]*

From there he went on, orphaned and aged only thirteen, to an apprenticeship with the London painter Peter Lel (1618–80), for whom he took on the task of adding the landscape and other background detail to his society portraits. However, according to Aubrey, he quickly realized that painting was something in which he needed no further instruction as he was already possessed of a precocious talent – 'Why cannot I doe this by my selfe and keepe my hundred pounds?'[48] he reportedly remarked, and he decided instead to use the funds that formed his legacy on learning Latin and Greek and playing the organ at Westminster School. Most commentators leave the matter there. Aubrey goes on to tell us that Hooke 'also had some instruction in draweing from Mr. Samuel Cowper (prince of limners of his age)'.[49] There is clearly a difference between being apprenticed to a society painter and to a leading limner. It is not simply a question of the level of artistry but, as we know from Hilliard's *Treatise*, of maintaining standards of fastidiousness and tidiness and the extremes of accuracy and concentration required. The limner's studio and the scientist's laboratory must both be scrupulously maintained. Limning, we might say, is a suitable training for the scientist-illustrator, demanding similar skills in transferring the image seen through the microscope to the page. From Westminster School Hooke progressed to Oxford where he became Boyle's assistant. But the evidence is that he was always a proficient artist, whatever the other fields that he elected to explore.

Illustration of a stinging nettle from *Micrographia* by Robert Hooke. British, 1665. Wellcome Library, London.

In *Micrographia* Hooke describes the sensation of being stung by a nettle and then proceeds to explore the topic scientifically. He explains that under the microscope – in this case a powerful single-lens version – he could observe that the bristles on the nettle spiked his skin without bending and in doing so introduced a 'poisonous juice' into the body.

41

Micrographia had several beginnings. In 1661 Wren had been commanded by Charles II to produce a series of illustrations of insects and other minute phenomena only visible through a microscope. Wren does seem to have made some of the required drawings. However, he proved to be too busy to complete the task and the project passed to Hooke, who, the following year, combined it with his appointment as the Royal Society's Curator of Experiments. There was already some suggestion that the Royal Society was not achieving all that had been foreseen when this intellectual and scientific powerhouse had been set up around 1645 and formalized in late 1660. It struggled to find a medium through which to communicate the new discoveries that were being made, and was suspected of frittering away its efforts on ultimately worthless observation and debate. The realization of such a commission as Wren had originally received, if merged with the wider activities of the Society, would be one large step towards maintaining the interest and patronage of the king and other constituencies. In 1663, at a Council meeting, Hooke was 'solicited to prosecute his microscopical observations, in order to publish them'.[50] He had, in fact, already begun several months earlier to produce a series of illustrations for the weekly meetings of the Society. Many subjects were suggested by the interests of his audience. In quick succession he provided pictures of subjects as diverse as frozen urine, dog's blood, petrified snow and viper powder. Sir George Ent had Hooke do a drawing of deer's hairs; other Fellows were obsessively interested in nematodes, minuscule eels swimming in vinegar.[51] That these drawings were Hooke's own is beyond doubt, although the identity of the eventual engraver is not known.[52] All this labour-intensive study was good preparation for bringing the wonders of vanished nature before a more popular, but no less demanding, audience.

There are in all thirty-eight plates in the book, ranging from smaller detailed images to dramatic renditions of natural phenomena otherwise invisible to human observation. The image that came to characterize the book was his detailed drawing of a flea (see p. 45). After all, the popular name for the microscope at the time was *pulicarium*, or 'flea glass'. It was the classic insect for such an enterprise, not a thing of beauty at one level, but, when illustrated on a large scale, one that appeared thoroughly intimidating. Having solved the problem of illumination, there remained the tricky issue of arranging the flea so that it could be drawn. The purpose was not to dissect and damage the specimens but to find a method of quietly looking in on their natural form. 'This [the flea] was a creature more troublesome to be drawn than any of the rest, for I could not for a while think of a way to make it suffer its body to ly quiet in a natural posture', Hooke says in the commentary that he attaches to the published illustration. He could not simply kill them, as they quickly lost their shape. Some insects could be immobilized by sticking their feet in glue or wax, but fleas and ants were a different matter. Hooke's solution in the end was to drown them in spirit of wine so they could be pinned out in as natural a pose as their drunken demise allowed. That done, he then had to find a method of drawing them accurately. There was, however, no means of projecting the image seen through the microscope to

enable the drawing to be made. Even for an inventive mind like Hooke's there was no alternative: the only way to draw it was to view the same subject over and over again, often in different lights, moving back and forth between the microscope and the page, a time-consuming and physically demanding process.

The results were widely applauded. The well-known scientific luminary Christiaan Huygens was fulsome in his praise; the leading scientific journals were unanimous in their admiration. Even Samuel Pepys sat up into the small hours of the night reading it and subsequently declared it 'the most ingenious book that ever I read in my life'. We must remember that the practice of illustrating printed books on scientific subjects was still in its infancy. As Antony Griffiths documents, the 1660s saw the beginnings of an explosion in printmaking: within two decades of the publication of *Micrographia* 'the new technique of mezzotint had created a new industry, and new demands had given rise to new types of print to service scientific illustration, technology and other subjects that had previously been ignored'.[53] But, when Hooke was publishing in 1665, what his combination of philosophical reflection and illustration revealed was something altogether new. He used his skills at illustration to advance a scientific understanding that was beyond the 'philosophy of *discourse* and *disputation*'. His intention was not to persuade and inform by argument and words but to demonstrate his case '*ad oculum*' ('by the evidence of the eye').[54] This was what he thought of as experimental or mechanical philosophy – not just the reflections to which observation had led, but the very images that had inspired them, faithfully reproduced as they had been seen through the microscope and rendered at a scale where their detail and structure were completely accessible. Hooke recalled his first sight of a slice through the cells of a piece of cork: 'the first microscopical pores I ever saw, and perhaps, that were ever seen'.[55] He was aware of opening up new, if microscopical, vistas and conscious of sharing with his readers visions that it had never before been possible to see – at least not since the Fall. The evidence of the eye was more powerful and communicable a proof, and more stimulating a challenge, than dull reports of scientific observations. Othello had demanded 'ocular proof' of Desdemona's supposed infidelity. Now it was not just cuckolds who looked to the ocular for their evidence, but the astronomer and biologist, or in the terminology of the day the 'natural philosopher', armed with telescope and microscope. For Hooke it was not enough to postulate that the form and shape of matter was a composite of minute particles; he needed to be able to demonstrate it in a convincing experimental context. He needed, in effect, to be able to *see* such minute entities before being secure in asserting their existence. The experience was thrilling, exhilarating; the micro-world was yet to admit of the microbe, and the flea was yet to be identified as the source of plague, which in Hooke's day remained a threatening scourge in London, as in other urban concentrations of population.

Micrographia retains the power to impress, not least through the quality and impact of its illustrations. The philosopher of aesthetics and art critic Arthur Danto has devoted a lively essay to a consideration of the sources of 'the uncanny power and

strange beauty' of Hooke's illustrated creatures.[56] He is drawn to the contrast between fleas as pestilent, yet as 'imposing in the intricacy and the proportion of their astonishing bodies'.[57] He finds in Hooke's illustrations a mingling of the aesthetic with the cognitive. The microscope had summoned in an Age of the Marvellous;[58] like the discovery of new continents, it opened up an enhanced understanding of the possibilities and beauty of nature; and like the artefacts and products brought back by returning explorers, these illustrations made visible whole new worlds. The flea in its smallness was every bit as intriguing as 'Zarafa', the first giraffe to be seen in Europe in 1826 when she came ashore in Marseilles,[59] or the white Siamese elephant that Stamford Raffles had sent to Japan a decade or so earlier (and that, though it attracted large crowds in Japan including many artists, sadly proved impossible to unload when it arrived in Nagasaki).[60]

But what of the scale at which they are engraved? Hooke's flea is a giant fold-out not a reduced drawing. There is a story concerning an illustrated talk on the mosquito that has been retold sufficiently often by African ethnographers that it has acquired all the semblance of truth. It takes place in a remote country village where cinemas and screen projection are quite unknown. An eager health worker is trying to explain with appropriate slides the association between certain kinds of mosquito, their blood-sucking manner and the sources of malaria. At the end of the talk the villagers breathe a collective sigh of relief and, as one, acclaim their good fortune in being blessed with only very small mosquitoes in contrast to those of monstrous dimensions they have just seen illustrated on the screen. But *Micrographia*, significantly, did not pose this contrast. The view through the lens of the microscope, which he illustrated with such artistry, had in practice abolished scale. Beasts, large and small, could be rendered in similar dimensions. There is no point of comparison, no tiny humans (as Danto remarks) cowering beneath some massive science fiction monstrosity. Small things could be rendered on a large scale, smooth things could be shown to have ragged surfaces, sharp points proved to be smudged. 'Such epithets as "large" and "small" or "smooth" and "coarse"', Harwood suggests, had 'now lost all meaning'.[61] In our terms, we might say that Hooke revealed not so much the art *of* small things, but the art *in* small things. His flea is every bit as monumental, every bit as armorial a beast as Dürer's famous rhinoceros or Bosch's elephant.

Science and technology have moved on significantly since Hooke's time. We are now in a world of nanotechnology, where entities are created at the scale of the atom, and we are familiar with investigating and creating dimensions of smallness so minuscule that they approach the nothingness that Flann O'Brien's Third Policeman explores with such obsessive tenacity. There is something ethereal about the creation of small things. And for Hooke, the son of a family of ministers of the Church, as for many of his time, there was a clear theological underlay to the visions he was observing through his lenses. If seeing is believing, then the art in small things was divinely created. Man would have been able to see these wonders unaided had it not been for the Fall, just as the young see better than the old. 'I judged', Hooke says, 'that

Scbem XXXIV

whatever men's eyes were in the younger age of the World, our eyes in this old age of it needed spectacles.'[62] His little creatures reveal the hand of the divine every bit as readily as the giants of the natural world: 'my little objects', he concludes the Preface of *Micrographia* by saying, 'are to be compar'd to the greater and more beautiful Works of Nature, A Flea, a Mite, a Gnat to a Horse, an Elephant, or a Lyon.' Indeed, the structural and anatomical intricacy to which smallness is witness suggests that God's creative hand is, if anything, more evident in the flea than the elephant.

For a previous generation John Donne had invoked the flea as a metaphor for the mingling of lovers' physicality – it grows and swells in proportion to the quantities of blood it has sucked from the lovers who are the ostensible subject of the poem. The flea, which in earlier poetic formulations had often been conceived as a kind of Lilliputian trickster investigating and exploring the anatomy of female hosts unchecked, is here metaphorically reconfigured as the site of the mingling of lovers' vitality: 'one blood made of two' or again, and with an additional and more directly theological reference to the Trinity, as 'three lives in one'. The flea, the least of God's

Illustration of a flea from *Micrographia* by Robert Hooke. British, 1665. British Library. The flea, the most elusive yet most insidious of God's creation, is here rendered as a scientific specimen through illustration. Ironically, and without knowledge of the association, 1665 – the year of the publication of this illustration – was also the year of the Great Plague.

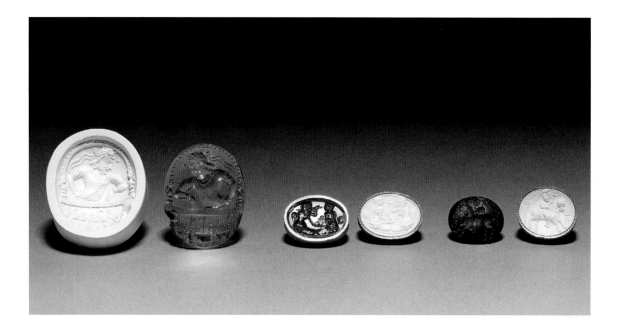

creatures, is at once expanded into a metaphor for the whole created universe and contracted to express the exclusive world of intimacy of the two lovers. Hooke preferred a witticism with a double meaning at once biblical and scientific. With *Micrographia* he had added his 'mite' to the treasury of natural philosophy, as the widow in the New Testament parable had added her *mite* (that is, a low-value coin) to the treasury of the Temple. Both had, the implication is, made a modest contribution, but one with greatly enhanced significance, to the divine cause.

Of lice and lace

With the invention of microscopy, then, man had retrieved a lost world of God's creation. The outcome of that retrieval was the rendering of the intricacies of nature on an enlarged scale. Visual access to wonders that had been forfeited with man's Fall was recovered, and, appropriately, *Micrographia* included Hooke's illustrations of the microscope itself, the instrument of that reparation. The focus is on means. In terms of the apprehension of the miniature, what had been achieved was an act of observation that had proved impossible unaided. Where the eye can no longer discern structure and detail with clarity, the mind seeks to restore the missing elements through the contemplation of process. The same holds for the observation of things of natural creation, for the realm of the divine and for the artefactual, man's creative domain – for the world of both lice and of lace.

Seals with plaster-cast impressions. India and Pakistan, 1st–3rd century AD.
The process of imprinting enabled miniature images to be reproduced in quantity. The task of rendering minute things visible to the naked eye at a viewable scale required not just the means of seeing things, made possible by the microscope, but the equally tricky process of reproducing them at a much enhanced scale so that others could see them too. Robert Hooke's book *Micrographia* represented the crucial breakthrough.
H. (of seal on left) 2.8 cm

Alfred Gell makes a similar point about his response to looking specifically at Vermeer's *Lacemaker* (c.1669–70), a work on a larger scale. How much more apposite are these remarks when applied to the world of the miniature:

> I must accept that Vermeer's painting is part of 'my' world – for here it is physically before me – while at the same time it cannot belong to this world through my experience of being an agent within it, and I cannot achieve the necessary congruence between my experience of agency and the agency (Vermeer's) which originated the painting.[63]

Miniature painting and miniature sculpture bear no marks of their making, for the process of their creation functions at levels of visibility that effectively conceals their agency.

A theme that recurs throughout the discussion in this book is that the aesthetic experience of the miniature has a whole bodily context. There are several elements to the observation. Firstly, it is our sense of our own body and its dimensions that sets the baseline for judgements of scale, as is exploited so suggestively by Swift in the guise of Gulliver. Also, as mentioned, the artist working at the scale of the miniature has to be in control of the functioning of their own nervous system. Beyond that, our sense of the aesthetic, as Gell observes, is related to our sense of what it is possible for human beings to achieve, given our experience of our own bodily inheritance. The creation of things that stretch our expectation of human achievement engenders a feeling of wonder that is part of the response to the miniature, widely reported in both western literature and other cultural contexts. The more something approaches the extremes of visibility, the more it challenges our sense of the physical and creative potential our biology has gifted us.

With Gell's observations on Vermeer we are, then, back to lace and its representation in art as a locus of the western experience of awe. We need to revise the phrase 'small is beautiful' with its passive, descriptive air, or at least to spell out its dialogical implications further. In exploring the world of small I have before my own eyes evidence of intricacy executed at the limits of visibility; Gell associates the enchantment of certain types of object with the fact that it hardly seems possible that these are created things. Miniatures are especially potent examples for they make me aware that I live in a world that, if I had to create these aspects of it for myself, would defeat me. It is a wondrous place. I can indeed possess aspects of it – I can wear Pliny's mosaic doves on my finger – but I am not in control of it. I live in a world that has been created *for* me, but not *by* me. In that sense I experience the world of small as a place at the edge; it is also potentially an unsafe place. There are things within in it that are thrilling to contemplate, but part of the thrill is the awareness that, despite its reduced scale, it possesses dimensions that escape me, one of which is how it came to be in the first place. This confrontation with the process of creating wonders in miniature is at root an 'aesthetic' perception.

2. The Colossal and the Diminutive

In making the assertion that the miniature is a realm of the exquisite we beg the question: what is small, what is miniature? In a review of the history of miniature painting in Europe, the Danish art historian Torben Colding has dismissed the idea of size as both an 'unattractive' and a 'pointless' place to begin. 'Mere smallness', he wrote, 'is a poor criterion; every size is small in relation to a larger one and large in relation to a smaller one.'[1] He is obviously right. There are no absolutes: 'small' and 'large' are relative terms, and when the same question has arisen in discussion with colleagues, I, too, have instinctively sought to sidestep it.

However, this certainly does not mean that scale is to be seen as but an incidental aspect of human experience. There is a sustainable perception, from prehistory to the present, that size matters. We cannot deny that there are some categories of the material world that would seem to qualify uncontroversially as miniatures. An Elizabethan portrait that can be held in the palm of the hand is nothing if not small; by contrast, the colossal sculptures of classical antiquity were clearly made to be big and intended to impress by the very fact of their 'bigness'. Likewise, a macrocosm may be at the unimaginable dimensions of the universe, where a microcosm is confected at a more imaginable and graspable size. Even so, where a microcosm is at a reduced scale we might not immediately think of it as 'small', because its smallness is in relation to a prototype that may itself be vast. A museum's collections, for instance, represent a deliberate, selective scaling-down of a wider totality; furthermore, it is constituted as a world in its own right through the processes of exhibition and interpretation. Museums might be considered as microcosmic, despite the fact that the sites that they occupy can cover many acres of space. In neither case is the diminutive merely a reduced replication of the large. The colossal and the diminutive, the macrocosm and the microcosm may invoke ideas of mutual self-definition, but they elicit quite different responses and have their own rationale and veracity. The more illuminating question, then, is not the absolutist one of what a miniature is. Rather the issue to be explored in this chapter concerns the nature of the relationship of the vast to the minute.

Opposite
A selection of the Lewis Chessmen set up for a game. Probably Norwegian, 1150–1200. See next page.

The measure of all things

These are ideas that Jonathan Swift plays on in his classic study *Gulliver's Travels*, written between 1720 and 1725. The book is made up of several parts. The first concerns 'A Voyage to Lilliput', during which Gulliver encounters a race of tiny people, while the second concerns 'A Voyage to Brobdingnag', where he is the dwarf and the inhabitants are a race of giants. Much in the first part of the book is concerned with bodily functions. Gulliver's first hilarious attempts to relieve himself unobtrusively are described in an apologetic tone. It is among the first challenges that he, as a giant in this land, must face – how to perform those acts that would otherwise take place discreetly, when his very size makes him the biggest thing around. Later, Gulliver is summoned to a fire raging out of control in the royal apartments and puts it out by urinating on the building – an act that, though it may have saved the royal dwelling, was also in breach of the statutes governing behaviour in the palace enclosure and led to his impeachment. As to food and drink, the sustaining of Gulliver has the potential to create famine in the realm of the Lilliputians. The details are given with a mathematical exactitude as precise as that of any eighteenth-century calculation of the vastness of the heavens. Gulliver explains:

> [H]is Majesty's mathematicians, having taken the height of my body by the help of a quadrant, and finding it to exceed theirs in the proportion of twelve to one, they concluded from the similarity of their bodies, that mine must contain at least 1728 of theirs, and consequently would require as much food as was necessary to support that number of Lilliputians.[2]

The text is at once fictional and anthropological. It imagines worlds coming into contact with each other and trying to make sense of each other's assertions. Thus Reldresal, 'Principal Secretary (as they stile him) of Private Affairs', comments on Gulliver's insistence that the land that he has come from is populated by people of his general dimensions:

> For, as to what we have heard you affirm, that there are other kingdoms and states in the world, inhabited by human creatures as large as your self, our philosophers are in much doubt; and would rather conjecture, that you dropt from the moon, or one of the stars; because it is certain, that an hundred mortals of your bulk, would, in a short time, destroy all the fruits and cattle of his Majesty's dominions.[3]

But, as Gulliver points out, these are exact scaled worlds:

> As the common size of the natives is somewhat under six inches, so there is an exact proportion in all other animals, as well as plants and trees: for instance,

Walrus ivory and tooth chessmen. Probably Norwegian, 1150–1200. The so-called 'Lewis Chessmen' are an assemblage of pieces from four different chess sets that were found in a bay in the Outer Hebrides. Their scale is a function of the need for them to be manipulable. They are 'small' because they fit in the palm of the hand. However, their standardized scale in the versions of the game found extensively in Europe and Asia makes them a possible metaphor for the sense of small and large, as in the fictional context of Alice in Wonderland. H. (of largest figure) 10.2 cm

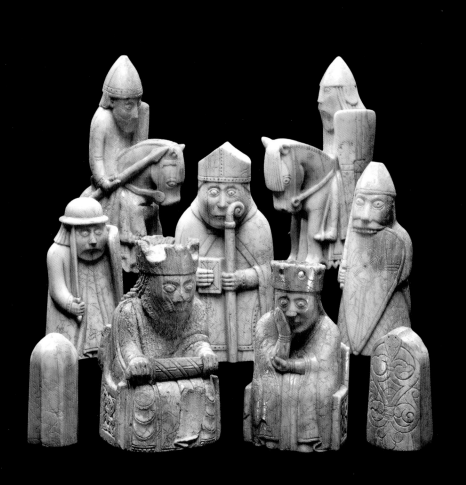

the tallest horses and oxen are between four and five inches in height, the sheep an inch and a half, more or less; their geese about the bigness of a sparrow; and so the several gradations downwards, until you come to the smallest, which, to my sight, were almost invisible; but nature hath adapted the eyes of the Lilliputians to all the objects proper for their view: they see with great exactness, but at no great distance.[4]

The LITTLE PRINCESS and GULLIVER.

Gulliver thinks about bringing back actual Lilliputians,[5] but in the end he settles for bringing back examples of these miniature animals with him when finally he leaves the island of Lilliput. One of his sheep, being in Gulliver's terms diminutive, is devoured by a ship's rat. However, the cattle survived the journey and Gulliver eventually finds appropriate grazing for them – on a bowling green 'where the fineness of the grass made them feed very heartily',[6] and appropriately located in Greenwich, London, where the first Royal Observatory had been erected in 1675.

In Brobdingnag the coin is flipped and Gulliver has the misfortune to be abandoned by his frightened, fleeing shipmates in a place of giants. Here he is taken in by a family of colossal people. The baby of the family, having been disavowed of the impression that Gulliver was a plaything to be sucked, needs to be quietened by a wet nurse. Gulliver sees her breast, which 'stood prominent six foot, and could not be less than sixteen in circumference'. Her nipple 'was about half the bigness of my head'.[7] He declares the sight 'nauseous', and the breast and nipple 'monstrous', continuing:

> *This made me reflect upon the fair skins of our English ladies, who appear so beautiful to us, only because they are of our own size, and their defects not to be seen, but through a magnifying glass, where we find by experiment, that the smoothest and whitest skins look rough and coarse, and ill coloured.[8]*

The gigantic nipple is a confection of spots, pimples and freckles rather than a thing of beauty, just as the Lilliputians had found his own face – enormous in their terms – pitted, with the stumps of his beard 'ten times stronger than the bristles of a boar'.[9]

Thus relative scale clearly provides one sense of size. Yet the Lilliputians and the Brobdingnagians are never directly compared. The dimensions of Gulliver himself provide the constancy of measure. Although Gulliver remains the same size throughout, those among whom he finds himself are successively midgets and giants, and he

Hand-coloured etching by Charles Williams. British, 21 October 1803. This illustration is one of a series, often by different artists but in an identifiable common style, that evokes *Gulliver's Travels* to poke fun at political figures, frequently Napoleon. 'The Little Princess' referred to in the caption is Princess Charlotte, who wears an oval miniature of the Prince of Wales. 'You attempt', she says, 'to take my Grandpap's crown ... I'll let you know that the Spirit and Indignation of every Girl in the kingdom is roused by your Insolence.'
H. 32.5 cm, W. 23.7 cm

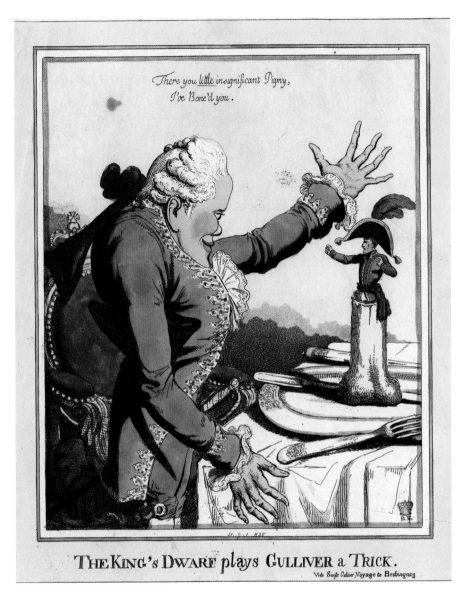

There you little insignificant Pigmy, I've Bone'd you.

THE KING's DWARF *plays* GULLIVER a TRICK.

Vide Swift Gulliver, Voyage to Brobingnag.

Hand-coloured etching by Charles Williams. British, 18 October 1803. A further snipe at Napoleon, who is here rendered 'boned' and ready for the table at the behest of a dwarf at the British court who is proportionately large in relation to Napoleon, the satire being portrayed in terms of the Kingdom of Brobdingnag in *Gulliver's Travels*. The series of which this is part was issued after propaganda aimed at recruiting a volunteer force to resist an anticipated French invasion. H. 29.7 cm, W. 23.7 cm

by turn gigantic in one context and diminutive in the next. If man is the measure of all things, it is not just philosophically or morally: man is also literally the measure of all things. The sense of the smallness or bigness of things is related to our own sense of the body as the gold standard in the realm of measurement. Parts of the body have been used as traditional measures since antiquity. The digit is the breadth of a finger, the cubit is the distance between the elbow and the outstretched fingers of the hand, the foot obviously is the length of the foot itself, the span is the width of an outstretched hand and so on. We tend to anthropomorphize scale.

Our subject here is principally the sense of smallness. Yet we should note how in many contexts the massive can appear overtly declaratory, made for public display, and confected to impress and often to repress. Edmund Burke (1729–97) said that it is the ability of the eye to take in the diminutive in one glance that sets the experience of the miniature apart from that of the massive, where the eye needs to scan the object to comprehend it.[10] And, even then, a single glance is never subsequently going to be sufficient to take in its totality. It is impossible to relate to the colossal in an individual way. In the context of the rise of fascism in Europe, the commission of massive sculpture to be displayed in architectural settings – in relation to buildings that were themselves of massive conception – effectively reduced the individual to mere instrumentality. It is only as one in a vast grouping of humanity that the object and its surroundings attain a scale of mutual dimension. Thus the displays of disciplined human behaviour on the Zeppelin fields and at other Nazi demonstrations only brought the size of the spaces into relation with people by the presence of massed humanity. Yet this was hardly an individual human scale. All individuality was erased by participation in the ordered crowds that paraded before these massive structures. Many are well known from photographic evidence or film footage of, for instance, the 1936 Olympic Stadium in Berlin (adapted by Albert Speer from an original design) with its striking references to the Colosseum, the Zeppelin Field Stadium or the Mark Field, the last capable of holding 500,000 people. Enlarged representation denies the function of art as an elevating medium, as it has been presented throughout much of the history of 'western' art at least. Rather, it challenges and reduces the sense of individuality; art emerges as the servant of social control.

The point is made effectively by the architect Colin St John Wilson who speculates on the relationship between the individual and monumental architecture. There is, he notes, a feeling of exposure that is 'experienced not only in the extreme form of agoraphobia, but also in the drama of confrontation that can take place between the façade of a monumental building and the visitor who, approaching across the open space, is compelled to stand off at a respectable distance and, in that intuitive act of deference, is made to feel vulnerable'.[11] A similar psychology seems to underlie the creation of colossal figures, the massive architecture and the public parades of the classical world. Indeed, there is some overlap between the two examples, for it was in Rome in the 1930s that the original Forum of Augustus was largely destroyed to create a magisterial avenue down which Mussolini could parade at the head of his Fascist displays. He was to be memorably photographed processing on horseback down broad boulevards with the Colosseum in the background. Likewise Hitler had in mind classical ideas of both celebrating greatness and dominating the individual citizen when commissioning the monumental buildings of the Nazi era. The appropriation of the massive in antiquity to vaunt twentieth-century self-esteem was still a political vision of serious potency.

Hercules and the gods

Yet are all big things necessarily gross and intimidating? In the ancient Greek model, gods, notably Zeus – or exceptional humans, such as Hercules or Alexander the Great – were rendered on a massive scale. The vocabulary for their description included the term *kalloi*, a word often translated as 'beautiful'. The emphasis is on the overpowering, extra-human dimensions of the sculpture, which reflected the heroic conception of the person represented and the exceptional nature of their achievements. 'Greatness' was the issue, a quality that Alexander attached to his own name for the first time in a European context in the fourth century BC (following Assyrian practice) and was adapted thereafter to describe rulers elsewhere. Alexander himself, the ruler described as living in a world that was already too small compared to his own greatness, had inspired a scheme to carve Mount Athos into the form of a man – a classical precedent for Mount Rushmore – as an appropriate expression of his fame and achievement. Alexander aspired to representation on the god-like scale of the colossal. His conquests and achievements had expanded not just the geographical jurisdiction of the Greek empire but also the Greek view of the dimensions of their own world, to the point where Alexander's sway was now immense.

His favoured portrait sculptor was, by repute, Lysippus, revered for his skill in the creation of the colossal, although it has proved impossible to identify unequivocally any single creation as by his hand. He is known principally for the attribution to him of work on an inspiring scale, notably a figure of Zeus 70 ft (21.3 m) high and a figure of Hercules (both at Tarentum). There were also further figures, notably one that served as the model of Hercules Farnese in Naples. Lysippus was reputed as the master of the massive. Yet he was also, by common consent, the creator of what appears to be one of the earliest-known statues in small scale from the classical world – a figure of Hercules seated on a rock covered appropriately in lion skin, with club in one hand and raising a drinking cup in the other. It is known from a series of about twenty Roman copies. In the context of his gigantic figures, this 1 ft (30 cm) high ornamental statuette is of a genre known as Hercules Epitrapezios (literally 'on the table' – a table Hercules). The uniqueness of Lysippus' versions of Hercules is that they are known at both extremes of scale; and it is not that one is an artist's model, and the other the finished work. So, almost uniquely, we have in Lysippus an artist adept in the domains of both the massive and the small; it is hard to think of any other artist who has seriously explored both of the limits of scale as a mathematician or a philosopher might do, invoking the infinite and the infinitesimal to approach dimensions that challenge the idea that man, and his typical size, is indeed the measure of all things. Again Burke has interesting comments to make. He contrasted the sublime and the beautiful as aspects of both extremes of scale: 'The sublime, which is the cause of the former, always dwells on great objects, and terrible; the latter on small ones, and pleasing; we submit to what we admire, but we love what submits to us; in one case we are forced, in the other we are flattered, into compliance.'[12] Both

the colossal and the table versions of Hercules are equally works in their own right, not copies of each other in different scales; they are known from antiquity in the dimensions in which they were intended to be rendered and to be seen. And both achieve Burke's identified responses. He continues: 'In short, the ideas of the sublime and the beautiful stand on foundations so different, that it is hard, I had almost said impossible, to think of reconciling them in the same subject …'[13] Arguably, the two versions of Hercules produced by the same artist and at the behest of the same patron are exceptional in achieving just this exploration of the boundaries of both visual perception and technical possibility – of the awesome and the aesthetically intriguing.

If the table on which the figure of Hercules was to be displayed was that of Alexander, as tradition relates it was, the comparison may have been intentionally between the patron and the subject – both larger-than-life figures. In the privacy of Alexander's domestic world Hercules was a less dominating presence. His function, nonetheless, would seem to have been to inspire at any feast to which he, Hercules, was witness the heady mix of raucous festivity for which he himself was renowned. Hercules needed to be a commanding presence despite being portrayed in what was, for him, a diminutive scale. The focus, therefore, is as much on the artist as on the patron or subject. This was, as art historian John Onians speculates, probably the first genuinely small Greek sculpture to attain fame. Certainly opinion is that both the colossal and the small versions of Hercules were well known in antiquity. The sculptor's aptitude in suggesting Hercules' physical strength and the greatness of his deeds in small compass was in this context a revelation. To use exaggeration of scale to suggest some extra-human quality is a clear enough technique for inducing awe, but to achieve equivalent effects by extremes of reduction, when this is far from expectation, is all the more remarkable. In making a familiar large thing in small format, the artist opens up new possibilities of perception. 'Miniature', in the words of Gaston Bachelard, 'is one of the refuges of greatness'.[14]

Subsequent assessment of Lysippus' achievement dwelt on the technical skill involved: in the words of the poet Statius 'he (Hercules) is seen as small but thought of as enormous'; or again, in a commentary by Martial, the table Hercules is described as 'a great god compressed into a small bronze'.[15] The point is all the more significant because the portrayal is of a figure of colossal dimensions, both in mythological concept and extant physical models. It takes the conventions of massive representation into the domain of the miniature, but it retains the power and strength of the domineering figure. William Carpenter, the mid-nineteenth-century Professor of Physiology at the Royal Institution of Forensic Medicine in London, and a great proponent of the insights revealed by the invention of the microscope, wrote: 'we cannot long scrutinize the "world of small" … without having the conviction forced upon us that size is but relative, and that mass has nothing to do with real grandeur.'[16] What God had achieved in creating the small things only visible through the lens of a microscope, Lysippus sculpted with his own hand, not perhaps in the minuscule but, by comparison with the colossal, small enough for its attainment of grandeur to be

Limestone sculpture of Hercules by Diogenes after Lysippus. Roman, 2nd–3rd century AD.
This sculpture takes the original image of Hercules Epitrapezios into later years and wider parts of the Greek Empire. This version is from Nineveh in modern-day Iraq.
H. 21 cm

judged remarkable. 'To make the point that any representation could be awarded or denied sheer, or mere, size was to locate power, not at the beck of a baron, but in the gift of the artist', as Mary Beard and John Henderson remark of Lysippus' sculptural prowess.[17]

In another medium exploited in the Hellenistic world – gold – similar criteria applied. Images of the gods known in massive scale are rendered in miniature. Gold jewellery portrayed subjects from across the whole range of Greek experience of the world, both physical and divine.[18] We know little of the social status of goldsmiths in classical Greece, but most appear to have been slaves rather than free citizens, albeit that the price commanded by an experienced jeweller well exceeded the normal cost of a slave. There was also a surcharge on their work, which represented a small proportion of the actual manufacturing cost.[19] The products of the various goldsmithing workshops were of course intended to be worn but were also dedicated to the gods, placed on cult statues in temples or on tombs in honour of the dead, and stored as bullion. The most common consumers of gold jewellery were women, for whom earrings, necklaces, bracelets, finger rings and other adornments were made. The associated iconography focused on female deities. Aphrodite herself predominates, as 'Golden Aphrodite', the goddess of love. Sometimes she is accompanied by her son Eros, who occasionally also substitutes for her. Artemis appears as both

Gold earrings. Greek, said to be from Kyme, Turkey, 330–300 BC. These intricate gold earrings feature figures of Eros (Love) and winged Nike (Victory), favourite subjects for jewellers from the eastern parts of the ancient Greek world. D. (of disc) 2.4 cm

huntress and an Olympian. Demeter and Persephone – the mother goddess of the earth and her daughter, goddess of the underworld – are found, as they are appropriate to major deities with associated women's cults. Athena is among the familiar subjects, often as a depiction of her cult statue, both in recognition of her association with the city of Athens and in her guise as the goddess of handicrafts. Dionysus, god of wine and mystical ecstasy, is the only male deity to appear with any regularity in this company of female divinities. Male jewellery, by contrast, focuses on masculine stereotypes: men fighting and riding horses, fierce animals and monsters. Of these, the sphinx is the ultimate hybrid monster, furnished in Greek mythology with a woman's face, the chest and feet of a lion and the wings of a bird. From its mountainous abode near Thebes it ravaged the countryside and devoured mortals. Its demise was finally secured when Oedipus solved the infernal riddles it posed to those who carelessly passed that way. If these remained unanswered, and inevitably they did, the sphinx duly ate them.

The subjects of Greek jewellery are thus 'big' subjects, conceptually if not inevitably physically. Many were, of course, also rendered in large-scale sculpture. However, the connection between these large monumental images and miniaturized treatments is less clear than in the case of images of Hercules. The common assumption has been that such figures were created as large public sculptures *before* they were copied on small scale or, if not direct copies, before they provided the inspiration for miniature sculpture. It seems reasonable to assume that portrayals of well-known subjects should first have been displayed in a public context in advance of being rendered in the refined, more personalized, format of jewellery. We know that sculptures of Athena, especially the figure of her created for display in the Parthenon, were of massive proportions; depictions of her in jewellery, therefore, reproduced in small scale the characteristics otherwise associated with visualizing her as enormous. Another example is a pair of gold earrings that show Ganymede in the embrace, literally, of an eagle, which in some narratives is seen as an emissary of Zeus and in others as one of the guises of Zeus. When Ganymede was barely an adolescent, he was seen by Zeus tending his father's flock of sheep near Troy. Zeus fell instantly in love with the young boy and carried him off to Mount Olympus where he was installed as a cup-bearer entrusted with filling the divine vessel with nectar. The two appear in an assemblage that shows a masterly control of materials and subject and is thoroughly sculptural in conception. The gold miniature versions appear to be related to a larger representation of the pair in bronze. Both are dated to roughly the same period, the fourth century BC, with the larger piece attributed to Leochares. The description of the original is owed to Pliny, who wrote: 'Leochares represented the eagle which feels what a treasure it is stealing Ganymede, and to whom it is bearing him, and using its talons gently, though the boy's garments protect him.'[20] Ganymede is portrayed as a juvenile with a skimpy diaphanous wisp of drapery, but the eagle whose claws rest on his thighs does appear to treat him with a tenderness appropriate to the thrust of the mythic story on which it draws.

There is, then, a connection between the experience of the miniature and a sense of space, for it is one of the characteristics of the miniature that without any other indication of scale it is often impossible to tell the difference between it and something massive from a reproduction alone. Indeed, as with the illustrations in this book, the scale at which a miniature is reproduced in a photograph may be larger than it actually is in reality. The Polish-born painter Josef Herman (1911–2000), an avid collector of miniatures, once explained his fascination with miniature sculpture, especially that from sub-Saharan Africa.[21] He remarked that

> the Greeks invented space for us. The African world is much narrower and instead of adapting the statue to the space, they put the space into the statue. I have always been interested in small-scale monumentality. Of course a large piece is impressive, but monumentality is something higher than that, it is a synthesis of forms.[22]

Both the colossal and the diminutive are concerned with space and, without a scale to tell them apart, they seem to achieve ends that are indistinguishable from each other. Today, we tend to experience sculpture as much in reproduction as in physical space. Their monumentality is thus independent of perceived scale, for there is no evident relation to the scale of our own bodies and we can imagine them to be big or small interchangeably. Similarly, in the assessment of Hercules in majuscule and in minuscule there is at once an aesthetic judgement on the physical qualities of the works but also the insistent paradox that Hercules is no less imposing in the diminutive form.

Temples and temple carts

In practice, Hercules achieves the feat of existing in two dimensions of scale with comparable sculptural impact. Switches between the two take on a particular significance in literature and in myth. We have already mentioned Swift's familiar fictional reflection on the transformations between the dwarf and the gigantic. In Hindu myth the first of the incarnations of Vishnu in human form ('avatars') also invokes this distinction. The King Bali is recounted as having achieved such power and authority that he had begun to challenge even the gods, and thus represented a danger to the order and harmony of the cosmos. To combat this threat Vishnu in his guise as Vamana, a dwarf, first petitioned Bali for a gift of land in an unpopulated area, the amount being what he could encompass in but three steps. The gift was granted. However, at that moment Vamana transformed into Vishnu Trivikrama, a giant otherwise known as the Lord of Three Worlds, and in that guise took three huge steps, which encompassed the earth and the skies. Bali was thereby superseded and in consolation granted lordship of the subsidiary underworld. Small sculptures of Vishu in an incarnation as Vamana, made to be sold at appropriate temples in India, show him

holding an umbrella in one hand and a water pot in the other, signs of his identification as a Brahmin.[23] Vishnu is here conceived as both dwarf and giant; but there is also a transformation between the small microcosmic space circumscribed by his dwarfish state and the macrocosm of his divine territory. What, then, of the relations of microcosm and macrocosm?

In an Asian context it might seem perverse to think of wheeled temple carts as miniatures. After all, although some are indeed smaller in size, the most dramatic are of massive construction. They are known from India (where they are often referred to by the generic term *rathas*), Nepal and Iran. In south India, in particular, they are often several storeys high; they are borne on enormous wooden wheels, up to sixteen being required to bear the weight of some of the largest of the carts (which can weigh upwards of 20 tons); and it takes as many as six hundred people to literally haul and lever the monsters as they are manoeuvred along a square of streets that form the outskirts of a temple complex. Often they get stuck – they are difficult to manoeuvre round corners – and they may take hours to shift relatively short distances. An emphasis on their ponderous hugeness is a common element in the metaphors used in inscriptions that mention temple carts.[24] It is therefore apt that they have been described as 'mobile architecture'.[25] The word 'juggernaut', often used to describe a large articulated lorry, derives from the Hindi word *jagan-nath*, referring to Jagganatha, the Hindu Lord of the Universe. Jagganatha is the subject of one of the most renowned cart festivals, which takes place at Puri, the site of a major Hindu temple complex and pilgrim centre. There are a number of descriptions of the cart festivals in this part of Orissa going back to the fourteenth century. One of the earliest discusses what has become a part of the mythology of the festival, the practice of devotees throwing themselves under the wheels of these giant structures in an act of self-sacrifice.[26]

There is an argument that, however large the temple carts might be in the scale of wheeled vehicles,

Soapstone figure of Vamana. Indian, probably 18th century. An image of Vamana, the dwarf incarnation of Vishnu. It was probably produced for sale at one of the Vaishnava temples. H. 26.5 cm

Wood model of a temple cart and details (left). From area around Madras, India, late 18th century.
This temple cart in the British Museum's collections is a model of an actual cart on which images of gods are processed in Hindu festivals. Bronze images of temple deities have been placed on the model, which appears to be drawn by a pair of rearing horses (although in reality the carts are hauled by hundreds of devotees). The sides also have images of deities and guardian figures, while the central platform has sculptures of priests and musicians. The cart that this model represents embodies the temple complex itself, which in its turn is a microcosm of the wider universe.
H. 220 cm

they are nonetheless small in relation to a whole temple complex, let alone to the habitat of a deity whose ambit is the universe itself. Indeed, temple carts are in a demonstrable sense the temple 'on manoeuvres'.[27] Structures may seem large or journeys lengthy when judged on a purely human scale, but other points of comparison suggest a different set of relationships. Douglas Adams' *Hitchhiker's Guide to the Galaxy* makes the point: 'Space, it (*The Guide*) says, is big. Really big. You just won't believe how vastly, hugely, mind-bogglingly big it is. I mean, you may think it's a long way down the street to the chemist, but that's just peanuts to space.' Yet it is not that the temple cart itself is a miniature. After all, on a human scale, massiveness is precisely its point. However, it can be argued that its significance is rather that it defines what might be considered as a microcosmic space. This is linked to the idea of a single location as capable of condensing in one place a whole series of dispersed sites. Circling round it establishes its contained sacredness. There are a series of analogous activities of this sort, ranging from pilgrimages round the whole of India to going round individual temples, journeys that are, alternately, in macrocosm or in microcosm. Thus a pilgrimage that takes in the circumference of individual holy sites is equivalent in miniature to encircling the whole of the Hindu world. A trip round Benares is equivalent to the classic pilgrim route round the whole subcontinent, potentially taking a significant part of a lifetime to complete. For devotees the effort in getting the huge structures to move and keep them progressing is such a massive physical undertaking that it replicates in the course of a day the rigours of larger-scale pilgrimage, a challenge in time as much as in space. It is only achieved at all by dint of the cumulative efforts of the community of followers. The temple carts' perambulations take in this pattern of pilgrimage, but they are of a slightly different order, for it is the centre itself that is moving, circulating, as it were, around itself.

This is a complex thought, for the inner recesses of the temple are otherwise seen as a fixed central point, *mula-sthana* (literally 'the root of fixedness').[28] The *vastushastras* portray the temple as a representation of the cosmos in miniature, which, one source suggests, may be associated with Vedic notions of the transference of the cosmos from open-air sites to permanent temple structures.[29] The deity comes to occupy the centre within the temple's sanctuary chamber, the *garbhagriha*, or 'womb-chamber'. The deity's retinue is arranged spatially outwards from this focal point according to precedence, with the consorts closest and more local folk-deities most distant. In the temple cart procession, then, it is as if the centre is encircling itself, a classic expression of the containedness of microcosmic worlds by comparison with the potential for boundlessness of the macrocosms from which they derive and to which they refer.

Museums as arks

Regardless of actual size, then, microcosms share the characteristic that they are focused, contained versions of larger, and sometimes enormously larger, universes. The vocabulary used of certain types of building demonstrates the ubiquity of such conceptions. Thus at the time of writing one of the most persistent and successful characterizations of the British Museum is that of 'The world under one roof'. It was coined by an incoming Director as a contemporary restatement of the original eighteenth-century conception of the institution during the year 2003, the 250th anniversary of its founding. The inspiration that lies behind the phrase is the Enlightenment spirit that informed the establishment of this world-famous institution, as it did other great European collecting projects of the period, such as Diderot's famous *Encyclopédie* (1751–76). It is intended to suggest both the geographical and the temporal reach inherent in a worldwide collection. At root the British Museum is conceived as a kind of Noah's Ark in which the natural and the man-made might sail on together for the edification of future generations, rescued from the tides of history, from destruction or from simple, neglectful forgetting. The departure of the natural history collections in the second half of the nineteenth century to form the fledgling Natural History Museum in South Kensington, London, diminished that original conception of a universal collection, but at the same time focused it more comprehensively on creations of the human hand, on so-called 'artificial curiosities' in eighteenth-century parlance.

The phrase 'the world under one roof', with its mix of references – to totalities contained within a concentrated space – matches well others coined at the time to describe similar institutions that were beginning to emerge not just as the personal preserve of the scholarly and scientifically inclined elite but as wider vehicles of public understanding. Jean de Renou, in the seventeenth century, described the medical potential of a museum's holdings of natural history as a 'Magazine of the Globes

Watercolour of Sir Ashton Lever's museum by Sarah Stone. British, before 1806.
A taxonomic display of natural history specimens including large mammals, shells, birds and, on the left, spirit jars. An intrusion from the world of so-called 'articificial curiosities' is an Arctic kayak placed above the first arch. The emphasis on neatness, with each specimen accorded its own box within a case, and the use of perspective to suggest infinite regression all conform to the ways in which knowledge is constructed and displayed through visual classification – an effect enhanced by the theatricality of the green curtains.
H. 40 cm, W. 42.6 cm

Treasures, a Store-house of Nature's Arcana'.[30] The Harveian Museum set up in 1654 for the College of Physicians by the celebrated doctor, William Harvey, was dubbed 'Solomon's House in reality', recalling a project of Francis Bacon's to create a wide-ranging centre of scientific research and endeavour.[31] However, of all the images invoked in such descriptions, the image of the ark, and of the creators of such diverse collections as latter-day Noahs, is the one that most frequently recurs in contemporaneous accounts of early museums.[32] The Tradescant family has a special place in this history. The family brought together a collection that was placed on public display at the Tradescant house in Lambeth with an associated botanic garden, which from 1638 was already affectionately dubbed 'the Ark'. In modern times the emphasis on so-called museum-related 'rescue' archaeology – where, typically, campaigns are mounted, often by museums, to salvage the evidence of the past from destruction by constructors laying the foundation of buildings on top of it – has endorsed the image

of the ark as a vessel of redemption. In the mid-seventeenth century the popular allusion was more akin to another modern conception, that of the 'seed bank'. Like Noah's Ark, the Musaeum Tradescantianum was an *omnum gatherum*, a place where, as one seventeenth-century visitor reported, 'a Man might in one daye beholde and collecte into one place more Curiosities than hee should see if hee spent all his life in Travell'.[33]

The collection displayed in the Lambeth Ark, as is well documented,[34] was the creation of the elder John Tradescant (*c*.1570–1638) and his son, also named John (1608–62). Both were naturalists and travellers and both acted in the capacity of royal gardeners, successive 'Keepers of His Majesty's Gardens'. The younger John published their collection in the *Musaeum Tradescantianum* (1656), which described the assemblage of objects and natural history that father and son had created. The collection was ultimately handed down by deed of gift to Elias Ashmole, physician and alchemist, and went thence in 1677 to the University of Oxford, where it formed part of the founding collection of what became the Ashmolean Museum. The tomb that contains their remains is in the churchyard of St Mary-at-Lambeth in London. There, reference is made to 'The Ark', which became a popular attraction for visitors to London. The epitaph of the tomb refers to 'A world of wonders in one closet shut', and the line has a preceding rhyming couplet that makes a comparison between their collection and a classic statement of the kind of creation that miniaturists aspire to: the display of the Tradescant collection is 'as Homer's Iliad in a nut'.

The assemblages of objects that made up such collections could be vast. Many descriptions of the diverse contents of these seventeenth- and eighteenth-century cabinets exist. Their essential feature is that they go far beyond what were otherwise the conventional acquisitions of the period, which focused on pictures and statues, on medals and antiquities, with a preference for the classical, especially when the Grand Tour got going in a peaceful interlude in the Napoleonic Wars at the end of the eighteenth century. The collections destined for the 'cabinet' also included natural history objects, religious relics, objects derived from non-European cultures, and things of more 'mythological' status – unicorn horns being among the most prized.[35] The collections of the Tower of London went further: it is recorded that a gown 'lined with the skin or fur of a unicorn' was displayed there.[36]

Such collections were not static, nor were they dispersed at the owner's demise. They were regarded as having a coherence and integrity of sufficient significance that they would be inherited and developed by further additions. One example must stand for many other possible cabinet collections that might be cited. Thus, when John Evelyn went to see the collection of 'Signor Rugini' (*sic*) on Christmas Day 1645, the year after 'Carlo Ruzzini' who had owned the collection had died, he saw a collection that had already passed through several owners' possession and had been added to by each of them. It had in the process grown ever more encyclopedic. So, by 1645 the 'stately Palace' in which it was displayed was 'richly furnish'd, with statues, heads of the *Roman Empp*' and 'a Cabinet of *Medals* both *Latine & Greeke*' – the usual suspects. However, moving on, Evelyn records encountering a rich selection of the wonders

known to the expansionist Venetian world of the mid-seventeenth century. There were 'divers curious shells & two faire *Pearles*'; above all, there was a collection of petrified things: 'Walnuts, Eggs, in which the *Yealk* rattl'd, a peare, a piece of beefe, with bones in it'; a 'whole hedg-hog, a plaice on a Wooden Trencher turned into stone … & very perfect'; and examples of charcoal, cork, sponge, 'Gutts' and 'Taffity'. Evelyn was shown a number of 'Intaglias', and noted 'a *Tiberius's* head, & a Woman in a Bath with her dog'. The collection of precious stones was extensive and included crystals 'in one of which was a drop of Water not Congeal'd but plainly moving up & down as it was [shaken]'; but what attracted Evelyn's wonder was 'a *Diamond* which had growing in it a very faire *Rubie*' – an apt prelude to the discovery of 'divers pieces of *Amber* wherein were several *Insects* intomb'd', or another cut in a heart-shaped form that contained a '*Salamander*'. The best is kept to last: the 'greatest Curiositie I had ever seene', 'a *dog* in stone scratching his Eare, very rarely cut, & Antique', was, in terms of the skill of its execution, a true exemplar of the high art of the miniature.[37] From the description it is an example of an engraved gem, of a type whose significance is at least partly in the domain of the magical.[38]

Krzysztof Pomain, who quotes this passage in full, went on to argue that the spirit that led to the assembling of such diverse collections of the wondrous, the exotic and the plainly weird, culminated in a passion for mummies and for enigmatic hieroglyphics, for objects that seemed to embody secret meanings. The very oddity of the objects in the Ruzzini Palace, and other like locations, is precisely their purpose. The

Box of red sulphur impressions of a collection of 111 engraved gemstones. These gemstone impressions are shown here in the same arrangement as the originals in the Richard Payne Knight collection, which was bequeathed to the British Museum in 1824. Museum practice was such that they were subsequently dispersed among various curatorial departments to integrate them into a wider taxonomic schema, and some were subsequently destroyed in the bombing of the Second World War.

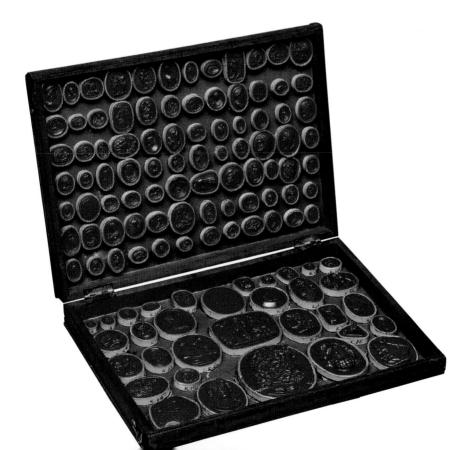

common and the mundane excite no spirit of enquiry, they have no meaning beyond themselves, they are not evidential of the wider intentions of God and of man and elicit no sense of wonder, or 'curiosity' in the vocabulary of the time. The peculiar, by contrast, bears a semantic content that is much greater than itself, a hidden meaning awaiting discovery. As fragmentary archaeological remains are the material trace from which whole cultural universes in antiquity are constructed, so the cabinet with its storehouse of curiosities is itself a world in microcosm.

The idea of the museum as it developed in Europe carried with it this sense of a place where discoveries were to be made if only the scholar and the visitor could draw it out of the mysterious assemblages of God's and man's creations. The modern questioning as to whether museums are to be defined in terms of the temple or the forum was more clearly focused then: the early museums were special places where the transactions were couched in terms of a deeper knowledge of the natural and human condition, its potentiality and its potency. They were both temples and forums, compressed public spaces in which ground-breaking insights might occur to those who possessed the eyes to see them: in the words of a Bob Dylan song, 'inside the museum infinity goes up on trial'. Museums are about infinities in the sense that their collections are potentially limitless. Yet, they cannot contain all. They are *selections* at the same time as they are *collections*; and they exist within controlled, contained dimensions.

Likewise, *World* Fairs and *Universal* Exhibitions, despite their globalizing ambition, are also, in the end, selections. And they share an entrepreneurial spirit of showmanship with modern theme parks such as Disneyland, for instance.[39] They have all held a fascination for anthropologists and cultural historians, partly perhaps because they seem to pose questions about the relationship of simulation to reality, or of fantasy to knowledge. Jean Baudrillard remarked: 'Disneyland is presented as imaginary in order to make us believe that the rest is real, when in fact all of Los Angeles and the America surrounding it are no longer real, but of the order of the hyperreal and of simulation.'[40] Umberto Eco has also talked about the American obsession with replica, reconstructed worlds as 'travels in hyperreality'.[41] The abiding architectural legacy of the less permanent of these ventures is often an enlarged structure, such as the ill-fated Crystal Palace in London – moved, enlarged and then destroyed by fire. Exaggeration may be characteristic of the physical presentation of such sites, but the events themselves always involve deliberate and explicit acts of miniaturization. However much the museum-based insistence on authenticity may seem to separate out such institutions from other kinds of so-called 'heritage' institutions, both are engaged in the same activity of creating intelligible, microcosmic worlds from the universes they seek to condense.

This book is largely concerned with the intellectual and cultural implications that lie behind the creation of miniaturized worlds, whether as a discrete physical space or an individual work of art. Part of this is a consideration of the significance of assembling representative collections or selections of a wider world and giving

them a sense of order and intentionality that may not be immediately obvious in their found condition. Museums, through their practices of acquisition, inventory and classification, effect essential acts of processing wider realities to refashion them in comprehensible form. Curators and the designers of theme parks are not alone in undertaking these acts of creating coherent microcosms from the fragments of larger worlds. The Tradescants' garden, like their cabinet, was also a constructed world in small.

Is a garden, then, worth considering in a similar way? The obvious answer might seem to be that it depends on whether it is cultivated in a Japanese bowl, a back garden or spread over the rolling acres of a country estate, but for our purposes that will not do. I would argue that when compared to all the possibilities of species differentiation and the diversity of environmental contexts within which wider, wilder nature has evolved, the garden already has a microcosmic aspect. It, too, is a selection based on an expectation of what will grow well in particular circumstances, and how the different colours and sizes of plants can be blended in appropriate and pleasing combinations. This is both an adaptation to the confines of whatever size and space the garden in question must occupy and an ordering into categories and types. The gardener is a closet curator – or, taken chronologically, this should perhaps be the other way round, since gardening is of biblical origin and attested in evidence from the ancient Near East: the paradisiacal gardens of antiquity. The technologies of museums and gardens may be different, but the deliberate reduction to organizing principles and visualization through display are common to both. Both are, arguably, small worlds in their own right, not just lesser versions of larger prototypes in nature or in culture. They take on identities of their own.

Microcosms and models

Clearly not all reductions of larger worlds are of the same kind. Some discrimination needs to be exercised. In talking of miniaturization we are conflating, arguably, two different ways of conceptualizing the world of small things, that of the microcosm and of the model. So, we are not necessarily talking of small things as fragmentary. They may sometimes be parts, but even then a part is not always simply a bit of something else. And, if it were, it would not be a miniature of it unless it could in some sense 'stand for' the bigger thing from which it had been taken. Small things, in the sense with which we are principally concerned here, are for the most part entities that are or can be regarded as complete in themselves, for all that there are larger things to which they refer. Thus, for instance, the architectural fragment bears a different relationship to the building that is its source than does the relic to the saintly body from which it is derived. The one is but a sample of the greater entity from which it derives and in that condition inert, a souvenir in Susan Stewart's excellent discussion,[42] whereas the other is saturated with the power of its sacred source to change the world. One might generate nostalgia, but the other religious ecstasy.

Model mechanical ship and details (right) by Hans Schlottheim. German, about 1581.
This ornate model ship (or 'nef') was used as a table ornament to mark the place of the host at a banquet. It is thought to have been made on commission for the Holy Roman Emperor Rudolf II, probably by Hans Schlottheim of Augsburg, and finished in 1581. Great attention has been paid to detail. Figures representing members of the Habsburg court process before the emperor seated on a throne beneath the main mast, at the base of which is the Habsburg double eagle (right). The ship also includes firing cannons, a miniature clock and lookouts, who would revolve when activated. It originally had organ pipes so that it sounded a fanfare on the quarter hour. Being mounted on a carriage it was also potentially mobile. Thus it is suggested that it might have enlivened the dullest imperial banquets by racing along the table, guns blazing and trumpets blowing.
H. 99 cm

In talking of museums as a concept we have veered towards the term 'micro-
cosm'. Museum collections are full of models of one sort or another, but we would
not readily talk of museums themselves as 'models' of a wider world. The process of
conceptualizing small worlds is not necessarily a matter of simply reducing majus-
cule to minuscule – of 'A' to 'a' – for all the ability of a small 'a' to recall the more
imposing mass and grammatical priority of a capital 'A'. Microcosms have their own
independent veracity: they are neither scrupulous and small reproductions of larger
totalities, nor fragments of larger entities. In fact, if we were to visually enlarge such
reductions, we would not end up with the macrocosm that they are held to represent
– we would end up with an enlarged version of the microcosm, without the precise
cartography of the bigger entity from which it derives. Paradoxically, if we think only
in terms of parts as strict scaled-down models of wholes, we lose sight of the proper
relationship that the microcosm has with the macrocosm in the many graphic repre-
sentations of the connection in different cultures.

Furthermore the reduction in scale is not necessarily a reduction in significance.
In fact, it can imply the very opposite. A true model is to some extent a lesser version
of the bigger entity that it represents. Yet many microcosms are in fact more, rather
than less, powerful. We need to move from the merely visual to the more directly

organic. Boiling something down can end up enhancing rather than diminishing its efficacy. A model, by contrast, can be a 'working' model – indeed, the efficacy of the larger prototype may be judged by the ability of the model to function – but it may never be able to carry the weight, functionally and conceptually, that its big brother will be expected to bear. A boiled-down version, however, can in some conceptions – and not merely that of western chemists – be seen as a reduction to essence. Boiling down has two potential results: one is the removal of impurity, so that it ends up free of corrupted material; the other is a concentration of active substances. Reduction can be purification, and it can be intensification. The ephemeral is departed; the true, powerful centre remains. Less is more.

Typically, this is reflected in the professional hands that manipulate things. Those that make or display models are those of educators or instructors, whereas micro-cosms are often in the hands of spirit mediums, diviners and healers. The model-maker is engaged in trying to represent the appearance of the world, whereas those engaged in the practice of divination are involved in looking behind appearance in order to identify essential realities. The one reproduces what is there in the world at a reduced scale, the other strips away contingency and redundancy to identify something more elemental. The latter do things, they change the conditions of the world in which people live. Models retain a mechanical relation to the world; essences attain a cosmological relationship – or, in pharmacological contexts, a chemical one.

Models are, by definition, mimetic objects. Sir John Soane (1753–1837) was at once a distinguished architect, most notably perhaps of the Bank of England, and a great collector of architectural models, both those representing to scale the great buildings of the classical world and those of his own buildings. They are displayed as he left them in his London house, now a museum in Lincoln's Inn Fields, London, near the British Museum. Soane spoke in his 1815 *Lectures on Architecture* of the value of scaled models of buildings: 'Large Models, faithful to the Originals, not only in Form and Construction, but likewise to the various colours of the Materials, would produce sensations and impressions of the highest kind, far beyond the powers of description and surpassed only by contemplation of the Buildings themselves.'[43] These are models both in the sense of being representations of particular buildings and also as being reflections on the ideal, models to be followed and learnt from, not just examples, but in themselves exemplary. Soane's collection of models was formed after the era of the Grand Tour when fragments of antiquity were being acquired and displayed in the niches of the grand houses of northern Europe, and indeed his lectures had bemoaned the lack of the very models he was to assemble. Where the passion for collecting architectural fragments left the viewer struggling to imagine the whole from which the fragment was derived, the model actualized the complete building. The fragmentary is but a part of a ruin made ever more ruinous by the acquisition and removal of fragments. The model not only leaves the ruin intact as it is, but it also allows the possibility of reconstructing in miniature all the bits that

Model of a building in *cloisonné* enamel with coral, silver and jade. Chinese, Qing dynasty, 1772.
This model represents a Buddhist mandala given miniaturized architectural form and operating in three dimensions. The mandala is a way of modelling the cosmos figured as a square within a circle (as in the Renaissance representation of the human being as a divine microcosm) and with four points of entry.
H. 56 cm, D. 41 cm

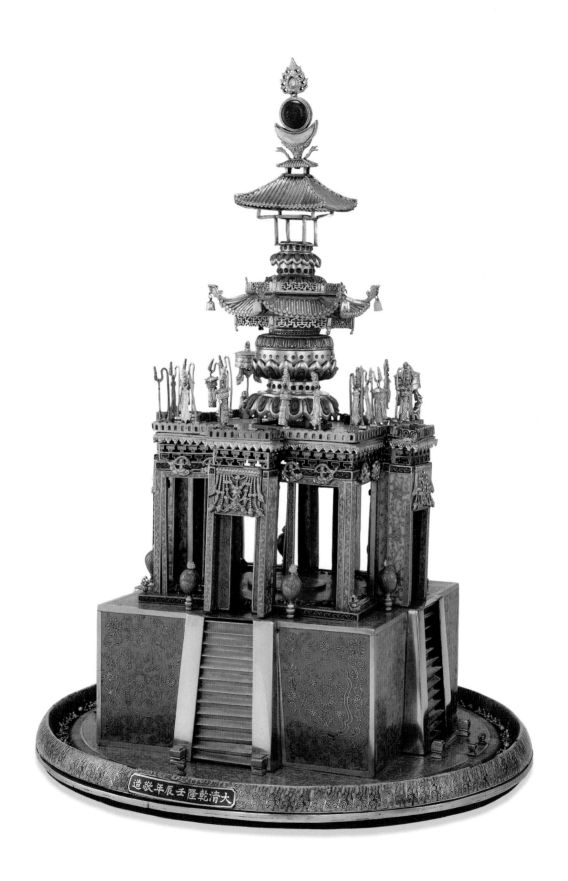

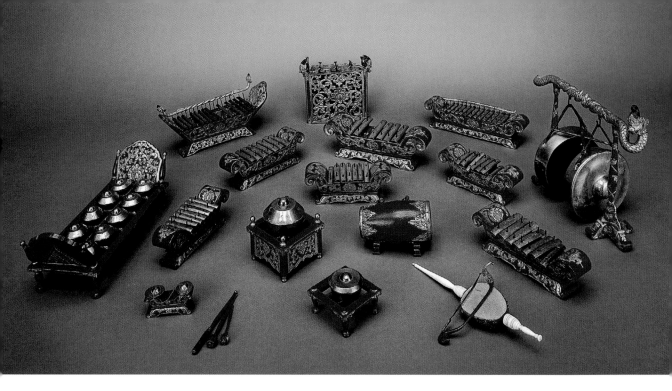

human intervention and the vagaries of weather, earthquake or other natural forces have separated from the original. It represents the possibility of replacing what the passage of time has removed, re-conceiving historic buildings or the ruins of antiquity not merely as partial structures but as whole entities. This is perhaps the defining characteristic of the model: it realizes on a reduced scale what is or what was.

The model also, of course, realizes what could yet be. The Lords of the Admiralty used to inspect models of ships before they commissioned them. Likewise architects' offices are full of models of buildings to discuss with prospective clients. The model realizes visually and with the full panoply of technical architectural detail what the architect's plans of a prospective building achieve in only two dimensions. The model is to show what a building will look like; the plan tells those who need to know how to build it. The model shows the external features, where the architect's drawings delve into descriptions of the interior workings. There is a distinction between the public face to be appreciated aesthetically and the hidden structures and conduits to be understood technically. You cannot create a real building from a model alone. As Ludmilla Jordanova remarks, 'models purport to reveal a reality without being the real thing themselves'.[44]

If this discussion is couched in terms of individual models, what happens when a whole series of models are displayed together? Soane was among the first not just to commission models of his own buildings, but to place them alongside those from classical antiquity in his 'house of models'. His assembling of models transgresses the confines of space and time within which the real buildings were located. The models are presented as if the buildings they imitate in miniature existed at one time and in a single space. In other words, if we were to expand the models to their original scale

Miniature model of a complete gamelan orchestra. Indonesian, late 18th or early 19th century.
This model was acquired by Sir Stamford Raffles, colonial governor and 'founder' of Singapore, to record the society and arts of Java. The function of such models was largely documentary. However, Raffles also acquired one of the finest full-scale historical gamelan orchestras.
L. (of set of gongs on extreme left) 31 cm

and put them together, we would produce a selective pastiche, a theme park, a hyper-reality. In displaying them together, Soane created a world of architecture in micro-cosm, a museum.

The gross and the exquisite

The comparison of the colossal and the diminutive introduces us to a series of contrasts. If small is beautiful, the corollary, as Burke observed, holds, but in a different way. The gigantic may be sublime, but it is – very often – repulsive: at once 'awe-full' and awful. In terms of objects, the colossal may be at once heroic and threatening, inspiring or gross, awesome or a force of nature. Gulliver in that guise has trouble in concealing his bodily functions from the inhabitants of Lilliput. In a sense all is revealed; try as he might to find privacy, Gulliver is visible, warts, bristles and all. Yet because nothing is hidden, the colossal is also the dimension of untrammelled self-regarding greatness. There is no need to imagine that anything is concealed by the vicissitudes of scale and visibility, because through its imposing size the massive is rendered unchallengeable. It exceeds human measures and thus threatens to dominate the human imagination – and the human spirit. By definition its habitat is found in public spaces, the open air, the infinitudes of the stars and the universe. Our approaches to the gigantic are those of fear, awe, prostration, submission.

As macrocosm, such conceptions of the world threaten to escape human dimensions and intelligibility; as microcosm, they are contained, but may yet retain a still impenetrable centre. The diminutive has things to hide. We can see it, but only by increasing the strain on our physical capacities of sight. We cannot be sure we see everything, the more it approaches dimensions of invisibility. Indeed, it challenges the very sense that we live in a world all of which we can potentially see. It is inherently intriguing, challenging us to see if we can see more. It is wholly explicable that Vishnu in the guise of the dwarf Vamana is a trickster, a role that is also accorded dwarves and fairies in many cultures. As objects, small things also constitute a realm of vulnerability. Even if made from hard materials, the miniature has all the potential of fragility when juxtaposed with something infinitely larger, which may be ourselves. We are made to feel clumsy when faced with the small and beautifully formed. Fae Ray, though of our own size, is suddenly made to seem defenceless when held helplessly in the grasp of King Kong. Putting ourselves imaginatively in the place of small things, we are at the mercy of forces much more powerful and imposing than ourselves. Small can be intrusive; but it is also fragile.

If, then, it is tempting to avoid the definitional questions, it is because the interesting issues are not those of definition alone. Rather, what is important is the relationship between the technical processes of reducing scale and the conceptual, cultural and aesthetic motivations or outcomes of such practice – or, rather, reduction in scale (like its opposite) is at once a technical and a cultural process.

3. Visualizing Small Worlds

The most memorable expression of the idea of the microcosm in literature is sure-ly that of William Blake in 'Auguries of Innocence' (*c*.1803):

To see the World in a Grain of Sand
And a Heaven in a Wild Flower
Hold Infinity in the palm of your Hand
And Eternity in an Hour

It is one of innumerable attempts in literature, art and theology to find the means through which to express the idea of the world in small. Indeed, in many faiths books themselves are held to contain the keys to an understanding of the universe and are in that sense akin to other kinds of microcosm that we are considering. All emphasize the containedness of the image. It is not just that small worlds are subsets of larger entities, they are also bounded, nucleated. Big things can expand to become limitless, but small things need definition; there can be no vagueness about their outer limits. All have some framing device. The frame may be literally that: an edge to a picture or an illustration; or it may be a box, a container of some sort – even a building, as is the case with a museum. We consider a number of these below.

The protagonists here are artists, cartographers, diviners, gardeners, scholars and hermits. Each is working with a world that is controlled, defined, constructed. However, the motivations of each are different. Cartographers seek to express the world as they perceive it to be, to create an artefact that is meaningful in itself and that accurately portrays the objective contours of the wider world as it is observed. Whether or not they are successful in this – indeed, whether all so-called 'maps' are really the same kind of artefact – is doubted below. Nonetheless, they all purport to offer an interpretation of the world sufficient to record and document a version of how it is, even if they are not all concerned with physical route-finding. Diviners, on the other hand, seek to determine what has happened or what will happen – and why. Their arts are those of discovery, adapting potential scenarios to particular circum-

stances in order to describe individual constellations of influence. Whereas maps are public documents, diviners' equipment is esoteric. These dual possibilities of the microcosm – as a visualization of the world in small and as a small world to be manipulated – are discussed in the next two chapters.

Artists and boxes

Reference to cabinets of curiosity and to museum classificatory systems seems to underlie the work of the American surrealist artist, Joseph Cornell (1903–72). Like MacCruisken, Cornell revelled in the image of the box. But where Flann O'Brien's fictional creation made boxes to contain other boxes, Cornell's containers contained myriad things. His exact inspirations are unclear. However, one story told by Cornell himself suggests his method of working. He talks of passing a shop and seeing in the window a collection of compasses:

> I thought everything can be used in a lifetime, can't it, and went on walking. I'd scarcely gone two blocks when I came on another shop window full of boxes … Halfway home on the train that night, I thought of the compasses and the boxes, it occurred to me to put the two together.[1]

This visual format – the box with its contents displayed in ordered series but each with a meaning much greater than itself – is the hallmark of Cornell's mature work. Indeed, in his 'Soap Bubble sets' dating from the 1940s and 1950s he suggests one of the big topics that the world of large and small challenges us to contemplate: that of the minuteness of the world of human perception when compared to the immensity of the universe. The bubbles circulating round each other but never crashing and disintegrating, nor ever merging, are compared to the orbiting of the planets within the solar system. The image is, as the art critic Robert Hughes says,[2] banal – deriving, as it does from playing with a Dutch-clay bubble pipe – but it playfully rejoices in a tradition of creating meaning by suggesting totalities beyond the merely fragmentary, a tradition that lies at the very heart of museum culture, archaeological practice or forensic science.

Cornell's boxes are described in terms of a kind of theatre, a theatre of memory as much as a museum-like cabinet (though the two may of course be linked).[3] His influences go back to Renaissance and Mannerist painters such as Agnolo Bronzino (1503–72). Yet there is another parallel lurking here, awaiting exploration. Hughes sees the glass that separates the viewer from the contents of Cornell's boxed creations as a kind of diaphragm separating two contrasting worlds: 'outside, chaos, accident and libido; inside, sublimation, memory and peace'.[4] Cornell was creating 'Heaven in a box'.[5] The boxes contain consolation, a promise of tranquillity, a world of fragments rescued from the turmoil of the external world to become satisfying memory. Perhaps the greatest expression of this image of the box as comforting microcosm is that great, lost artefact of the Renaissance, the Theatre of Memory created by Giulio Camillo (1480–1544).[6] We know of it only from descriptions, as no drawing or plans of its contents survive. It, too, was a box, something of the size of a large crate, adequate to admit two people, perhaps, but not more. Inside, laid out so as to reveal interconnections and conjunctions in a memorable form, was a visual presentation of the sum

This portable boxed shrine contains miniaturized representations of thirty guardian deities, one for each day of the month. The figures are an assemblage of *kami* (native deities) from major shrines throughout Japan, a concentrated sacred collection that focuses both time and space in a single contained box, which itself opens out to replicate a shrine. In the centre is an invocation to the Lotus Sutra, an important Buddhist script, written by the monk Nichinen (1656–1732). H. 42.2 cm, W. (fully open) 46 cm

of human knowledge. Exposure to the system that Camillo had devised promised a life-changing experience. Again, it played the trick of condensing the complex, shrinking it down to a series of meaningful juxtapositions, suggesting a universe much larger than itself.

Some connection of art and museum practice also lies behind the project of Marcel Duchamp (1887–1968) that led to the creation of his *Boîte-en-valise* (Box in a Suitcase), a work – or, more accurately, a series of works – begun in 1936 but not completed until 1941. Even then, this deluxe limited edition of twenty suitcases (plus four more for his own purposes), with its cloth-coloured box contained within a leather-bound valise, was followed by upwards of three hundred other boxes, which appeared in batches over the next three decades without the accompanying suitcase. The idea of boxes containing traces of the past, of thought and of its outcomes is one that he had already explored. Duchamp's work *Large Glass* was accompanied by a series of notes and facsimile scraps of papers, which seem to promise an interpretation but are deposited in their boxes in such a random and fragmentary way as to frustrate rather than encourage the search for meaning. Three sets of boxed notes

Casts of Roman gems issued in book form by Tommaso Cades. Italian, early 19th century. Interest in ancient gems developed during the 18th century when illustrated works began to appear cataloguing known examples. In the 19th century casts of ancient gems were issued in boxed form arranged and categorized in museological fashion. This illustration is part of one of twelve volumes by Tommaso Cades, himself a skilled gem engraver. H. 25 cm, W. 17 cm

were published between 1912 and the middle of the First World War: *The Box of 1914*, the *Green Box* and *Towards the Infinitive. White Box*. The suitcase project takes as its parallel the idea of the museum as a container of histories and as a place to construct identities. Duchamp himself likened the project to the construction of an 'album'.[7] He consistently refused the role of the artist as evidenced in many of the supporting constructions of the artist as a creative spirit. As Christopher Green points out, there are no photographs of Duchamp in his studio as there are of other artists.[8] When he did appear in photographs, it was not as himself but under an assumed identity. Thus, when he was photographed by Man Ray in the 1920s, he is identified as Rose or Rrose Sélavy (possibly a pun on *c'est la vie*), a female counterpart whom he invented for the purpose. He sustained the identity by adopting female attire and by using the name, in conjunction with his own or alone, in titles of his works.

Duchamp had lived periodically in both Paris and New York, always ready to move on, avoiding an accumulation of possessions. The sparseness of the conditions of his private life and the uncertainties of existence in occupied France are expressed in the suitcase of the title of his 1941 work. On the outside is the hand-lettered inscription (in French) 'of or by Marcel Duchamp or Rrose Sélavy'. Inside the box were sixty-nine separate items cleverly put together as a series of sliding partitions and openings. When unfolded, the boxes are found to contain miniaturized versions of Duchamp's own works, reproduced not as they would be in an art book but with an attention to colour reproduction that renders them exceptionally close to the original larger-scale paintings. To each box he added an original piece so that there are marginal differences between each of them. As the works unfold in their container, they suggest, as some commentators have remarked, a medieval triptych or altarpiece. But the purpose is intensely personal. The boxes with their reproductions of his own works were created in the wake of the large retrospective exhibitions of Matisse and Picasso and the publication of substantive catalogues of contemporary artists in the 1930s. Duchamp was not part of any of these, and his letters reveal his attempts to get in touch with the current owners of his works as part of a search for photographs of the works,[9] which would enable him to reproduce them in the miniaturized form in his box. After an apparent disdain for the trappings of the artist's life, he sought to reassemble his works as if he had woken up to the need to ensure his own legacy. But it was all in his own hands. Duchamp was not relying on a curator or art critic to assemble the details of his career. The box contained what he regarded as the essence of his oeuvre, all rendered at a size appropriate to inclusion in the suitcase regardless of their original relative scale, put together and articulated as he saw fit. He was his own chronicler, documenting his work in his own idiosyncratic way. The American collector Walter Arensberg wrote that Duchamp was creating 'a new kind of autobiography ... a kind of autobiography in a performance of marionettes. You have become', he said, 'the puppeteer of your past.'[10]

Gardens as small worlds

Gardeners are also puppeteers, and not just of nature. In western tradition the practice of placing sculpture in gardens goes back at least as far as the Romans, whose copies of Greek sculpture had a horticultural context. Their significance as outdoor ornament is not fully explored, although Pliny talks of the statues of the satyrs in the garden of the Forum in Rome as being 'dedicated as a charm against the sorcery of the envious'.[11] This, however, is not sufficient to explain the origins and wider significance of the contemporary western (perhaps specifically British) habit of filling spaces immediately adjacent to dwellings with garden 'characters', typically gnomes. That practice is associated with the locating of miniature spirits – particularly fairies – at the furthest borders of domesticated areas; and this introduces the idea that carefully cultivated spaces are sometimes conceived as small worlds in their own right, populated at their perimeters with ambiguity. There is no particular implication that gardens are made to 'aestheticize' space like those described by the anthropologist Jack Goody when he discusses 'the culture of flowers'. Gardens, he suggests, fall into two types: those that produce food and those that produce décor or are themselves decorative. Fruit, Goody notes, may be both eaten and in some cultures used like flowers in decorative contexts, whereas vegetables are largely regarded as, simply, produce.[12]

There are several aspects to this. Firstly, some of the earliest gardens were explicitly created as places of paradise. It is not simply the biblical Garden of Eden that provides the authority for this association. It is in fact an explicit element of the Near Eastern tradition of walled gardens, which developed in Mesopotamia and Persia. Kubla Khan's stately pleasure dome in Xanadu was no doubt provided, by decree, with such a paradisiacal prospect. Such gardens were the direct inspiration of Islamic paradise gardens. In Arabic the word for paradise, *al-janna*, also means 'garden'. Typically, such gardens would have this symbolical microcosmic aspect, being divided into four quarters with a combination of irrigation channels and paths cutting the square of the enclosed garden at right angles. In the middle would be a pool or a small shelter. Goody interestingly traces the layout of western botanical gardens to this same template with paths defining the four squares rather than irrigation channels. Oxford Botanic Garden, of seventeenth-century origin, is an example. An overlap with exploration and cartography is suggested, as the discovery of the New World led to an association of the four squares with the continents of Europe, Asia, Africa and the Americas divided by their four rivers, an elaboration of the T-shaped 'maps' discussed below.[13]

Further, there is also a clear tradition of constructing gardens specifically as places of contemplation. The idea of building small houses in appropriate places in a garden, and then retiring there periodically to meditate, goes back in Britain to the seventeenth century. It was recommended for 'clergymen and other studious persons' as a place of spiritual refreshment, ideal for the contemplation of God and his ways. By the eighteenth century, rather than doing it themselves, some had begun to build

The Botanic Garden, Oxford. From *Oxonia Illustrata* by David Loggan, 1675. The layout of this 17th-century garden follows the elaboration of medieval tripartite 'maps' into quadripartite ones after the discovery of the Americas in the late 15th century, which meant that there were four continents rather than the three previously known to Europe and the Near East. Here each quarter has been subdivided into four further squares, a conjunction of mapping conventions and the form of Near Eastern paradise gardens brought together in the tradition of the European botanical garden.

small cells in their gardens that were inhabited by professional hermits who could be hired by the year for the purpose. Greenhouses were regarded as having a 'moral' value, thought William Cobbett. Domestic gardens were considered good places to be buried.[14] Arguably, however, the most explicit exploration of the garden as a small world is not in Europe but in Asia, where the separation between the functional and the decorative is most meaningful, where cherry trees could be grown and admired for their blossom rather than for their fruit.

In part, the spirit that led to the development of gardens in eastern Asia was parallel to that which led to developments in museums and arboretums elsewhere. Chinese emperors, for instance, sought to assemble in imperial parks living examples of plants and animals, including those from distant lands,[15] which anticipates the creation of zoological and botanical gardens in Europe. In a sense, these were already microcosms of a wider natural world. Landscape as an uncultivated expanse is known

Bamboo root carving of a mountain and details (left). Chinese, Qing dynasty, 18th century. Miniaturized images of mountains were associated with the retreat of scholars to a contemplative life parallel to that lived by hermits, typically in caves on the upper slopes. Daoist ideology recognized these remote parts of the natural world as the home of the immortals and its crevices and caves as the gateways to eternal life. This example, itself carved from a natural bamboo root retrieved from the earth, shows the immortals examining a diagram. H. 25 cm

in Chinese as mountains and water (*shan shui*) and is rarely, as Craig Clunas observes, 'without a cosmological tinge'.[16] The combination of the two is also linked by most commentators to the harmonious interaction of the male (yang) and female (yin) principles. The associations are with the paradisiacal, with eternity and the contemplative. Jessica Rawson quotes[17] the poet Xie Linyun (AD 385–433) on the role of a particular hill as the means by which humans might ascend to heaven. During the Han dynasty two thousand years ago – the era of Daoism in China – hermits would move to areas near the peaks of mountains, the physical space in closest proximity to the ultimate dimensions of immortality. Mountains were seen as a bridge between earth and the heavens above, and representations of them were incorporated into the organization of imperial tombs, reinforcing the image of the mountain as making a link with eternal life. The move to enclose and husband the forces of nature within carefully ordered spaces rendered them comprehensible and observable. It is not just a matter of nature being transformed into a cultural analogue, but of an uncontrolled world being contained, regulated and – in its artificial reconstruction – embodied. Chinese imperial parks were already reduced versions of wider, wilder nature. The exercise of the arts of horticulture rendered the more formalized gardens an aestheticized domain. Indeed, in the concept of the 'Peach Blossom Spring', the ideal garden is equated with a timeless paradise,[18] and the evidence of the several millennia over which the Chinese have created gardens suggests a long continuity of approach. From here it is but a short step to marking the contemplative aspects of nature in ornamental form.

Mountains may appear in miniaturized representations in the form of a rock, a conical peak or lid, or even the stalk of a trained and decorated gourd. Sometimes they are carved with representations of caves or dwellings near the peaks, which

recall their particular fascination for hermits seeking an escape from the ordinary world and a sight of the infinite. If the objects are naturally occurring rocks, many are pitted and exceptional in form. Indeed, an earlier tradition of using stones with appropriate pitting as incense burners intended to ward off evil may be implicated in the historical circumstances from which the practice emerged. These stones may, in a felicitous conjunction, have been washed into their particular shapes by the erosive action of water. Others are in the form of a series of peaks and some with a horn-like structure move in the direction of abstraction. As objects, they have both a contemplative and a functional aspect, and in their selection and arrangement subscribe to symbolic and mythical principles. They are described as being destined for the studios of scholars. In this context 'scholars' refers to painters and calligraphers, who, like hermits, have retreated from what others would recognize as 'ordinary life' to reflect on paradise, inspired by these miniature versions of mountains. The mountains have a further function. When provided with several peaks, they also act as paintbrush stands. Indeed, the interplay between Chinese landscape painting and garden design provided mutual sources of inspiration. What was idealized in painting achieved realization in actual gardens: the Lion Forest in Suzhou, for instance, 'was supposedly created in the style of paintings by Yün-lin with splendid rocks and many old trees'.[19]

Back and front (above) and a detail (right) of a turquoise mountain carving. Chinese, Ming dynasty, 1368–1644. H. 14 cm

88

The miniature, mountain-like paint-brush stands linked the great outdoors to the contemplative world of the study and studio. But miniaturized landscapes were not the exclusive preserve of the refined and the ascetic. Another type involves miniature gardens set out in basins. These may include real plants together with rocks and sometimes precious stones. They are known as *pan jing*, or 'dish landscapes', and seem to have first appeared in the sixteenth century in Suzhou, whence they spread throughout China.[20] The techniques of dwarfing trees and shrubs were the same as those that were more famous in Japan. In the Suzhou region in the mid-sixteenth century they were to be found in 'even humble families in rural hamlets',

but as their popularity expanded, so they became luxury items. As Clunas remarks, their emergence as luxury objects is evident from their appearance in late Ming-period morality books as something not to be overindulged alongside a love of leisure, gambling, excessive antique collecting and lust.[20]

The equivalent tradition in Japan goes well beyond the techniques of *bonsai*, although that is probably the most widely known term to describe an aspect of the miniaturization of nature. Japanese practice includes a series of classificatory distinctions depending on what form of container is used, and whether the miniature scene is an open landscape or one involving miniature plants. As in China, the first of these small gardens were landscapes and the contemplation of stones lay at its heart. Also, as in China, mountains are accorded an aesthetic and spiritual quality, and Mount Fuji, in particular, is a ubiquitous subject in Japanese art and printmaking.[21] The origins of the contemplation of stones are traditionally associated with Empress Suiko (593–628), to whom is attributed a practice of sending stones in unusual shapes as diplomatic gifts to the Chinese court. In Japan the appreciation of stones was associated with the development of *bon-seki*, or 'tray stone', in which stones were displayed on lacquered trays together with sand to suggest a setting in a radically scaled-down landscape. Such landscapes, however, were not always simply imaginative constructions: sometimes they were attempts to suggest the mood and tone of poetry, and sometimes they were deliberate reconstructions of actual admired landscapes. The stones themselves might be changed periodically through the year to suggest the succession of the seasons. Another version of this is *bon-kei* or *ban kei* ('tray landscape'), in which peat is used to model landscapes and coloration added to produce

Bronze brush stand. Chinese, Ming dynasty, 16th century.
A brush stand in the form of a five-peaked mountain with riders on horseback.
H. 10.2 cm, W. 17.3 cm

Porcelain modelled and
carved brush stand.
Chinese, Qing dynasty,
19th century.
H. 6 cm

realistic scenes that may be moulded and remodelled at will. A further distinct form, *sui-seki* ('water stone'), uses a stone of admired form, which may be placed on a tray and surrounded with sand and water. They are then themselves watered periodically, and after an appropriate period they may develop a green mossy coating suggestive of a verdant island.

The greening of *sui-seki* is an intermediate form. The practice of *bon-seki* was simply a display of stones and sand with no plants involved. But the cultivation of miniature trees is regarded internationally as a Japanese speciality. In *bonsai* the propagation of dwarf trees is achieved from cuttings. An adaptation of this is what is called *sai-kei,* from *sai,* 'to plant vegetation', and *kei,* 'landscape'. Here earth and moss are wired to the branches of dwarfed trees so that they root by a process known as 'air-layering'. The rooted braches can then be removed and replanted so that the display continues to develop and evolve, where the artificial world of the tray landscapes will gradually deteriorate. The use of real stones to represent rocky outcrops and mountains and of dwarf plants that evolve and propagate gives these displays a desirable aspect of permanence. On a slightly larger scale, these miniature indoor gardens are the basis for the small gardens found inside stores, restaurants and hotels in modern Japan.

Japanese gardens have a largely domestic context, whether they contain real plants, plants of restricted growth or models. As places of contemplation, they are linked to the functions of the temple. The anthropologist Joy Hendry discusses Japanese gardens as contained or 'wrapped'[22] – a concept equivalent to that of taming or pruning. Japanese conceptions of space are expressed in two contrasting terms,

uchi (inside) and *soto* (outside). However, because gardens are enclosed within fences or borders of some kind, they are conceived of as inside, even if we would regard them as physically outside.[23] Thus one of the words for a home, *katei*, encompasses the idea of the house and the garden as a single concept.[24] The features of the garden are described as *oku*, which is a complex word that is used for the inner recesses of a shrine or building, a core of wood or even the heart of a mountain. There is a suggestion, therefore, that the garden provides a kind of abstract sacredness, a suitable subject for contemplation, a view capable of heightening the imaginative sensibility. The garden is, in effect, an abbreviated model of nature: it is enclosed, but it is given a sense of increased depth and scale, which physically it lacks, by the arrangement of its plants and features. It is, in Hendry's terms, a 'microcosm of Japan's view of the world'.

Finally, we should note that this intersection of interests, in miniaturizing rugged nature in both its geology and its biology, is found elsewhere, though with less well-analysed significance. At Machu Pichu in Peru the Inca set up stones in imitation of the silhouette of the large mountains visible in the distance. Landscape was important, although direct sources of information on Inca ideas are scanty. Much has to be interpreted from Spanish accounts dating from the sixteenth century onwards, and from the richness of the Inca remains and the excavated evidence of their empire. Nonetheless, ideas of the overlordship of the Inca emperor and of the sacred nature of the Andean landscape, as well as the importance of appropriate ancestral acknowledgement at sites of significance, are clear in the literary and archaeological records. Its most spectacular evocation is the so-called miniature 'garden' reported by a Spanish soldier, Pedro de Cieza de Léon, in 1553. As is often the case, the term 'garden' with its contemporary meaning in English may be somewhat misleading, but that it was a spectacular and deliberate representation of a world in miniature format is undoubted. The garden was located within the Temple of the Sun at Cusco, itself described in microcosmic terms as 'the navel of the universe', the very centre of the Inca empire. It is described thus:

> There was a garden in which the earth was lumps of fine gold, and it was cunningly planted with stalks of corn that were of gold – stalk, leaves, and ears … Aside from this, there were more than twenty sheep of gold with their lambs, and the shepherds who guarded them, with their slings and staffs, all of this metal. There were many tubs of gold and silver and emeralds, and goblets, pots and every kind of vessel all of fine gold.[25]

Another sixteenth-century source, Garcilaso de la Vega, a commentator of mixed Inca and Spanish descent, recalls the garden as yet more populous. He mentions 'many herbs and flowers', both 'tame and wild' animals, and 'creeping things such as snakes, lizards, and snails', 'butterflies and birds', together with figurines of men, women and children all cast in gold and silver.[26]

Colour woodblock print, including a potted *bonsai* tree, by Katsushika Hokusai. Japanese, 1822.
This print is one of a series by Hokusai focusing on Lake Biwa, near Kyoto. Here the references to the lake are esoteric, being incorporated into the design on the porcelain plant pot and the towel. The miniature tree recalls a giant ancient pine in the region, which would have been well known. The technique of *bonsai* is put to good use by Hokusai in assembling in one image a suggestive compilation of connections to an actual landscape.
H. 20.1 cm, W. 17.6 cm

93

This was an idealized world linked to the wider Inca cosmos. The location within the most sacred space in the Inca empire already implies this. The use of gold and silver suggests an association with imperial rule: the Inca emperor and empress were thought of as children of the sun and the moon. As is well attested in book and exhibition titles on Andean subjects, gold was considered to be the 'sweat of the sun' and silver, 'the tears of the moon'. The very materials of which the garden was constructed were themselves elemental materials associated with the world of the Inca divinities.

Maps and microcosms

Unlike gardens, the history of cartography has at one level less to do with microcosms and more to do with the modelling of actual geography. However, this perspective is not sustainable when we consider all the different representations that comprise the category rather vaguely and loosely referred to in western practice as 'maps'. The most 'accurate' maps are those that most closely resemble physical realities and that enable journeys to be reliably planned and routes predicted. From medieval times the drawing up and interpretation of such maps was a vital part of the seafarer's craft. The first European maps to try and model space accurately were the so-called 'portolan' charts, the term deriving from the *portolano*, or pilots' book, written rather than diagrammatic sources recording anchorages, ports and courses to be sailed. They were focused more on the seas and the coastlines and less on the landmasses, concentrating notably on the areas around the Mediterranean, the Black Sea and parts of the Atlantic northwards to the islands of Britain and south round the north-west coast of Africa. So-called rhumb lines radiated from sixteen equidistant fixed points, including the four cardinal points of the compass, and were used to chart courses between distant ports. Such charts date from the late thirteenth century and began to be perfected by Italian map-makers in the early 1300s. Subsequently, their details were incorporated into charts drawn up elsewhere in the Mediterranean, particularly the Catalan map of 1375 commissioned for the French king. This was intended to assemble all the observations from seamen's portolan charts to give the beginnings of an accurate world map, at least as far as the world was known to fourteenth-century southern Europeans.

The more or less accurate outlines of the coastline provided the basis for more general maps, which began to fill in the rivers and mountains further inland. In the first decades of the fourteenth century maps associated with the name of Pietro Vesconte started to take this cartographic precision further, developing documents and illustrations that seem to be the source of the attempts during the century to represent the geography of Italy. Several, notably a map of Palestine, used a grid system to assist in the expression of the relative locations of the features to be included. The technique is found in various Islamic maps and on at least one twelfth-century map of China, which, based on scaled maps known in China as early as the third century

Psalter world map. British, c.1265. British Library.
This small map is modelled on the large-scale *mappae mundi* of the same period. It shows Christ presiding over the world flanked by angels. The map is centred on Jerusalem with the easterly direction at the top where paradise is also located. Given its incorporation into a religious book, its purpose is clearly to encourage spiritual contemplation. D. (of the earth) 9 cm

AD, survives because it was inscribed on stone.[27] Such large expanses of land, with many potential features to include, are complex to chart. By contrast, peninsulas and islands are easiest to map from the starting point of an accurate outline of a coastal perimeter. In Britain the maps of Matthew Paris, a Benedictine monk working at St Albans in the mid-thirteenth century, began to exploit the potential for accurate cartographic modelling and representation. Like portolan charts with their suggested sailing courses, Paris's maps were centred round the itineraries of actual journeys conceived as a straight line, notably that from Newcastle in the north-east to London and Dover on the English Channel coast, passing of course through St Albans. One of Paris's journeys, indeed, was an itinerary map detailing the route from London to southern Europe and including notes on the different stopping-off points, each a day's travel from each other – a useful guide for those looking to cross the continent to the nearest point of embarkation for the Holy Land.[28]

However, it is significant that, of the sixteen or so of Paris's maps that survive, the most geographically sensitive were made as illustrations to the *Chronica Majora* (translated as *Matthew Paris's English History from the Year 1235 to 1273* and published in 1852–4). Although Paris was a monk, his aims were those of a chronicler, not a theologian. We know that he assembled his information from direct observation, from a kind of ethnographic fieldwork in which he recorded what he could learn, not just from well-travelled visitors to the abbey but from discussions of local affairs, and from his own travels in both Britain and northern Europe. His writings and his maps betray a quite different intention from the much more numerous books and so-called maps emerging from priestly hands in monasteries in many different parts of Europe. 'Here be dragons' is a joking reference to an uncharted area, but it derives from a perception of landscape as a mythological as well as a physical space. To see early forms of maps in the modern sense as more-or-less accurate representations of the coordinates of physical space fails to do justice to their complex power of encoding. Maps in medieval times were far from a simple reflection of geographical space. Indeed, had they been intended as such, almost all were patently inadequate and misleading. We have to assume that physical measurement and relative scale were hardly the point. Thus the word *mundus*, as in *mappa mundi*, did not usually mean 'world' in the sense of the earth (*terra*) but rather referred to the universe as a whole,[29] and *mappa*, for that matter, simply meant 'cloth'. Maps in the familiar modern sense had yet to be conceived; rather, we need to think of medieval 'maps' as diagrams of a wider compendium of knowledge. Even the pictorial atlases that most approximate those of the present-day Ordinance Survey often had an explicit philosophical and religious context; biblical reference and cosmological understanding were the familiar topics of such early spatial diagrams, rather than details of longitude and latitude. The disjunction between the term *mappa mundi* and modern cartography is evidenced in the 'Mappa Mundi' by Gervase of Canterbury (*c*.1141–*c*.1210). This was not at all graphic in character, but simply comprised a listing of bishoprics and monasteries – and most turn out to be in Britain.

A *mundus-annus-homo* diagram from Isidore of Seville, *De natura rerum*. Spanish, 12th century. British Library.

The central circle of this diagram is expressive of medieval ideas of the human being as a world in miniature. *Mundus-annus-homo* (world, year, man) draws together man's experience of both time and space, not however, in the form of a modern 'map'. Here, in the circles around the central roundel are arranged the humours and temperaments (in this instance sanguine, melancholy and choleric), together with their relationships to water, air, earth and fire.
D. 10 cm

In the simplest of these diagrammatic representations of the world a circular image is divided into three parts by an internal 'T' shape, giving what is often referred to as a 'T-O' map. They do not attempt to sketch in the physical outlines of real geographical space but generally indicate what each of the divisions represents by writing in the names and any associated characteristics of the three known continents or other information. Maps in other, less schematic forms also see the three continents of Asia, Europe and Africa as distinct areas of human habitation surrounded by the oceans. This physical cartography is frequently given biblical veracity by textual annotation, which relates the tripartite division to the three sons of Noah, and this in its turn invokes the idea of Noah and his wife as the single progenitors of a renewed distribution of humankind after the Flood. A biblical interpretation of demography and genealogy is thus depicted. In other versions a New Testament context is sometimes suggested with the 'T' becoming a crucifix and the tripartite division an allusion to the Trinity.

In these tripartite representations Asia is often shown in the largest sector with Europe and Africa nestling in the smaller ones. 'Y-O' maps, where each sector is given equal spatial dimensions, are rarer. The pre-eminence of Asia is also related to the biblical or cosmological idea that this was where the original earthly paradise was located, in the east and – following the conventional orientation of such maps – at the top. On the maps that illustrate Ranulf Higden's influential fourteenth-century account of the history of the world, the *Polychronicon* or *Universal Chronicle*, Adam and Eve are portrayed at the top standing either side of a coiled snake in the Garden of Eden, the snake itself in one version having a winged head. As the story of humankind is thus identified with the story of creation, and geographically located in the east, so too the great rivers – the Ganges, the Tigris, the Euphrates and the Nile – are often shown as descending from a common font in a paradisiacal part of Asia, all so configured as to issue from a single shared source. The maps are often centred on Jerusalem. Such maps, as Edson remarks, were plainly not designed for travel, but for contemplation.[30] Space is here a reflection of biblically inspired conceptions of time and place rather than of any resolutely objective geographical reality.

Such diagrammatic maps are studied miniaturizations, a reduced alternative to real space: they possess an economy of reference where, by conjunction or by metaphor, multiple purposes and descriptions are conjoined. In Isidore of Seville's eighth-century text *De natura rerum* ('On the Nature of Things') the sun comes to represent Christ and the moon the Church, while the tides are associated with the waters of baptism and the seven phases of the moon with the seven Graces of the Holy Spirit.[31] As will be discussed in more detail in the next chapter, man is also implicated as a kind of '*locus* in miniature' of this wider cosmography. Thus the four elements of air, fire, earth and water correspond to humours of the body – blood, yellow bile, black bile and phlegm. These in their turn invoke the four basic temperaments of the sanguine, the choleric, the melancholy and the phlegmatic. All is encoded in a circu-

This simple diagram shows the relationships understood to exist between Asia, Europe and Africa. The east is at the top with the landmass of Asia spanning the north and south. The bottom left (or north-west) represents the northern-hemisphere continent of Europe, and the right (or south-west), Africa. This basic format might be further elaborated with reference to the three sons of Noah, and the T is sometimes more explicitly an illusion to the crucifixion and the salvation of the earth through the sacrifice of Christ.
D. 6.3 cm

lar diagram, or *rota*, at whose centre appear the words *MUNDUS*, *ANNUS* and *HOMO*: 'world', 'year' and 'man'.[32] The pervasive medieval idea of a microcosm is thereby linked to the macrocosms of space and time. In a further elaboration the ages of man are implied by association with the seasons. Childhood, for instance, is linked to spring, to blood and thus to a sanguine temperament; old age is associated with winter, with phlegm and a phlegmatic humour. A rich cosmological cartography lies behind such diagrammatic presentation.

Rotae were simple flat circles or wheels that sought to present essential information about the nature of the world and its workings in a simplified and memorable form. Such medieval diagrams are often explicitly described as 'wheels of memory', and there is a clear adaptation of the convention of presenting information in visual form for mnemonic or explanatory purposes, including more 'map-like' configurations. The wheels or circles compress text and image into a single representation, fill-

ing the bounded space available with a web of pre-digested information. Diagrams consisting of regular spaces, in which geographical material is conveniently listed, are much more readily remembered than terms deployed across maps with the irregular spaces of physical reality. As in Camillo's Theatre of Memory, *rotae* were compendiums of knowledge about peoples, places and oddities of the natural and cultural landscape laid out in graphic form; they displayed their information in a series of interconnections to make the world comprehensible and memorable. It is much easier to visualize and thus recall an orderly and geometric presentation of material than it is a random distribution of terms. To the extent that maps were charts of factual information to be communicated and retained, rather than accessible works of reference available on the shelf whenever needed, the *rotae* were a more immediate model for the medieval map-maker than actual geographical space. And their construction presents us with a direct parallel to the practice of the nineteenth-century museum curator setting out his collection in typological sequence.

It is important to remember that such representations were deployed in a largely non-literate context, one where the authority of the written word was unquestioned, but where it needed to be read or explained for it to be communicated in the first place. Oral testimony together with visual presentation were the mechanisms of communication. As Naomi Kline remarks: 'The map presented its information in a non-linear way, and hence extracted narratives depended on viewers' capacities for making associations ... Information may be told in any order using building blocks to fit into the structure that is imposed upon the information by the actively involved viewer-participant.'[33] Kline goes on to characterize maps as 'conceptual enclosures for stored information'.[34] She thereby explicitly links the function of *mappae mundi* to that of the *rotae*. Some were also the inspiration for church decoration, such as the thirteenth-century rose window in the southern transept of the cathedral at Lausanne. On these the congregation could reflect, and in their quiet contemplation register a distillation of cosmology and of divine purpose for future recollection.

However, the fit between the two, between *rotae* and *mappae*, is sometimes less than perfect. Both picture the information to be conveyed within an encompassing circular format, the familiar device of monastic schoolbooks. Yet, where in the *rotae*, or wheels of memory, all is ordered and concise, on maps such as the Hereford Mappa Mundi (to whose interpretation Kline's book is devoted) an outer circular frame encompasses a more elusive, less explicit arrangement of spaces and information. Instead of the *summa*, a term referring to a logical and orderly presentation of assembled information, we get something closer to a *florilegium*, a collection of appropriate quotations. 'The frame', Kline notes, 'must be relied upon for reminding the viewer that the map is a microscopic view of what is contained in the undifferentiated inner hubs of cosmological constructs'.[35] The more the *rota* gave way to the concept of the 'map' as we now understand it, the less it was a purely didactic device. Kline notes that in the Hereford map the circular world is surmounted by a vision of

the Last Judgement. She concludes that what is shown is neither an educational tool, nor a simple picture of the world; rather it is an evocation of God standing above the universe, and looking down in judgement on earthly pursuits.

In addition to diverging from the model of the *rotae*, the Hereford map – itself an unlikely survivor from the late thirteenth century, and made more celebrated when the cathedral, which owns it, threatened its sale in 1989 to raise funds for the restoration of the cathedral fabric – is in fact also quite large, measuring approximately 2 metres square. Yet despite its grandeur, it remains a microcosm; for within its compass there are no fewer than 420 towns pictured, 15 biblical events, 33 plants and animals, 32 different races of people and 5 scenes from classical times. It is a vivid spectacle that draws on a large range of mythical and historical accounts of journeying, on contemporaneous pilgrim reports, known trade routes and Old Testament highlights – notably those involving Adam and Eve, Lot's wife, Noah's Ark and the Tower of Babel (which is the largest man-made object on the map). As usual,

Engraving of the animals leaving the ark by Giulio Bonasone after Raphael. Italian, 1544.
The image of the animals leaving the ark to repopulate the world is an apt metaphor of the microcosm – the ark as a container of generative power containing the possibilities of creating worlds much greater than itself in both spatial and numerical terms.
H. 29.8 cm, W. 37.8 cm

Engraving of Noah attributed to Baccio Baldini. Probably Italian, c.1470–80.
In this medieval image Noah is portrayed sitting on a bank of clouds, holding a miniature ark. On its roof is a dove holding an olive branch in its beak. Rather than the ark being a large vessel carrying off the animals of the known world as it was portrayed in many early modern illustrations, it is here shown in miniature, relative to the size of Noah. The reference would seem to be to Noah as an image of the risen Christ and the ark as an allegory of salvation. The link between the sons of Noah and the tripartite division of T-O diagrams into the three known continents suggests such an interpretative merging of Old and New Testament traditions. H. 14 cm, W. 10.5 cm.

Jerusalem lies at the centre of the map, though as regards relative scale, Lincolnshire, where the Mappa Mundi was made in or around 1280 for (it is assumed) a canon of Hereford Cathedral, is portrayed on a larger format than its actual size warranted in relation to the rest of Britain. Again, absolute measurement was not the issue. 'Near here' was always on a comparatively larger scale than 'over there', and 'here' could

mean both a physical place, round which the 'map' was centred and articulated, and also, as in this case, the Christian faith. In the words of Veronica Sekules, 'The world is not merely recorded: it is orchestrated to convey a geographical sense of place within a political and religious context, in terms of past and present history, and within a clear overall ideological framework.'[36]

One of the familiar metaphors, which is common to descriptions of both museums and the natural and human world, is the Old Testament one we have already encountered, that of Noah's Ark. A twelfth-century source, Hugh of St-Victor, places the ark at the symbolic heart of the earthly domain, and thus of the cosmos, in his *De Arca Noe Mystica* (1128/9). He is deploying the ark in its redemptive role, not just as a vessel of rescue in the time of the Flood but as a figure for the Church itself, the guarantee to the faithful of ultimate salvation. The cosmic diagram in which he brings together the mnemonic expression of his thoughts is now lost.[37] Many aspects of the image are familiar from other cosmic diagrams of the period. Overlooking the universe is Christ in Majesty with two seraphim shading him with their wings. A host of angels are in attendance. The universe itself is conceived with an outer sphere in which are identified the months of the year together with the signs of the zodiac. Moving inwards, and surrounding the earth, is an encircling sphere personifying air, and located within it are the seasons and their appropriate humours, and winged figures representing the different winds, each blowing on trumpets. At the centre of the diagram is a rectangular figure that represents the ark, together with a *mappa mundi*, in which are listed geographical features such as mountains and rivers, together with castles, Egypt (representing release) and Babylon (a place of captivity). The link between the ark as a protective vessel for the souls of believers and the typical listing of the biblically inspired landscape serves to situate the faith in a physical setting. At the same time it offers the reassurance of redemption through the image of the ark, encircled by the spheres and overseen by Christ enthroned, transporting its cargo of the faithful safely towards salvation.

Other more or less articulate expressions of the containedness of cosmic representation are found elsewhere in early European divine texts. In the New Testament St Paul offers a number of images, including a contrast between the unbounded eternal home of God in the heavens and the earthly habitation of the tent or tabernacle. Already in the sixth century AD an independent Alexandrine Greek thinker and traveller, whom we only know as Cosmas Indicopleutus (or 'Mr World Sails-to-India'), was employing this image of the tented tabernacle as a metaphor and inspiration. Cosmas took the Pauline image as an important symbolic vehicle through which to draw together an understanding of time and space. He believed that the earth was not spherical but flat and rectangular, and he saw it as encompassed beneath the canopy of the sky raised above it like a tent on its four poles. Cosmas was also a map-maker and his image of the earth nestling statically beneath the tenting of the heavens included an otherwise familiar set of coordinates: the seas and rivers, the cardinal directions and the winds, and paradise.[38]

Pilgrim sites

Some overlap of maps and pilgrimage might be expected. Pilgrim routes are among the most enduring of cartographical traces.[39] In geographical terms, the sites of pilgrimage to be visited by the faithful are often very dispersed, representing the successful spread of the faith. In Christianity the sites range from Compostela and Canterbury in the west to Lourdes, Rome and on to Jerusalem in the east. For the Hindu faithful India itself represents the sacred geography of the faith. In myth Sati, the wife of Shiva, is said to have died inconsolable after having inadvertently insulted her father. Shiva, distraught at her demise, carried her body off in uncontrolled grief. To assuage his grieving, the gods took the corpse of Sati and distributed her remains to sites that became sacred throughout India. Visiting all of them on a grand circular tour is the ultimate Hindu act of penitence.

For Muslims Mecca remains the primary site of annual pilgrimage (*hajj*), together with Medina nearby; orientation in prayer and the positioning of the *mihrab* within mosques throughout the Muslim world are in the direction of Mecca. Other more local sites outside the immediate Arab world also function as places of pilgrimage, with the Dome of the Rock in Jerusalem among the most important. In Ethiopia Harar is a major site of pilgrimage for Muslims (many of non-Arab descent) throughout eastern and north-eastern Africa, though located in a country whose history is otherwise almost always recounted in terms of the Ethiopian Orthodox Church, ignoring its strong Islamic traditions. Jewish pilgrimage, though less formalized than Islamic, is also of course focused on Jerusalem, where the Wailing Wall, which is all that remains of the Temple of Solomon (itself destroyed and rebuilt on various occasions in the past), is revered as a place of prayer.

Buddhism has an explicit tradition of pilgrimage that derives from the Buddha's own identification of four places as sites to be visited by those who follow him. These are all in what is now northern India and neighbouring Nepal: Lumbini (thought to be Rummindei in Nepal), Bodhgaya in Bihar, Sarnath near Benares, and Kushinagar. Other sites associated with the Buddha have subsequently been added to the list, as well as places thought worthy of veneration because of a link with someone who has attained a state of enlightenment. As Buddhism spread to eastern Asia some highly influential figures in the development of Buddhism in China continued to visit the Indian sites as pilgrimage destinations, despite the major distances involved in the journeying. However, when Japan began to adopt Buddhism, pilgrims were drawn to China rather than southwards to the subcontinent, until the islands of Japan began to develop their own sacred sites – sites associated not with the life of the Buddha, clearly, but with those who had attained a state of enlightenment.

The ability of each of these major sites to gather up pilgrims from the spatial fringes of the faith gave geographical expression to the dispersal of religious practice. Yet, for many people in more remote places the opportunity of pilgrimage was clearly limited; and penitential acts, equivalent in rigour to what was endured by those

Red-sandstone, miniature version of a Shiva shrine. Indian, possibly from Benares, 18th–19th century. Inside the small shrine is a *linga*, an aniconic representation of the god Shiva, and above the doorway is a miniature figure of Ganesh. The upper tower recalls Mount Meru, the sacred mountain located at the centre of the Hindu cosmos. Small shrines such as this are often placed beside rivers or other sacred places as donations by the pious. H. 1.2 m

journeying on full-scale pilgrimage, might be performed locally. Indeed, all religious practice potentially engages and channels the widest world of the faith, whether it takes the form of Muslim prayer offered towards Mecca or of architecture. Churches, mosques, temples and synagogues are all, clearly, in some sense concentrations and microcosms.

Little Walsingham in Norfolk has been a major site of pilgrimage in England from the eleventh century. Its emergence derived not from the possession of relics but from a visionary experience when the widow of a local aristocrat was transported to the house of the annunciation in Nazareth, and there was directed by Mary to erect a replica building. A small wooden version was duly created and then incorporated into a small stone church. Gradually the legend developed that the spirit of Mary had fled the Holy Lands, then being overrun by infidels, and had taken up residence in the shrine dedicated in her name at this out-of-the-way village in East Anglia. The Augustinians set up a priory in the twelfth century and later the Franciscans built a priory nearby. Walsingham had become a major Marian site of pilgrimage not just for British but for continental pilgrims, a Nazareth for western Europe. Both priories, however, were substantially demolished in the Reformation. Although it remains a site of Roman Catholic pilgrimage, in the twentieth century Walsingham re-emerged as a site of Anglo-Catholic pilgrimage also. A locally born priest, Alfred Hope Patten, revived the fortunes of Walsingham when appointed vicar in 1921, a post he held until his death in 1958. He set about recreating the original shrine, not in the grounds of the older priory but in the precincts of the twentieth-century Shrine Church. A new figure of the Virgin and Child was sculpted after a medieval abbey seal in the British Museum. The altars themselves represent an architectural assembling of the ruins of other ecclesiastical buildings, stone from which is incorporated into the fabric of the recreated pilgrimage site. The site, identified in medieval thought with the events of the early life of Jesus, is thus symbolically reinvented with materials and references to the wider world of Christendom. Like many religious sites, Walsingham thus represents in microcosm a rendering of the unity of the dispersed faith.

By tradition pilgrims approaching the shrine of Our Lady of Walsingham leave their footwear at Houghton St Giles, about a mile to the south of the site. The last part of the journey is completed barefoot as an act of humility. Such devotion was often played out at a local level. Elsewhere in East Anglia there are records (from Beccles and Bungay, for example) of chapels being specifically arranged so that a journey round the church might recreate a journey round the sacred sites of the Holy Land. In the Middle Ages these might either be completed on foot or, to make the task more demanding and more penitential, on the knees, recreating in the locality the sense of the wider pilgrimage. Chapels in a cathedral might be visited in turn as a means of creating within a single sacred space the totality of other sites in the Christian world. This then can be taken down to the level of the individual icon, which might have around it a series of individuated elements that can each be 'visited' in turn.

Hinduism provides further examples of the practice. Benares, on the sacred River Ganges, is recognized by devout Hindus as the holiest of cities, and the most important place to be visited by pilgrims, some of whom are in almost perpetual motion circumambulating India. Shiva is especially associated with Benares. A pilgrimage round Benares can thus be perceived as a surrogate for the prolonged and demanding undertaking of travelling round the whole of the subcontinent. One of the temples in Benares is dedicated to *Bharat Mata*, 'Mother India', and was opened in 1936 by Mahatma Gandhi. Instead of the image of the divine person, the central icon of veneration is a relief map of the subcontinent itself, carved in marble and showing the principal rivers and mountains and the holy *tirthas*, or pilgrimage centres. It is a fitting image. The map represents the sacred geography of Hinduism, but it does so within a temple in a city that is itself a microcosm of the great expanse of India. It is as if there is a progressive shrinking and concentration down to the level of a single temple. As with the East Anglican examples, penitential acts can be produced within the reduced geography of a single building, visualized, in the case of Bharat Mata, as a map.

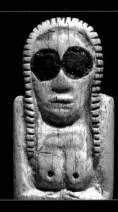

4. Seeing Hidden Things

Many so-called 'maps', then, are less, dispassionate, objective representations of landscape than a form of moral and spiritual cartography. But the world rendered in microcosm is far from exhausted by the cosmological and broadly geographical knowledge represented in maps, map-like diagrams or globes. Those we have been discussing are largely depictions of an already interpreted world. An image of the Benedictine abbess and mystic, Hildegard of Bingen (1098–1179), who appears in one of the most glorious illustrations of medieval cosmic man seated in a corner quietly writing at her desk, is a reminder that this version of the functioning of the cosmos is one that is explicitly authored. Other scholars and visionaries have produced their own versions of the place of man in the universe, often adapting the visual conventions to their own interpretations.

Divination as we encounter it in the writings of ethnographers provides instructive parallels. Hildegard experienced visions from early childhood but it was only well into the middle years of her life that a monk was appointed to assist her in recording them. There had been twenty-six by this stage, and when she established her own convent at Bingen in Germany in 1147 she continued to record new prophecies and visions in her writings.[1] But her visionary experience had little of the immediate, intensely practical application found among diviners and healers, for it was not directed towards curing individual affliction and, as written up and – especially – as illustrated, it was in an already interpreted state. The equipment of the diviner is different for, although describable as a world in microcosm, it gives us only the parameters of that world and is yet to be applied to particular cases. Thus, in drawing a parallel between the world of cartography or cosmological diagrams and that of divination, there is a crucial procedural difference: in the former case the representation is a finished microcosmic image, while the other, though a prescribed, contained world, remains to be manipulated. How this happens is considered in this chapter.

Opposite
Bone figure with lapis lazuli inset eyes. Upper Egypt, 4000–3600 BC.
See pp. 116–17.

Divining the world

When mystical forces are invoked, they are normally constrained within boundaries, which may be in the form of bowls, trays, baskets, bags, pots, tortoise carapaces, gourds, mortars, antelope horns or even mats on which objects are deployed. The assembled elements will all have wider realms of reference. One of the more geographically inspired systems of divination is that of the Venda of South Africa. Venda bowl divination was the speciality of the most powerful diviners deriving from the *kosi* (kings) of the Singo lineage. The iconography and method of using the bowls related to the mythical geography of Lake Fundudzi, the Lake of Creation and the abode of the culture hero Thoho ya Ndou, who disappeared into the lake and set up his capital there. The lake is the only naturally occurring body of water in Venda country and has the unusual feature that both the source and the exit of its water are hidden.[2] The very presence of the lake is thus a mysterious one to those not intimately acquainted with the region's geomorphology.

Ten bowls survive as witness to one of the systems of divination formerly in use among the Venda. Apparently the bowls were kept in Singo capitals exclusively for the detection and exposure of witchcraft.[3] Each bowl has a wide rim on which are illustrated a series of images that indicate social groupings, gender and seniority.

Wood divining bowl and decorated underside (below left) with associated equipment. Venda, South Africa, 19th century.
The upper surface of the bowl (right) is incised with a series of figurative and non-figurative images, including a crocodile (below) that lives permanently in the 'lake'. The 'island' in the centre, surmounted by a cowrie shell, represents the mythical capital located in Lake Fundudzi, to which the bowl filled with water makes reference and of which it is a reduced model.
D. (bowl) 32 cm

When in use, the bowl was filled with water so that the imagery on the base represented an underwater world in which dwelt a crocodile picked out in low relief. The crocodile is a reference to one of the honorific titles of the chief: 'the crocodile never leaves his pool', that is the chief is always with his people, as the crocodile is permanently present in Lake Fundudzi. In the middle of the bowl is an 'island', which represents Thoho ya Ndou's mythic capital. At a yet more submerged level of reference the image of a python is represented as a zigzag pattern that curls round the perimeters on the underside of the bowl; it recalls the role of the snake as the primordial animal encircling the 'pool' ready to pounce on unsuspecting prey. The python is associated with the diviner-healer working with the authority of the chief.

The bowl thus encompasses at once a physical place, a myth of origin, an endorsement of the chiefdom, the ambiguities of magical and sorcerous powers, and the possibility of detecting the origins, and thereby the resolution, of endemic problems. The material object, the bowl, is to that extent a focused metaphorical theatre; it contains a condensed world of esoteric reference that is activated in divination to engage mystical and physical challenges. Thus, with the bowl full of water, maize kernels are floated on the surface and the bowl is tipped so that they float towards the edges. The images inscribed on the bowl at the points where they touch the sides are interpreted to give the diviner his diagnosis. Only at that stage does the reality confined within the bowl become apparent in its application to a particular set of circumstances. The bowl, thus, is the arena within which the interactions of the diviner, his client and the ancestral world are focused.

Geography and landscape are here symbolic elements. Many other systems of divination employ forms of non-spatial knowledge, which contrast with the physical precision of the Venda bowls, but which nonetheless also seek to represent larger totalities in miniature with the ambition of making particular circumstances comprehensible. They are all engaged in creating the arenas in which the essential may be discovered. To that extent they assert no order within the world but remove contingency and extraneous detail so as to focus on essential realities; they describe the parameters within which wider events take place. Many such systems of divination seek to invoke and test different kinds of microcosm to discover how the cosmological forces that influence human affairs are articulated. In the case of the Ifa divination trays of the Yoruba in Nigeria, the reference is not to specific physical places but to the forces that energize the cosmos. The underlying conception is of a world governed by spiritual powers that are articulated round the four cardinal directions and a central point at which they converge. The circular tray represents this vision of the cosmos as an arena of five spiritual dimensions. In divination a divining chain is placed on the four corners and the centre of the tray. 'By this visual act,' explains one commentator, 'the tray becomes the earthly sacred center from which the diviner makes present the heavenly center and the ultimate storehouse of Ifa's knowledge.'[4] Thus the client, through the intermediation of the diviner, can gain access to truths otherwise inaccessible about their personal circumstances. The tray provides the

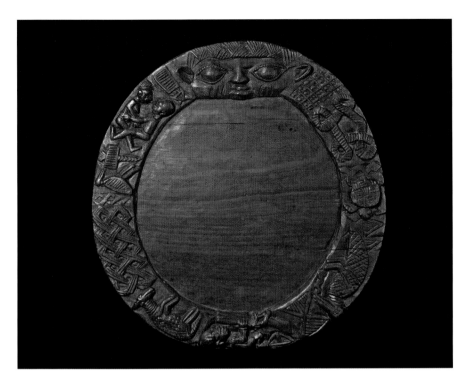

venue for this confrontation with cosmological realities. The world the diviner seeks to invoke and interpret is contained within defined physical boundaries; and this very boundedness is an attribute of the constraint he seeks to impose on an otherwise limitless world of possibilities. At root, the process of comprehending worlds of possibility is one of reduction to a system of options that may be explored to arrive at particular conclusions.

Divination baskets containing a wide variety of small sculpted images, such as miniature masked figures, ancestor figures, weeping women, couples in sexual union, cripples, a person possessed, a corpse, a dead person being carried in palanquin – each with a wider symbolic field of reference – are well described for peoples of the southern Congo and neighbouring parts of Angola.[5] Diagnosis is much more common than prediction or prophecy. The diviner tosses the objects together in the basket. Each time the objects settle down in different configurations, they provide the diviner with clues to the resolution sought. Such consultations can be a matter of a few minutes or, in more complex cases involving a group of people, they may perhaps last for several hours and demand a whole sequence of tossings.

Manuel Jordán recounts in detail the divining techniques and equipment used by a Luvale diviner, John Samusevu, who travels from village to village in Zambia offering his services.[6] His container is a metal trunk in which the divinatory objects are kept when he moves from place to place. Rather like Policeman MacCruisken's boxes

Wood divination tray (*opon ifa*) and detail of the carving. Yoruba, Nigeria, 20th century. In Ifa divination an approach is made to the god who knows the secret of the forces that shape individual human existence. The larger face at the top of the tray represents Eshu, the god who is an intermediary between the diviner and the divine source of knowledge, and who also bears offerings to the gods and other spirits. The method of divination is complex and involves the shaking of palm nuts, the interpretation of marks on the tray and reference to one of a series of 256 verses. D. 36 cm

within boxes, the trunk itself contains innumerable other containers. In divination the trunk acts as a kind of altar on and around which a whole series of these other containers are unpacked and deployed – metal cups, bottles, plates, all charged with specific medicines. The diviner also has available to him a series of ceremonial axes, flywhisks, horns and a mirror, all of which could be used to confront adverse forces. As Jordán explains, the mirror is a crucial piece of the ensemble, for although it is completely covered with glutinous medicines, Samusevu can see pictures in the mirror that show him what is happening. By looking in the other containers he can likewise see further suggestive images, which give clues to the circumstances that result in a debilitating affliction. Each is in a sense a kind of peephole into a wider world of negative forces and scenarios.

Samusevu also carries a staff, which is again heavily encrusted with medicines, beads, shells and bells. Given his itinerant business, the staff thrust into the ground when he is divining provides for new clients an immediate confirmation of his powers. The various substances applied to the staff act as proof of and witness to the struggles with supernatural agencies that he has negotiated in the past. The word *ngombo* is used to describe the divining equipment, while *tambilika* denotes the diviner's staff. *Tambikila* has the sense of something that attracts and is also used of birds whose call is enticing. Thus the function of the staff is identified lexically as acting to summon both the clients beset with misfortune and the malign spirits that are troubling them. The top of the staff has a figurative carving representing a protective

Diviner's equipment. Angola, 20th century. A series of objects – including wood figures, bone, horn, a claw and cowrie shells – together with the calabash container. The flywhisk is also part of the diviner's accoutrements. Each diviner will have his own personal collection of objects judged efficacious in negotiating between clients and supernatural forces.
H. (of facing figures) 5.5 cm

ancestral spirit, which in various contexts has the power to gather together animals to assist the hunter, reveal the activity of witches to the diviner-healer or – since knowledge of witchcraft is an ambiguous thing – to trap the users if they themselves are witches.[7]

This assemblage of divinatory objects and substances together with the figurative staff has the effect of drawing in and localizing extensive and powerful forces to the benefit of the diviner's clients. The fact that each of these localizations occurs within a bounded space is consistent with the description of divination as 'attracting' and 'containing' so that the diviner can 'see' the source of malevolence in images or pictures. This is not simply the language of the ethnographer acting as interlocutor but is duplicated in many local vocabularies in the Bantu heartlands where Jordán's encounter with Samusevu took place. These contained assemblages of cosmological forces represent a supernatural world in microcosm, allowing the diviner to survey a range of possibilities in a single concentrated space.

The extensive use of mirrors and glass in a divinatory context stresses the privileged sight that diviners possess. Wyatt MacGaffey talks of the 'eyes of understanding' in describing the figures, known generically as *minkisi* (sing. *nkisi*), of the Kongo peoples further to the west – objects that, in the words of an indigenous commentator, can at once 'cause sickness in a man, and also remove it. To destroy, to kill, to benefit. To impose taboos on things and to remove them. To look after their owners and to visit retribution upon them.'[8] *Minkisi* frequently include mirrors embedded in the stomach, creating a reflective surface that – like water – represents the intersection of the underworld, the powerful abode of the ancestors and the physical world of the living (see p. 120).[9]

Elsewhere in Congo small slit gongs are the principal focus of divination and oracular statement. The most powerful analysis of their significance has been made among the Yaka in the Kwango river area and urbanized Yaka in Kinshasa.[10] It is difficult to summarize the richness of symbolic associations assembled in such a simple artefact. The slit gongs are small wooden drums in an oblong shape with a wide slit down the centre, through which an inner cavity has been dug out, providing the sounding box. They are carved from solid wood and have a head at the top that has a combination of human and sometimes chicken-like features. The gongs are the exclusive possession of the *ngoombu* cult, the cult of the diviners. And, like diviners, the gongs are also initiated: they are left at the grave of a deceased diviner where they are left to 'sleep' for three nights. By this process the drum becomes a place of dwelling for the ancestral spirit whose clairvoyance will be communicated through the rhythm of the drum, lending it an oracular voice. But in addition to this functional use as a container of ancestral voices, the slit gong has a range of other significance that, as Devish remarks, takes it well beyond the role of a 'simple prop'.[11] Firstly, the deceased source of the gong's oracular voice is often that of the same person who initiated the future user of the instrument. This adds significance to the assertion that the gong is the diviner's 'effigy', i.e. his alter ego or double. Yet the gong with its slit

is also identified, as might be expected, with the maternal and female world. It is, in effect, configured in linguistic and symbolic formulation as a womb: its slit is *ndaka phoongu*, literally its 'tongue' or 'uvula'. Its oracular utterance thus has an ancestral and uterine source, from which the slit gong gains its symbolic significance as the primordial womb, the womb of the world, whose spokesperson the initiated diviner becomes. What is invoked here, as in many other divinatory contexts elsewhere, are elemental states, origins – the spiritual beginnings from which human vitality ultimately derives.

Inside, the gong is coated with white kaolin. This is a substance with a common significance in many Equatorial Forest Bantu cultures. Often it is associated with the colour of the full moon, the moon that most successfully illuminates the darkness. The time of the full moon is acknowledged by the diviner staying awake throughout the night and anointing himself with kaolin especially round the eyes – something that both Kongo ritual specialists, as we shall see, and Luba diviners also do. Luba practice is discussed by Mary Nooter Roberts under the indicative subtitle 'Setting meaning before the eyes':

> The condition that facilitates the ability to 'see' is spirit possession, which, like the moon's rising, is greeted and induced by percussion and songs, and is heralded by the chalking of the diviner's body. Luba see an analogy between the moon's ascent and a spirit mounting a diviner's head, for just as the new moon brings into visibility what was hidden in obscurity, so the possession state affords a diviner an enlightened vision surpassing that of ordinary mortals.[12]

Nooter Roberts adds that the verb for becoming possessed, *kutentama*, is also used to describe the rising of the new moon. For the Yaka it is the moment of the full moon that is critical. The lunar cycle is also associated with the menstrual cycle, and thus the time of the full moon is the moment of highest fertility, in effect the moment of ovulation. The whiteness of the full moon 'extends this uterine space over the entire universe in order to regenerate it'. This combination of the idea of the primordial womb, and the association with the full moon, combine to render the slit gong and its divinatory messages a microcosmic source of restoration.[13]

Sightedness

Although the examples discussed here are from sub-Saharan Africa, the association of divinatory practice with special 'sightedness' – an ability to see worlds of action, motivation and intent in small things – is almost a defining feature everywhere divination is found. Mirrors are a familiar enough feature: it is not just in surrealist films that they are described as catching the image of otherwise unseen spirits. Elsewhere quartz crystal is used as an aid to sightedness, as recorded in a late-nineteenth-

Bone figure of a woman with lapis lazuli inlay. Upper Egypt, Early Predynastic period, 4000–3600 BC. Because of the grooving and pitted surface of bone, figures carved in it are often flat with the pitted surface hidden at the back, as here. This figure was found in a grave and is assumed to have a magical purpose in aiding regeneration. The emphasis on the eyes in the decoration is also suggestive of insightfulness.
H. 11.4 cm

century report of a Hopi shaman known as Yellow Bear, who sought to diagnose a pain that the visiting 'anthropologist', Alexander Stephen, was experiencing on the right side of his chest. He states:

> *Taking the crystal between finger and thumb, sometimes in one hand sometimes the other, he placed the crystal at arm's length toward me. Then he bent over so as to bring the crystal close to me, and thus he swayed back and forth, in silence, occasionally making passes with his arms to and fro toward me for about four or five minutes. Suddenly he reached over and pressed the crystal against my right breast, and just upon the region of a quite severe pain.*[14]

In one of the first attempts at a comprehensive survey of the literature on American Indian divinatory practice in North America, William Lyon produces many examples of how the skill is associated with more than just the metaphor of 'insight', as it might be understood in English. It is an actual, enhanced power of sight. In the Bear River area the Wailaki describe those expert in diagnosis as *isnasta*, 'seeing doctors', who can literally 'see' pain or disease, even if they are unable themselves to cure it.[15] A Lakota diviner named Fools Crow is quoted as saying of his diagnostic technique: 'I see on my mind-screen the full dimensions of a person's illness.' An Inuit shaman from the Cumberland Bay and Baffin Land areas reported that in divination he was able to see 'through

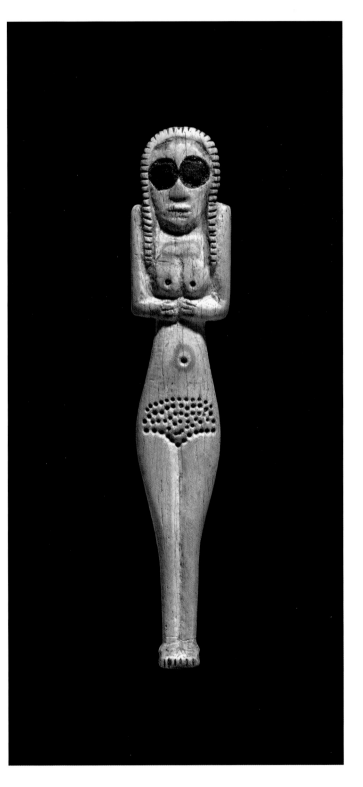

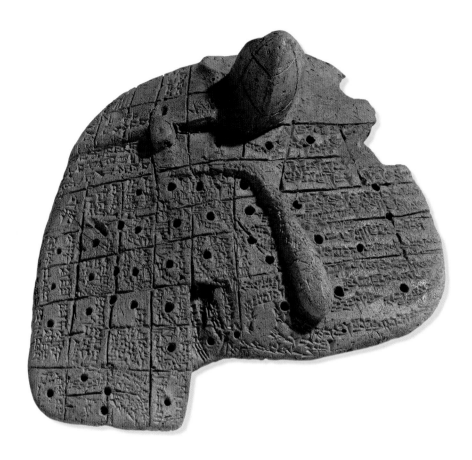

the back of his head'. When in trance, an Alsea shaman 'could see everything, all over the world'.[16] Sometimes these abilities are transferred to an object, which in its turn is in liaison with the shaman. Thus Waianae shamans are recorded as using sacred gourd rattles, which again are described as able to 'see' an illness. There is clearly a danger of quoting secondary accounts that use the English word 'see' to describe a phenomenon that does not actually involve sightedness. Reports of divination in the Inner Asia areas of the former USSR talk of the diviner being able to 'see clearly'. However, it is not certain, despite the use of inverted commas in the original description, whether it is an actual visualization or a diagnostic insight that is intended.[17] That said, in some Native American cultures shamans are described as putting their hands in front of their eyes in order to enhance their vision of otherwise unseen things. What they 'see' in such circumstances is seen 'in the mind's eye', as in a vision or a dream, but that it is thereby visualized is not in question.

Any treatment of the miniature overlaps to an extent with the discussion of questions of hidden things. Again the work of Nooter Roberts is instructive, notably in her exhibition and multi-authored catalogue, *Secrecy: African Art that Conceals and Reveals* (published in 1993), which considers these issues as they have emerged among anthropologists and art historians working in sub-Saharan Africa.[18] Not all secret things have to be small to be hidden, just as not all small things are secret and

Clay model of a sheep's liver. Old Babylonian (southern Iraq), 1900–1600 BC. Babylonians resorted to the otherwise unseen innards of animals to provide information about the events of the outer world. Questions that needed resolution might be referred to the divinatory significance of animal livers and lungs. The practice of referring fundamental questions to an inspection of animal livers and lungs is known from antiquity and from relatively recent times in parts of Africa. W. 14.6 cm

private; but the analysis of miniature objects and of secrecy converges round questions of what can be seen, by whom and in what circumstances. An ability to see small hidden things not accessible to those with ordinary eyes can indicate esoteric insight, an ability to visualize in the mind's eye other-worldly influence, but it may also manifest itself in the form of what is conceived as exceptional sightedness, literally. Although none of the contributors to Nooter's volume actually discusses the circumstances or contexts of miniaturization – and although the small-scale sculptures and other objects that illustrate that catalogue are not analysed from the point of view of scale – the intersection of the authors' comments with the subject of this volume adds a significant dimension.

At one level the overlap might always appear to be incomplete. After all, secret things have to remain secret if they are not to become common property. Most of the contributors to Nooter's discussion make the telling point that unequal knowledge of secrets is a source of power. At its most basic, knowing things that others do not sets the knower apart, while being out of the secret diminishes those not 'in' on the story. Clearly, secrets that are only ever utterly secret are meaningless as cultural constructions; they lack any possibility of comprehension and are by definition out of the social and political equation. So, at the very least, there has to be a common understanding that someone, somewhere, is capable of knowing a secret for it to have any veracity. And, of course, the world of the secret is not a world of what is, but of what might be. It has an edge: those who have access to secrets may be privy to ambiguous, potentially dangerous knowledge. Those who are not in on particular secrets are forever querulous, unsure whether what they do not know is significant (and in many cases those who have subsequently discovered secrets and have disclosed the experience declare them to be banal) or whether knowing something might make life's burden more tolerable and its course less fraught with unknown hazards.

Seeing hidden things, of course, is not a matter of applying common visual acuity. In one of the contributions to Nooter's volume Allen Roberts says of secrecy among the Tabwa in the south-east of the Democratic Republic of Congo: 'The concept of secrecy travels though language and myth, is represented in visual arts, dramatized in ritual, and made instrumental in magic.'[19] His point is a more general one. The link between secrecy and magical or ritual authority is primary. And the issue is frequently articulated around the question of 'seeing' or 'not seeing'. One of the Tabwa linguistic formulations to refer to the extended vision that those practised in the arts of magic have available to them is to say they have 'eyes'.[20] They are able to see into blackness and there locate the essence of things. In Gabon the Punu talk of diviners having *sadji*, a 'third eye', which enables them to look into the domain of spirits and ancestors.[21] Many societies employ divination techniques that explore the internal organs of animals. Their dissection and the discovery of the condition of the otherwise unseen interior of the animal or fowl allow the diviner to see truths deposited there. Thus, among the Sukuma of Tanzania, the presence of ancestral wisdom is indicated by the discovery of a small red, bloodied mark that should be

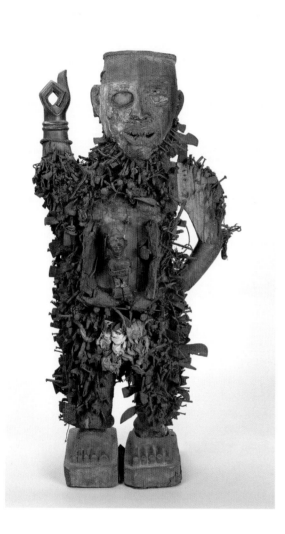 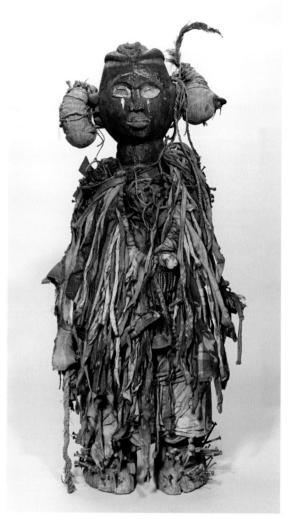

present near the spleen of a dissected chicken. If it is there, it is described as a 'canoe seat' (*nhebe*) or an 'eye' (*liso*) and authenticates any associated oracular statements. If it is not present, the chicken will be dispensed with as an element in the armoury of the diviner for 'it has no eyes' (*iti na miso*).[22]

Another example, for which there is a wealth of ethnographic and indigenous commentary, makes the point most strongly. In Kongo practice in the area of medicine, magic, witchcraft and oath-taking, and in the associated objects, an emphasis on the eyes is characteristic. The operators of these objects (*nganga*) are often pictured with white lines round their eyes, and the tools of their trade are *minkisi* figures (mentioned earlier). These figures are empowered by the addition of medicines and

Two nailed figures (*minkisi*). Kongo, Democratic Republic of Congo, early 20th century. The eyes are highlighted emphasizing enhanced sightedness. The figure on the left has lost the mirror that would have covered the stomach, revealing a small hidden figure. H. (left) 135 cm, (right) 86 cm

encrusted with nails and blades by which their powers are activated. They also have whitened eyes, sometimes painted, sometimes accented with inserted glass or ceramics. The whitening material is white kaolin clay or chalk (*mpenba*), which also refers to a graveyard and to the world of the dead. It recalls the pale skin of the deceased. This is an other-worldly figure, whose effect is described in terms of the impact on the viewer and supplicant or client: the face is not carved in an aggressive pose – indeed, it is, if anything, serenely unexpressive – but the eyes are said to be 'naked' and 'frightening'.[23] MacGaffey notes that the appropriate term to describe its spectacular appearance is *kimbula*, a verb that suggests 'to create a frightening effect'.[24] The mirrors set in the belly of many *minkisi* act as a kind of divinatory device and are likewise thought of as eyes – 'figurines have mirrors on them', says one indigenous commentator, 'in order to tell who is a witch; they are eyes for seeing.'[25]

Eyes are also an element in the explanation of another form of empowered Kongo object, the double-headed dog (*kozo*) in Janus form with its body covered in nails and a medicine pack on its back. They look both ways at once, towards the world of the living and towards the world of the dead. Indeed, as domesticated animals, they are capable of inhabiting both worlds at once: they are at home in the villages occupied by the living and yet have the facility to find their way in the forests that are

Wood double-headed dog (*kozo*) with nails, blades and 'magical' substances. Kongo, Democratic Republic of Congo, late 19th century.

The form of this dog-figure illustrates well the enhanced sight of magical figures and their operators. This sculpted example is furnished with eyes facing in two directions, one pair oriented towards the world of the living, and the other towards the world of the spirits. The nails driven into the object indicate the number of occasions when its perceptiveness has been invoked.
L. 61 cm

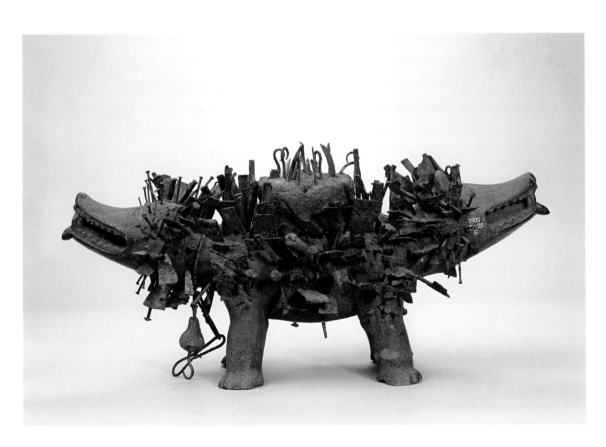

otherwise the domain of the spirits. The emphasis is not, however, on their ability to follow scents by smell but rather on their exceptional sightedness. They are described as having four eyes, two for the world they share with humans and two for the world of the dead and of spirits. The association of astonishing visual capacity with hunting, and of hunting with seeking out the sources of illness and disorder is a common theme. Nets are also a familiar element in the *nganga's* assemblage of materials.

Attention to the eyes is only part of the imposing presence that the *nganga* has in common with his empowered object. It contributes to a total engagement that does not stop short of confronting aspects of the terrifying, supernatural world. However, attention to the eyes, and to seeing in its two senses as we have it in English – observation and clairvoyance, sight and insight – is also part of Kongo understanding. The *nganga* and the *nkisi* share the facility to see the otherwise unseen, the hidden sources of illness and evil-doing. The emphasis on the eyes establishes that they can see things, both physically and intellectually, that ordinary people cannot.

Ordinary people are, by comparison, referred to as 'empty'.[26] They may lack the capacity for visionary insight, but that does not mean that they cannot be 'filled' by unwanted and uninvited forces, for the body is also a potential site for spirits. This is the reason, according to some sources, for the fact that much African sculpture is distinctive in representing the head in a larger format than the rest of the body. This often remarked feature has been attributed to a conception of the head in some African cultures as able to host not just one but a multiplicity of persons, as for example among some Yoruba in Nigeria. Otherwise, it is largely in the contexts of illness and healing that the potential of the body to receive multiple occupants is found.

This can be witnessed in part when the body responds in violent, often uncontrolled ways to unseen possession. In examples I have seen in southern Madagascar, the possessed may be catapulted to the ground by the arrival of a possessing spirit (*tromba*), where they may writhe uncontrollably, but with no apparent sense of the pain that these physical actions would otherwise have induced. The scene also has an oral aspect, as the possessed gabble inarticulately in a way that needs to be interpreted by a helper. Bodily responses of a similar kind elsewhere include the hand trembling of the *ndishniih*, North American Navajo who specialize in diagnosing illness. The diagnostician sits opposite the patient and with arms outstretched closes his eyes and enters a trance state. He reportedly visualizes a series of causes of the illness. When he arrives at the correct analysis, his hands and arms begin to shake and he is able to both identify the illness and indicate the necessary healing ceremony. Thus, like a hospital consultant, he sets up the whole structure of treatment appropriate to deal with particular cases.[27] An interesting variation on this consists of cases where the entry and departure of the spirit may be indicated by other activity around the boundaries of the event. Another North American phenomenon is tent shaking, which is part of a well-described ceremony performed by a Chippewa shaman, John King. In this instance, the structure within which the consultation is taking place shakes when the spirit passes through it.[28] Thus the tent is acting as the body does

in other spirit-related ceremonies elsewhere. Sometimes it is not the healer but the afflicted whose body is seen to be the site of spirit occupancy, and its uncontrolled reactions are not just symptoms of unwelcome possession but movements and responses that convey information about the nature of any ailment.

In this book the aim is not to describe altered states of consciousness or the nature of visionary experience but to focus on the way these phenomena are conceptualized. The body, like the divination trays or bags of implements discussed above, is conceived as an arena of cosmic interactions. Indeed, where the affliction manifests itself in corporeal terms, it is not surprising that the body should be regarded as a haven not just of microbes but of microcosms. At such moments, the body actualizes the fact of it containing a world within itself. It manifests all the wider forces and powers that influence its condition, drawing them together during possession or healing ceremonies so that the body becomes a totality. Much is made in the discussion of divination of restoring the body to 'wholeness', but in spirit possession and healing it is almost as if the body is bursting at the seams. It contains more intrusive energies than it can cope with. These are often seen as arriving and departing, and so it shakes and becomes uncontrollable. The body as microcosm is in this context an unstable thing: there is too much going in within its confines, at least until a cure is effected. In the throes of affliction the body is in the ultimate paradoxical state of sentient beings: it is both the method by which knowledge and truth are determined, while at the same time being the object of that knowing.[29] In the next chapter we turn to consider the body itself in more detail.

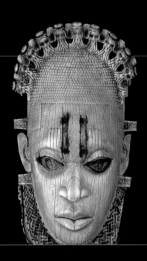

5. Small Bodies

One of the most renowned pieces of Oceanic sculpture is a representation of the ancestor-deity A'a from Rurutu in the Austral Islands. It was the subject of a William Empson poem,[1] and Henry Moore had a cast made of it, which he kept in later years on display in his house at Perry Green, Much Hadham, in Berkshire.[2] The figure is distinctive in having the main features of the body – eyes, nose, mouth, ears, torso and even knee caps – composed from a series of other little human figures carved in high relief. Some Cook Islands carvings similarly have smaller figures carved on larger ones,[3] and there are other objects where more abstracted, repeated relief imagery may also have the same intent.[4]

In terms of the internal scale of the sculptures, clearly the little figures are to be seen as miniatures of the larger ones, and it is generally accepted that the bigger figure represents a creator deity who is the progenitor of particular genealogies embodied by the miniature figures,[5] or, to follow Gell,[6] that a singular divinity is represented as an assemblage of diminutive divinities.[7] In the preceding chapters we have been looking at the construction of different kinds of contained worlds as microcosms and introduced the common cultural concept of the body as a theatre of wider mystical agency. Here we develop this observation, examining other ways in which the body has been considered microcosmic. In the second half of the chapter we move to look at bodies that are themselves small, to children and the construction of childhood.

The body as microcosm

A'a is a compelling image with which to start as it possesses a resonance that goes well beyond the Pacific Ocean. The most interesting aspect is that the 'features' of the larger figure are picked out by the miniature figures, which are much more than a merely decorative device. Without the addition of the miniature figures the progenitor deity would be inchoate, without detailed form. But in practice each of the little figures is a replication in miniature of the ancestor-deity itself.

Opposite
Ivory pectoral mask with a tiara of miniature heads of Portuguese soldiers at the top. Benin, Nigeria, 16th century.
See p. 134.

There is, in fact, a close correspondence between the underlying idea that is assumed to inform such images and western ideas of the body as microcosm, a concept with a tenacious genealogy of its own, beginning in Greek philosophy and continuing through the Middle Ages and into the Renaissance. Thus Plato in the *Timaeus* expounds the doctrine of likeness as a principle of creation. He dismisses the idea that in creating the cosmos as the likeness of a living creature, the creator would have chosen to replicate something at the level of a species, for a species is only a part of a greater entity and must therefore be an incomplete model. Instead, he suggests:

> *Let us rather say that the world is like, above all things, to that Living Creature of which all other living creatures, severally and in their families, are parts. For that embraces and contains within itself all the intelligible living creatures, just as this world contains ourselves and all other creatures that have been formed as things visible. For the god, wishing to make this world most nearly like that intelligible thing which is best and in every way complete, fashioned it as a single visible living creature, containing within itself all living things whose nature is of the same order.*[8]

That being so, it is clearly not just that the human body itself reproduces the cosmos but it opens up the possibility that the body is a container of other miniature versions of itself in a series of infinite regressions, where, like nested Russian dolls (*matryoshka*), the body, the cosmos, is reproduced in ever smaller form.

We know little about the background beliefs that informed the sculptural conception of A'a, but it could be, and has been, readily interpreted in just such terms. The missionary account of the acquisition of the object suggests that a party of Rurutan converts gave it up among a group of other 'idols'. John Williams describes how the objects were taken to the chapel and displayed on the pulpit:

> *One in particular … excited considerable interest; for, in addition to his being bedecked with little gods outside, a door was discovered at his back, on opening which, he was found to be full of small gods; and no less than twenty four were taken out, one after another, and exhibited to public view.*[9]

A recent source (the ethnographer Alain Babadzan)[10] recounts a contemporary evangelized Rurutan interpretation that explicitly links A'a and its miniature internal gods to Christian belief and, coincidentally, to the present location of the sculpture in the British Museum in London. There were, it is held, three god figures originally created to be kept in the compartment by Amaiterai, a locally recognized hero. Amaiterai himself visited London in fulfilment of an obligation that would win him the hand of the adopted daughter of the king of Ruruta. In London Amaiterai encountered the god of wisdom, identified with the Christian God, knowledge of whose ways were eventually vouchsafed to Rurutans with the arrival of missionaries. The three minia-

Wood figure of the creator god A'a and details of the miniature figures. Rurutu, Austral Islands, late 18th or early 19th century. The leading characteristic of this figure is the thirty smaller figures that form its facial and bodily features. It is also furnished with a hollow body accessed by a removable panel at the back (top right), in which, by report, a further twenty-four smaller figures were once housed. It seems likely that these aspects conform with its status as a progenitorial representation. H. 117 cm

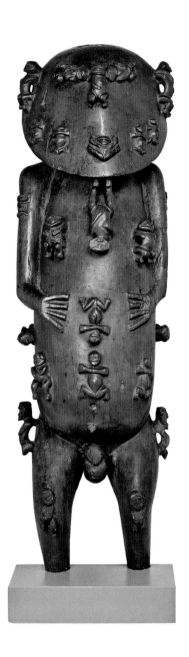

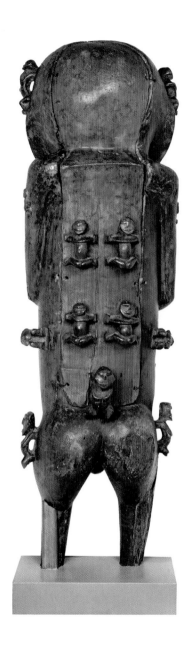

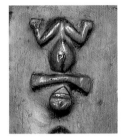

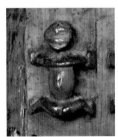

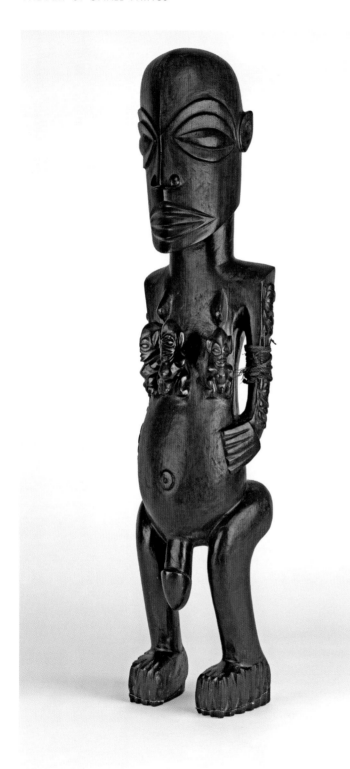

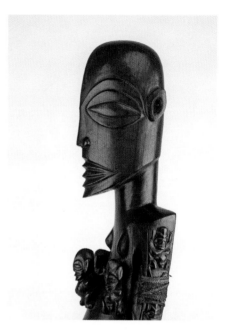

Standing wood figure and details. Rarotonga, Cook Islands, late 18th or early 19th century. Although the documentation of this piece is less secure than the figure of A'a, a similar practice of incorporating smaller figures on larger ones is common to both, in this case three figures in high relief on the chest. A similar significance is suggested.
H. 69.8 cm

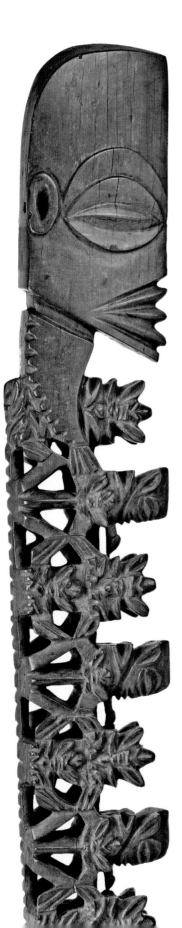

ture figures that Amaiterai placed inside A'a were thus interpreted as his version of God the Father, God the Son and God the Holy Spirit, an indigenous version of the Trinity, and an instance of syncretism that at once links A'a's transfer to the British Museum with the arrival of Christianity in the Austral Islands.

Of course, just as the conception of A'a can be rendered in Christian terms, so the Greek concept of the body as a miniature replication of the cosmos was elided with an explicitly Christian format as it was developed in medieval and Renaissance thought. As a microcosm the body comes to be an expression of both man's vastness and his limitations. It can be conceived, therefore, as simultaneously an expression of the unity of all created things and of their diversity. The body is the cosmos in small, and yet it is also one of the created things within the cosmos, a metaphor redolent of theological significance: it is *of* God at the same time as it is created *by* God.[11] What was expressed in theological terms also informed visual representations. We have seen how medieval maps were conceived as cosmograms with a series of concentric circles defining their outer

Wood staff god and detail. Rarotonga, Cook Islands, late 18th or early 19th century.
In this example, which has been broken at some point in the past, the four small figures are explicitly male and may refer to individual generations within a lineage deriving from a single distant ancestor.
L. 111 cm

Wood staff god.
(detail)

129

circumference, each attributed a particular sphere of significance, whether winds, months of the year, or signs of the zodiac. The circle in such images came to stand for cosmic completeness. Man as microcosm was also conceived in such diagrammatic terms: there is a coincidence in thinking about the physical universe and about the human body. Hildegard of Bingen offers one of the most completely worked out schemes. The overlaps are explicit in the analogies that she attributes to the different parts of the body. Thus she associates the brain with Saturn, Jupiter and Mars, the planets that occupy the sphere of fire. The eyes are connected to the sun and the moon in the zone of ether. The heavier parts of air are incongruously linked to the teeth. The breast is the seat of those areas of the atmosphere that are held to nourish animal life, while the belly is associated with the earth whose rocks are like the ribs of the torso. The arms and legs are linked with the wind and with water. Although the division of the body into parts suggests differences between the functioning of the human organs, the series of analogues with which each section is associated situates the body within a wider concept of cosmic unity.

More graphically, Hildegard employs a well-known image of the square within a circle to visualize the body as microcosm. The image of man with fully outstretched arms and legs creates a circle touched at four equidistant points by the extremities of

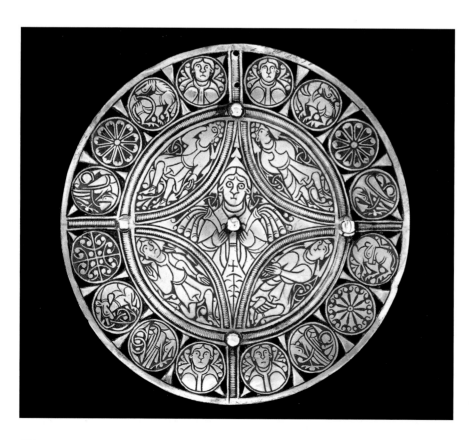

Opposite

Engraving and etching on vellum by Natale Bonifacio after Andrea Bacci with Michaelangelo Gidetti. Italian, 1580. British Library.
This schema represents an early attempt to render in synoptic form the principles on which man, at the centre of the chart, is seen as microcosm in relation to the universe, at top right, as macrocosm. All is placed under the providential eye of God at top centre. It seems that Bacci, a professor of botany, devised the form of the exploded diagram as an instructional device by which to impart his version of the Renaissance perception of man's place in the natural and cosmological order, a conception that goes far beyond the contemporary idea of 'nature'.
H. 63.1, W. 41.6 cm

Silver brooch. Anglo-Saxon. Late 9th century AD.
This brooch is made from hammered silver. Its central medallion is occupied by five figures which personify the five human senses. The central image is of 'sight', with its large staring eyes, which was regarded as the most important of the sense in medieval times. 'Taste' is identified with a figure which has its hand in its mouth, 'smell' stands amidst tall plants, 'touch' rubs its hand together, and 'hearing' cups its hand to its ear.
D. 11.4 cm.

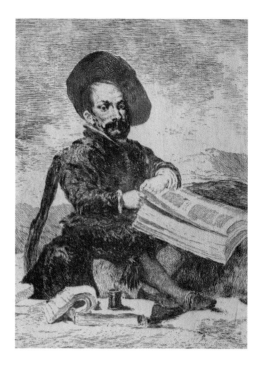

Above

Etching of a dwarf by Francisco de Goya after Diego Velázquez. Spanish, 1778.

Goya is at pains to portray the courtly dwarf as a cultivated man of letters.
H. 22 cm, W. 16 cm

Left

Silver figurine of Tutela (Fortuna). Roman, from Mâcon, southern France, 1st century AD.

This deity's overarching role in steering the course of people's lives or protecting particular cities is symbolized by the busts that surround her: Apollo and Diana in her left hand, Castor and Pollux on her wings and on the stand above them Saturn, Sol, Luna, Mars, Mercury, Jupiter and Venus representing the seven days of the week.
H. 14 cm

the body. If these points are connected by straight lines, they describe a square. This geometry refers both to the human body and to Christ. The image of the square diverges from the familiar representation of the crucifixion, which is closer to the T-O *rotae* imagery (see pp. 98–100). The reference, however, is a more metaphysical one, which conceives of Christ's body as reaching to the four corners of the earth. The fact that the human body can describe at once a perfect circle and a perfect square affirms its prominence as a model of ideal proportion. If man is a proportional, reduced replication of the divine cosmological body, then its measurement has both practical and philosophical implications. To study and to describe man, whether in words or in visual terms, is to comprehend the cosmos. The Renaissance was a period where the human body was measured in all its aspects.

Shrunken heads

If A'a is a dominant figure because of all the miniature versions of himself that give him shape, another pervasive image in a number of cultures is of human figures portrayed with ornaments in the form of human heads. A good example is provided by the rare but famous ivory masks from Benin in Nigeria, which were worn as pectorals; the one in the British Museum has a tiara of smaller heads of Portuguese soldiers round the top. There has been some speculation that the ornamental display of representations of heads is derived from the presentation of the actual heads of sacrificial victims or of those taken from enemies. Such ornamental heads may be a metaphorical reference to the power of an individual over the lives of others, whereas actual heads are witness to the exercise of that power. In the context of the subject of this book it is worth noting that, apart from obvious practical reasons, a person may prefer to display ornamental heads at a reduced size, if only so that the relation of the scale of the ornamental head to the actual head of the wearer emphasizes the authority of the dominant figure. However, there is one documented example of the miniaturization and display of actual skulls.

The Jívaro (or Shuar, as they are alternatively known) live in the remote areas of the Andes in eastern Ecuador adjacent to Peru. They have acquired a certain notoriety. This comes from two sources. One is the fact that, having resisted Incan incursions into their territory, they were, by common consent, the only native Amerindian population to rise successfully against Spanish conquest and thereafter to hold at bay all attempts to

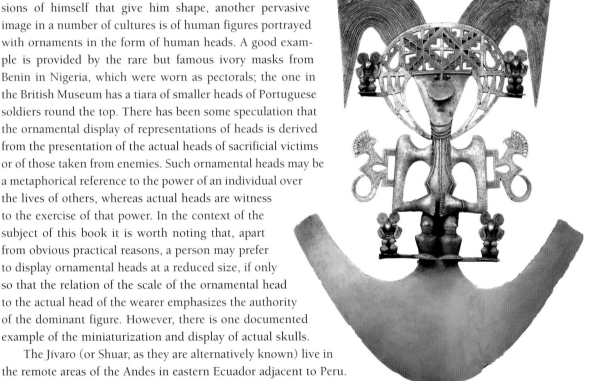

Cast gold pectoral. Popayan, Colombia, 1100–1600.
The figure shown here with an elaborate headdress incorporates in its construction a series of other smaller figures and, as worn on the chest, also implies the larger scale of the wearer.
H. 29.8 cm

133

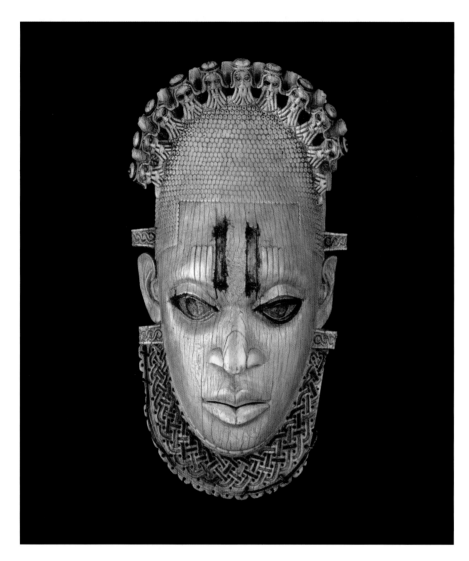

**Ivory pectoral mask.
Benin, Nigeria, 16th
century.**
The origins of this mask
are uncertain. It has been
authoritatively suggested
that it represents Idia, the
mother of the Oba (or
ruler) who was reigning
when the Portuguese
first made contact
with the kingdom. The
figures round the top
of the head are stylized
representations of
Portuguese soldiery,
which became a stock
image in Benin art from
that time.
H. 25 cm

reconquer them. This no doubt was partly due to their occupancy of inaccessible
areas of forested mountain terrain, although the lure of gold deposits fuelled colonial
ambition to explore and take over the region. A second reason for their fearsome rep-
utation is that they are the source of the 'shrunken head' trophies that, although
known to the original *conquistadores*, have since the nineteenth century found their
way into foreign hands – and thence to a number of museum collections. The Jívaro
disposed of shrunken heads to neighbouring mestizos once their ceremonial purpose
was accomplished. A lively trade developed in the hands of unscrupulous traders,
some of whom offered counterfeit versions manufactured from the heads of
unclaimed bodies taken from morgues in places as far away as Panama.[12] The

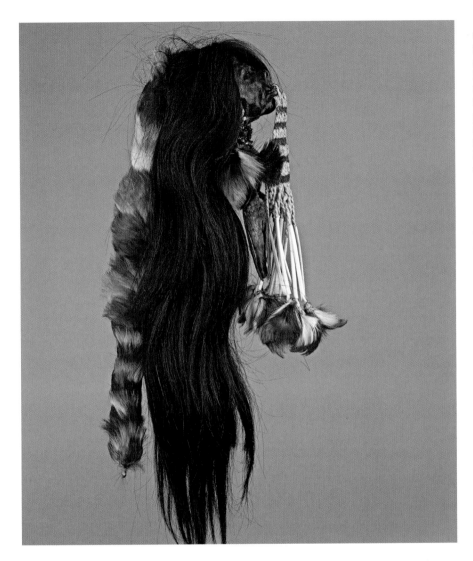

Shrunken head. Jívaro, Ecuador, 20th century. Among the Jívaro of Ecuador, the practice of taking heads was directed towards separating a person from their 'soul' (*arutam*). Accumulations of *arutam*, which could be acquired through dispossessing others and killing them, ensured a person's own longevity. Ideally, the victims were individual, identified men. When a killing expedition was being planned, an attempt was made to lure away the wandering soul of the intended quarry, as continuing possession of *arutam* was a guarantee of invincibility. Only when the raiders believed that the victim's soul had deserted him would they undertake an attack. Infusions of a hallucinogen were drunk and a signal drum was beaten, while the name of the prospective target was chanted to attract the soul. Once taken and treated, the shrunken head would be displayed, announcing the acquisition of an additional protective soul. L. (of skull and hair) 52 cm

presumed scale of the activity of taking heads thereby appeared greater and more profligate of human life that in reality it was.

Shrunken heads are known to the Jívaro as *tsantsa*. *Tsantsa* are typically reduced to a size little bigger than a fist. The hair and eyelids, however, retain their original length. The hair is usually black, glossy and healthy and in length up to four times the dimension of the face, giving an internal scale by which the smallness of the face is emphasized. The mouth is often sewn up with long cotton cordage. They may, additionally, be extensively decorated with colourful toucan feathers and the wings of iridescent beetles. Yet it is debatable whether, for the Jívaro, shrinkage alone is the primary point. There is evidence that taking the heads of enemies, preserving and

decorating them was once a more widespread Amerindian practice. In most cases the emphasis was on the preservation of the skull rather than the skin and hair, notably in central Brazil. Imagery on ancient textiles from Peru appears to show shamans holding trophy human heads. Arguably, therefore, shrinking the heads of decapitated enemies is as much a technology of preservation as a technique of miniaturization.

Jívaros' own ideas are difficult to characterize. Fortunately, though, we have one comprehensive ethnography (by Michael Harner) on which to draw, the research for which was undertaken while some Jívaro groups were still managing to maintain a fierce historical sense of their own independence.[13] Harner, writing in the 1970s, portrayed Jívaro understanding of human vitality as an attempt to balance positive and negative influences. The central idea was that of the 'soul', and especially of the *arutam wakaní*, the soul that produced a vision. Harner translates the term as 'ancient spectre'.[14] An *arutam* only appeared to humans for a brief moment, but, once created, it was in existence for eternity. Possession of such *arutam* souls protected the individual from ever-present dangers: one *arutam* secured protection against death by violence, poisoning or sorcery but not contagious disease; two provided a defence against all potential causes of death. However, a person did not have such a soul as a natural inheritance: the ordinary 'soul' that a person was born with (*nekás wakaní*) was present in blood (and bleeding thus diminished the reserve of such soul essence), but it was a passive presence. The way in which the *arutam* soul was acquired was through a momentary vision, a glimpse into the real world of the supernatural that contrasted with the falsity of the ordinary lives that people led. Such visions may have occurred through a vision quest conducted in the depths of the forest and involving a process of fasting and drinking tobacco water. If that did not work, the person might resort to the use of local hallucinatory substances. The process was completed when a dream came in the form of a Jívaro ancestral spirit, which, having announced itself, departed leaving the *arutam* soul lodged in the sleeper's chest.

The acquiring of such a soul is described as having produced an immediate, surging sense of well-being and self-confidence. That, however, was not the end of it. The protection afforded by soul possession might be refurbished and enhanced by acquiring further souls, and this was achieved by killing an enemy. Indeed, this was essential, for while the *arutam* was present when the person was awake, it tended after a period to drift off into the forests at night; and when on the loose in that way, it might be stolen by other Jívaro and desert its initial possessor. The victim should always be from a foreign group rather than the focus of some local vendetta, and ideally an identified man singled out in advance. Once the victim was killed, his head was removed and its preparation began as the raiders retreated homewards. The skin was removed from the head, and and the skull discarded in a river. The skin was next boiled, reduced in dimension, dried, scraped and then sewn up. Importantly, as we shall see, the lips were also sewn up securely. Heated sand was then placed inside the skin head, warm stones added and rolled around, and the skin massaged and finally blackened

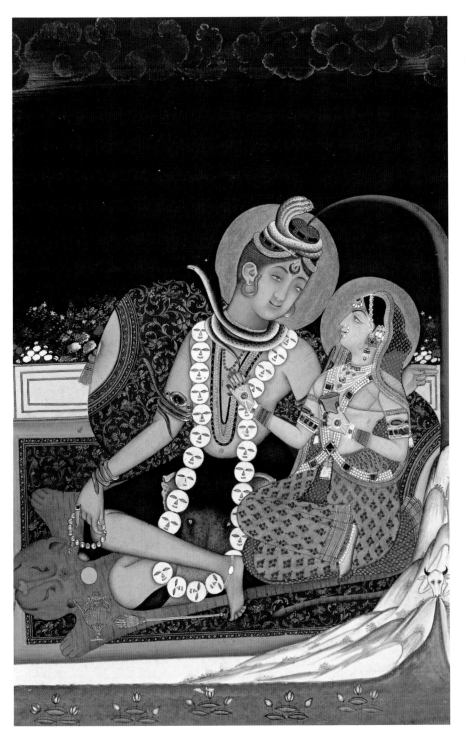

Painting of the god Shiva seated with the goddess Parvati. Indian, c.1800.
Shiva is shown here in his ascendancy, his power over human life demonstrated by the garland of skulls round his neck (and over animal life represented by the flayed skin of an elephant round his waist and by his ease with the reptiles round his neck and the crown of his head). His own authority is emphasized by his size compared to that of his consort.
H. 31.5 cm, W. 22 cm

by repeated rubbing with charcoal. By the time the raiding party returned, the skin head was largely prepared.

There then began a cycle of ceremonies. The notion that *tsantsa* are 'trophies' suggests that the purpose of this round of ritual was celebratory: an enemy had been diminished, and here was the shrunken relic. But the ethnography suggests that, at least to start with, it was otherwise. The taking of a head not only opened up the possibility of obtaining accumulated souls to secure the enhanced vitality of the head-taker, it also triggered a possibility of retribution. At the moment when someone who has possessed *arutam* dies, another kind of soul, a *muisak*, is released. *Muisak* is described as an 'avenging soul'.[15] When someone died by violence, it escaped through the mouth, and its sole purpose was to seek revenge. Thus, although the killer was empowered by his act, at the same time both he and his immediate family were subject to particular threats. The taking of the head, its subsequent physical treatment and ceremonial reception were directed towards containing this supernatural danger.

Aspects of the preparation of the *tsantsa* were directly designed to meet this challenge. Sewing up the mouth at an early stage of the process was intended to close in the *muisak*, and blackening the skin prevented the avenging soul from seeing its prey. Furthermore, once contained, the energy inherent in the avenging soul could be turned to advantage: like nuclear power, it was a vital source of energy when properly contained and channelled, but when it was released into the environment uncontrolled, its potential for destruction was immense. There were three ceremonies over a period of a year or more at which the *tsantsa* were used. During the last of these the head was finally decorated with new strings securing the mouth. In the course of the ceremony the head-taker held the shrunken remains of the victim above his head, and two female relatives, who otherwise, as women, do not generally have access to supernatural sources of power and vitality, held onto him. By these means the energy emitted by the *muisak* was transferred through the head-taker to the women. They were as a result thought to participate in the surge of power that came from the possession of 'soul', and their consequent ability to work hard was seen as a benefit to their agricultural output.

Each of the ceremonies was on an escalating scale of hospitality with large numbers of people supplied with food and drink over a number of days. If skirmishing and fighting should break out through intoxication, the ceremony was immediately stopped, as such signs of moral disorder might release the avenging soul otherwise contained and at bay. However, through the process of the ritual cycle the emphasis gradually shifted from the vengeful power contained by the *tsantsa* to their ceremonial attributes. A man would wear one dangling on his chest (where the positive *arutam* a person had acquired was also held to reside) and thereafter he might appear at other people's ceremonies wearing it more or less as a decorative pendant. He might decide to trade or sell it, but, if not, he would expect it to be buried with him when he died.

Woodcut of *The Suffolk Wonder*. British, 1755.

In Europe the fascination with dwarfism sometimes spilled over into showmanship, as in the 18th- and 19th-century displays of dwarves, often alongside giants, and the continuing tradition of circus dwarves. However, dwarves were also notable and respected figures at royal courts. The King of Benin in Nigeria is shown in a 17th-century print parading with leopards on chains and accompanied by court dwarves. In 1710 Peter the Great of Russia arranged a major wedding ceremony for the marriage of two court dwarves and even offered up the royal bedchamber to the newly-weds for their wedding night nuptials. In England the dwarf Jeffrey Hudson was a significant member of the Stuart court and a favourite of Queen Henrietta Maria, one of whose portraits by Van Dyck includes him. There is a strong sense that Jeffrey Hudson was regarded as a member of the extended royal family: he had his own servants and was credited with high intellectual achievement; he was even entrusted with a number of diplomatic missions on behalf of the crown requiring delicacy and judgement.

A lot of the fascination for people of small stature has focused on their ability to live exactly as others do and to realize similar ambitions. This image shows Christopher Bullock, 'three feet and six inches' in height yet 'no less than seven feet round his body', the so-called 'Suffolk Wonder' from Bottesdale. The accompanying text, however, points out that he is able to maintain his family and is a respected member of his community. His trade is that of a watch- and clock-maker, itself one of the professions requiring a concentrated and intense attention to the miniature. The text ends with a note of local market days and distances from London along the road to the East Anglian seaport of Yarmouth.

Child marriage

So far we have been discussing reduced representations of the body, specifically the head, which appears miniaturized when seen in relation to the scale of a human displaying it. In the following sections we turn to consider bodies that are naturally small. John Earle (1601–65), who was later Bishop of Salisbury, wrote in his *Microcosmographie* (1628): 'A child is a man in a small Letter … We laugh at his foolish sports, but his game is our earnest; and his drums, rattles and hobby-horses, but the Emblems and mocking of man's business.' He anticipates Wordsworth's famous observation that 'the Child is father of the Man'. Both seek to explore the reflexive relationship that exists between the world of adults and the world of children, and not always to the advantage of the adults. This image of the child as an adult 'in a small letter' is one that has been exploited in many different cultural contexts, not just in literary and metaphoric ways.

Among the Inca in the Andes, for instancer, early Spanish reports coincide with archaeological finds to substantiate a double exploration of the world of the child and

of the miniature. One involves children apparently represented explicitly as miniature adults; the other is a related tradition of creating miniature figurines in gold, silver and shell. The focus is the Inca *capac hucha* ritual festival. The term itself translates as 'royal obligation', to follow the insightful account on which the discussion here is based.[16] The festival took place periodically at the behest of the Inca priesthood. One or two children, both boys and girls aged between six and ten, were selected from each village within Tahuantinsuyu, the Inca 'empire of the four quarters' in what is now parts of Ecuador, Peru, Bolivia, Chile and north-western Argentina. The children should be the sons and daughters of local chiefs, of evident physical beauty and in good health, consistent with the ideals of innocence and perfection. They set out for Cusco, the Inca capital in modern-day Peru, from all corners of the empire following the royal Inca roads and accompanied by priests and elders from their home village. Once they had arrived, the children assembled in the central square containing the monuments dedicated to the Creator God, the Sun, the Thunder, and the Moon. There they were presented to the Inca king and his priesthood, and were received with great ceremony. The children were then paired off, often in accordance with genealogical and territorial considerations, and symbolically 'married' in a ceremony that duplicated adult marriage practice. This implies that they were no longer to be regarded simply as children but had become small adults – with a particular, fateful destiny. The child couples would be given gifts of the household goods appropriate to married status. They then processed twice round a site within the inner precincts of Cusco identified by tradition as constituting the centre of the Inca world. With these ritual elements complete and the children departing, the priesthood were instructed to prepare offerings and sacrifices to be presented at all the *huacas*, sacred places identified at significant points in the landscape throughout the extended empire.

The return to the children's home village was achieved by a different route. It is recorded that they would process in a broadly straight line regardless of the intervening, almost certainly mountainous, terrain and that their entourage would walk in single file while one of the priests offered a religious chant taken up by the others in honour of the deity. Within the file the children either walked or were carried together with the objects and offerings presented to them. These are described in a sixteenth-century Spanish source:

> The girls carried precious offerings and small vessels full of chicha (a maize-based beer), a bag of coca leaves, and toasted and cooked maize in the pots and jars, all made of gold and silver, and the boys carried (similar offerings) according to the rank they held in their houses.[17]

For those originating from the more far-flung parts of the empire the return journey could be a very arduous one of well over a thousand kilometres.

Arrival at the home village was a joyful occasion. However, following the celebrations the children were first intoxicated with the maize beer and then entombed

still alive in a specially constructed grave surrounded by offerings. They would be ritually fed liquids, though deceased, for five days through a tube. This final resting place was located at a significant point on the landscape, where subsequent excavation has revealed the variety and richness of the burials. It is not completely clear whether the children who were 'married' were also buried together. Some sources seem to imply that they were, although the overwhelming evidence from archaeological finds indicates that single burials were by far the most common. This suggests that it is the symbolic act of marriage, the alliances affirmed thereby and the admission to the category of the adult – and especially that of married status – that are important, rather than the forging of any new social bond that is carried to the grave.

The grave goods that have been discovered in association with child burials have been spectacular. They have been recovered from sites at the tops of some of the highest peaks in the Andes, from the Island of the Sun in Lake Titicaca and even from a deep gulley on a small island off the coast of Ecuador at the very northern extremities of Inca influence. This last was in a less viable state of preservation, but sufficient to show the richness of the grave goods originally deposited there with the infant sacrifice. Even at the highest point in the western hemisphere, near the peak of Mount Aconcagua in Argentina at about 7,000 metres, a perfectly preserved boy was found wearing distinctive Andean clothing and wrapped in embroidered blankets with an outer textile covered in yellow parrot feathers. It is worth quoting from the report of the objects associated with the burial even at this geographical extremity and its description of the Inca figurines recovered:

> *Three were male human figures: one of gold (formed by hammering and soldering sheet metal), one of solid silver-copper alloy, and one of* Spondylus *(conch) shell ... Averaging about two inches high, all the human figures were clothed, had plumed crests, and carried little bags containing fragments of coca leaves ... the other three statuettes, one of gold and two of* Spondylus *shell, were stylized llamas, coloured red on one side and white on the other.*[18]

The primary occasion at which the *capac hucha* festival took place was at the death of a king. There is evidence that the ritual as performed at state levels also took place at a local village level. However, the occasions on which it was carried out appear to have included not just the death of kings and the accession to the throne of a successor but – with less pomp and ceremony – the beginning and end of the annual agricultural cycle. In either case the sacrifice of children is associated with the initiation of a new temporal order, whether an imperial reign or an annual cycle of activity. And the fact that it was celebrated at all the sacred points on the Inca imperial landscape suggests that they felt a need to placate the earth itself.

McEwan and van de Guchte canvas a number of interpretations of this ritual cycle and its culmination in child sacrifice. Of particular importance here is the fact

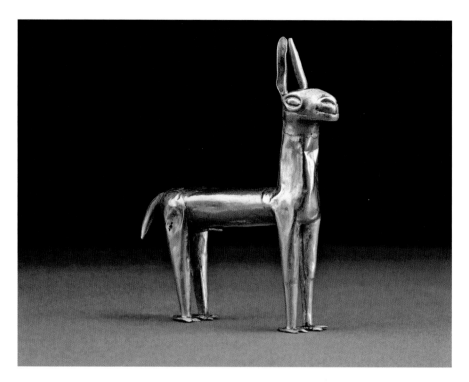

Hammered gold llama. Inca, Peru, 1400–1500. Although a miniature object, this image has been created by hammering out thirteen separate pieces of thin sheet metal. It was found in a funerary context and seems to have been created explicitly for interment at a sacred site. H. 6.5 cm

that the children are miniature adults, socially acknowledged as such through their imitation marriage, and they are subsequently arraigned with the trappings of married people. The children are in an idealized condition, at once selected for their beauty and their unblemished physique. At the same time their age attests to their purity of experience. The ritual condition of the children is akin to that of Inca women who had chosen to dedicate themselves to the cults associated with the Sun, the Moon and the sacred places, and whose houses, the *acllahuasi*, were thought of as 'convents' by the Spanish when they encountered the institution.[19] They are accompanied to their graves by offerings and gifts, which were again on a miniature scale, hammered and cut from sheets or cast in precious metals associated with imperial power and with divinity. The reduction in size – from adults to miniature adults in the form of unblemished children, and to gold and silver figurines – represents an accretion of cosmological significance.

The fact that the figurines were all made from gold, silver or copper alloys, or they were carved from shells harvested from the sea, establishes a linkage with elemental materials gathered from the earth and from water. One Inca emperor is reported as referring to the Pacific Ocean as *Mamacocha*, 'mother of the lakes', a parallel to the term *Pachamama*, 'mother of the earth'; and one of the local terms for a vein of metal is *mama* – as in many other languages, a respectful and affectionate term for a woman or mother.[20] Thus, the materials of which the figurines are made were them-

Miniature textile and cord with silver pins. Inca, Peru, c.1500.
This small textile replicates the type of cloth worn by Inca women, and the cord the means by which it was attached around the shoulders. Considerable care has been taken to reproduce in miniature the details of actual clothing. The textiles were used to clad small figurines and have been found at mountain-top shrines in Peru, Chile and Argentina.
L. (cord) 23 cm;
H. (textile) 8.1 cm,
W. 14.6 cm

selves excavated and harvested from the earth and the waters, and returned to them in votive contexts. Furthermore, there is also at least a suggestion in the ethnographic and archaeological detail of an emergent identity between the figurines and the sacrificial children.

Dransart notes that, in distinction to the implications of some of the second-hand accounts, the burials are either of single children or in other sites of single-sex individuals, and the figurines that are placed with them seem to be consistent with the fact that male figurines are associated with male burials and female figurines with female ones.[21] The level of detailing of figurines that have been recovered in good condition, largely those from the highest peaks where the permafrost has contributed to their preservation, is remarkable. They are clothed in every respect like real miniature people. They show evidence of considerable effort and skill to reproduce the patterning and colour of contemporaneous Inca costume, sufficient that differences in regional clothing practice are manifest in their attire, and gender is always clearly indicated by the observance of the detailed differences between male and female styles. Care has been taken to replicate methods of folding and attachment with miniature silver pins and appropriate bands securing the clothing. Caps and feathers are reproduced with attention to authenticity; and male figures sometimes have shoulder straps with bags attached, one containing (in the quotation above) the same coca leaves that the 'married' children are reported as carrying back with them on

their final journey from Cusco. We can but speculate that the figurines are themselves seen as the sons or daughters of the elemental divinities from whose materials they have been created. They appear to be placed there to assert a relationship between the earth in which the sacrifice occurs and the miniature adults who are the subject of the burial. As the mock marriage serves to reclassify the children in a social context, so the joint placement of the miniature adults and the miniature sculptures in the grave serves to redefine the children in a cosmological context.

This coheres with a wider Inca practice of representing the ideal invisible world through miniaturization, which we also encountered in the last chapter. The location of the golden miniaturized 'garden' within the sacred precincts of the Temple of the Sun at Cusco identifies the miniature as the closest approach to the otherwise unsee-able world of ideal existence, the ancestral world. Indeed, the same phenomenon has been observed and interpreted in this manner more widely within Pre-Columbian Andean communities. For the Eastern Cordillera region of Colombia, a similar argu-ment has been advanced that assemblages of miniature votive offerings are intended to replicate aspects of the real world, which are then manipulated to achieve symbol-ically prescribed ends.[22] The *huacas* were points of access to these unseen worlds, entry to which through sacrifice was not a matter of finality, but opened out new pos-sibilities in the world beyond. The 'victims' went to their reward richly attired, feted and chanting in fulsome praise of the king. The evidence is that they did not, in Inca perception, lose their lives. Their fate was to set the world to rights, to institute a new cycle or order, and to move on to join the ancestors at appropriate points in the sacred landscape. They were survivors. Their sacrifice was not a closure or a shrink-age of the human world to the miniature – and ultimately to disposal through burial in remote out-of-the-way places. Rather smallness was a visualization that was as close to the efficacious world of the unseen as could be attained. The world of small was not among the least but among the most significant of created things. Through the sacrifice of children, new worlds and renewed possibilities were opened up to the deceased and the living alike.

Constructing childhood

There is a story told that during the French Revolution Richebourg, the last court midget in France, disguised himself as a baby and, in the arms of his presumed nurse, smuggled messages out of Paris under his baby's bonnet.[23] That the bonnet, in this context, should be an adequate disguise emphasizes that childhood has its own dis-tinctive material culture, and it is – we might say, 'by definition' – one of replication and of miniaturization. If a child is 'man in a small letter', the things of childhood are likewise those of imitation in reduced scale; and if 'the child is father of the man', it is still the man who makes the material things of childhood. Indeed, among the many interpretations and cultural constructions of miniaturization, one of the most

pervasive is the observation that the smaller something is, the more child-like it seems to be.

It is interesting that the most intense modern miniaturization projects often involve the reproduction in ever diminishing scale of cartoon characters or other images that imply or relate to childhood or children's books. Among the micro-miniaturists discussed above (see pp. 19–20), Sandaldjian has created a range of Disney characters, and Wigan has produced a ballerina dancing on a pin head, Goldilocks and the three bears carved from cocktail sticks, two fleas boxing, a flea riding a bicycle, and a horse standing on the head of an ant. It is as if the complete concentration on detail that the technique of production requires – the hours spent peering unblinkingly through the lens of a microscope, the breathing control needed to avoid making a slip – itself creates a reversion to the world of childhood. The objects, after all, are not necessarily created for children. A Ukrainian micro-miniaturist, Nikolai Syadristy, takes many months to make one of his tiny sculptures, and they are destined for museum collections. Clearly utility, manipulation by small hands and fingers, is not the point. The association of children's stories with the micro-miniature is expressive of the imaginative, analogical engagement between childhood or children and the world of the small, rather than an actual physical relationship.

Susan Stewart remarks that 'the invention of printing coincides with the invention of childhood'.[24] She is thinking of the modern western conception of childhood with its mix of the fantastical and the didactic, and the development of a literature specifically intended for children. However, despite the fact that an ability to see is not more intense in children than adults, the fact of scale seems nevertheless to have been exploited as if it were. Many of the earliest miniature books produced were written expressly for children, notably in Germany and the Netherlands. Indeed, in a sense the arrival of the miniature book served to introduce women and children to the realms of literature, which until then had been largely a male domain. In London Thomas Boreman published his coyly titled *Gigantick Histories* in the 1740s, covering the history of some of London's historic sites – the Guildhall, The Tower of London, St Paul's Cathedral and Westminster Abbey. The first volume contained a dedication to 'all the little masters and all the little misses who are in London town'.[25] The last in the ten-volume series, *The History of Cajanus, the Swedish Giant: From his Birth to the Present Time* (1742), was an apparent diversion from the main thrust of the volumes, except that it linked to the first one on the

Silver statuette of Harpocrates. Roman Britain, 1st or 2nd century AD.
This figure represents a Roman version of Horus, the Egyptian god of the sky, as a young boy under his Roman designation of Harpocrates. His finger points to his mouth and he is shown with the wings of Cupid.
H. 6.5 cm

Guildhall, which focused, inevitably in view of the intended readership, on the legends of the two London Giants, Gog and Magog, and their association with the Guildhall. The playful presentation of stories of Giants in books of minuscule dimension reached its zenith with the publication in 1802 by R. Snagg of London of his *Lilliputian Folio Editions*, which measured a mere ½ by 1⅛ inches (2.9 x 3.8 cm).[26]

Such books were often produced not as single editions but as parts of a developing collection of miniature books. One of the most prolific publishers of such material was John Marshall, a London printer and bookseller. He published his *Infant's Library* around 1800 and an illustrated *Infant's Cabinet of Various Objects* in 1801; he also published *The Child's Latin Library*, where even his illustrations were captioned in Latin. In about 1802 *The Infant's Cabinet of the Cries of London* was published in two volumes. The idea of such volumes as parts of libraries and of cabinets is further emphasized by their sale in miniature bookcases, such as those by John Harris produced in 1802 as part of his *Cabinet of Lilliput*, an edition of twelve instructional volumes with chapters on such topics as 'The Spoilt Children', 'The Utility of Commerce', 'The Advantages of Industry' and 'Indolence Reclaimed'.

These books may have been intended for the nursery, but their practical utility as books to be read and thumbed through is hardly sustainable. It is just as likely that many would have ended up as additions to a doll's house, where they would take their place beside many other replica items of domestic material culture. Thus, famously, Queen Mary had a magnificent doll's house built for her in the 1920s by one of the most distinguished architects of the twentieth century, Sir Edwin Lutyens, which also has drawers that pull out to reveal a garden designed by Gertrude Jekyll. It contains specially printed miniature books including *The ABC, or Alphabetical Railway Guide* (1929), an issue of *Bradshaw's General Railway and Steam Railway and Steam Navigation Guide* and what is thought to be the smallest Atlas ever produced, *Atlas of the British Empire*, produced by the royal cartographers Edward Sandford at a mere 1⅜ by 1⅜ inches (3.5 x 4.1 cm). Well-known authors also contributed many small volumes with text specially composed and written by hand. There are even miniature versions of newspapers and periodicals – both *The Times* and *The Times of India*, together with *Punch, Country Life* and *Tit-Bits*. Painters were sometimes invited to create works for inclusion in these houses that were every bit as delicate as the limnings of Elizabethan England. Petronella de la Court had her seventeenth-century Dutch doll's house painted by the artist Frederick de Moucheron, who covered the walls and ceiling of the salon with paintings and adorned the lying-in room with a set of small oval portraits.

The emphasis here is on authenticity, faithful reproduction. This was a theme in the production of doll's houses in the western world from the start. Duke Albrecht V of Bavaria is credited with commissioning the first recorded doll's house in 1557–8. But this was no plaything for the untrained and inexpert fingers of the nursery. His house was a scaled-down four-storey version of his actual royal residence, put together at enormous expense and using the talents of perhaps as many as fourteen

Woodcut of a doll's (or 'baby') house with printed text. German, 17th century.
The print is by Hans Köferll of Nuremberg and shows a doll's house that was made by Anna Köferll, who may well have been his wife. It is accompanied by a text from which we learn that Anna was childless but devoted a number of years to constructing this house, which when finished stood 9 ft (2.7 m) tall. Her intention was that it should be used in the instruction of boys and girls in the running of an orderly household. H. (house image) 30.2 cm, W. 27.2 cm

different crafts guilds. The grand rooms were adorned with gold-embroidered silks and satins; it had two kitchens that were fully equipped with miniature pewter, and brass and copper cooking equipment and plates, and it had a bathroom with suitable tubs and bowls – and even three tiny bath hats hanging on the wall. This was universally known as the 'baby house' (a term that remained in use through until the nineteenth century), not to convey the idea that it was for the amusement of babies but rather that it was a miniature model of a real building.[27]

This obsession with architectural and design integrity led to the skills of architects, designers and artists all being brought to bear in creating these models. Their natural home, in terms of British institutions, is the museum of architectural models created by Sir John Soane, as much as it is the Bethnal Green Museum of Childhood. Sheridan and Chippendale made tiny doll's furniture, replicas in miniature of their full-size objects, while the great china-makers of the day produced little tea and dinner services. Indeed, the baby house commissioned for Nostell Priory in Wakefield, West Yorkshire, was made (c.1735) by the architect James Paine in tribute to the real Nostell Priory and was furnished by Thomas Chippendale, who was also responsible for furnishing the real house. The rooms are replete with miniature, marble chimney breasts and even doors fitted with working locks and handles. The designer Roger Fry created a doll's house (as they were then termed) in the early twentieth century in imitation of his own house near Guildford.

THE DOLLS AT HOME *designed and lithographed by* EDWARD BAWDEN · *Published by J. Lyons & Co. Ltd. Printed by Chromoworks Ltd. London*

The artist Sir Neville Wilkinson created a much exhibited house, Titania's Palace, in 1907. Not only were many of the buildings replicas in miniature of real buildings and their contents but many were populated with family and staff, including some clearly intended to portray actual occupants and possibly also actual events. The provision of a lying-in room was a frequent element of the grandest baby houses of the eighteenth and nineteenth centuries. Here the new mother would receive well-wishers, so the room was elegantly provisioned and usually included, in addition to mother and child, a wet nurse. Some went further. Lest there be any doubt, the oldest of English doll's houses – that given to Ann Sharp in the 1690s by her godmother, the future Queen Anne – had labels pinned to the dolls within: 'Roger, ye butler' and 'Sarah Gill, ye child's maid'. More obscurely, it also includes a wax relief portrait of a fifteenth-century witch, Mother Skipton.

Many doll's houses had an explicitly educational function, and were recommended in the seventeenth century by the philosopher John Locke as part of a strategy to keep children off London's crowded streets. In nineteenth-century religious households models of Noah's Ark, containing up to 400 miniature occupants from amicable glow-worms to elephants, were the only permitted toys. In adult terms, they were no doubt places where it was intended that nursery lessons in manners and domestic decorum might be illustrated. Yet they were also part of an ongoing imaginative construction.[28] Toys coming alive in nurseries when their human occupants are asleep is a recurrent theme in children's literature. Swift plays on the idea. In Brobdingnag Gulliver lives among a race of giants as the guest of the royal household. But, being so small by comparison with the inhabitants of the island, how was he to be accommodated? The answer was in a specially commissioned box.

> The queen commanded her own cabinet maker to contrive a box, that might serve me for a bed-chamber … This man was a most ingenious artist, and, according to my directions, in three weeks finished for me a wooden chamber of sixteen foot square, and twelve high; with sash windows, a door, and two closets, like a London bed chamber.[29]

We have to remember that in terms of the Brobdingnags sixteen by twelve was indeed a diminutive living space. Inside everything was lavishly furnished:

> The board that made the ceiling was to be lifted up and down by two hinges, to put in a bed ready furnished by her Majesty's upholsterer … A nice workman, who was famous for little curiosities, undertook to make me two chairs, with backs and frames, of a substance not unlike ivory; and two tables, with a cabinet to put my things in. The room was quilted on all sides, as well as the floor and the ceiling, to prevent any accident from the carelessness of those who carried me; and to break the force of a jolt when I went in a coach.[30]

A lock was needed to keep out the rats and mice – these, of course being of Brobdingnagian proportions and thus significantly larger than Gulliver himself. He was clothed in the thinnest silks that could be made, but found them to be of the thickness of an English blanket. Finally, he had made

> an entire set of silver dishes and plates, and other necessaries, which in proportion to those of the queen, were not much bigger than what I have seen in a London toy-shop, for the furniture of a baby-house.[31]

Thus accommodated, Gulliver was more or less a living resident in a miniature home. But, though sentient and possessed of vitality, he was still – as the occupant of a 'baby-house' – effectively treated in a baby-like manner. The disjunction between the

Opposite

Colour lithograph of *The Dolls at Home*, by Edward Bawden. British, 1947.
This print emphasizes the attention to the life of the interior that is characteristic of processes of miniaturization and their contemplation. What we see is the inside of a doll's house, itself no doubt within a real house, but within this doll's house a further doll's house is laid out on the floor. While children sleep, the dolls themselves come out to play – in this instance one on a piano. Yet the question is left as to whether something is also happening in the second doll's house.
H. 74 cm, W. 98 cm

149

protocols and politesse that the Brobdingnags show in their dealings with each other – the courtesies, indeed, that he himself is accorded in public – and their treatment of him in less guarded moments is striking and revealing. The maids of honour, for instance, 'would often strip me naked from top to toe, and lay me at full length in their bosoms; wherewith I was much disgusted', because, he continues, 'a very offensive smell came from their skins'. He was, he says, regarded as 'a creature who had no sort of consequence'.[32] The maids would place him on a toy box and, without embarrassment, dress themselves in front of him. One would even 'set me astride upon one of her nipples; with many other tricks wherein the reader will excuse me for not being over particular'.[33] As the resident in what was to become known as a doll's house, he was in effect treated as a doll – a diverting, charming plaything but not one to be attributed any deeper moral sentiment of his own. He was on his way to sharing the same fate as dwarves and midgets, relegated to joining the cast of a freak show.

Woodblock print of a European toy stall by Utagawa Sadahide. Japanese, 1860.
From 1858, during the Edo period in Japan, foreigners were allowed to reside in a certain number of treaty ports. Their customs, notably those related to children, excited great interest. Japan already had its own traditions of displaying dolls at children's festivals, though not as playthings. Here the toys include dolls, hobby horses, drums, horns and a toy axe.
H. 24.7 cm, W. 36.8 cm

Toys and dolls

Perhaps the only miniatures to develop a literary career of their own were a box of toy soldiers bought by the Reverend Patrick Brontë for his young son Branwell. Branwell, and his more famous sister Charlotte, began to develop not only games and stories involving the soldiers but also a whole literary output of written tales and dramas, the 'Angrian MSS'. Apart from their narrative content the manuscripts had one other distinctive feature: they were written in miniature writing to a scale consistent with that of the figures themselves such that they could only otherwise be read (as they were written) with the intervention of a strong magnifying glass. The conceit is clearly that the toy soldiers could read the manuscripts readily, even if the human occupants of the nursery could not.

This idea that toys and dolls have some element of an independent life is a familiar one. It is, however, somewhat at odds with the original idea of a 'toy', which had a sense somewhat akin to a thief's swag. The word 'toy' was once given to a cap or headdress of linen with flaps descending to the level of the shoulders and once worn by Scottish women. In thieves slang it meant a watch-stealer: a 'toy getter'; and it also referred to small articles made of steel – 'light toys' were rings or sword hilts; 'heavy

Wood and textile emperor and empress dolls. Japanese, early 19th century.
H. (emperor) 29.5 cm, (empress) 26 cm

151

toys' were sugar-cutters or nutcrackers.'[34] Its original meanings, however, have moved on. The word 'toy' has come to connote an inanimate plaything, but in the hands of a child it becomes an agent of the imagination. Like a souvenir, it is, in Stewart's terms, a starting point of narrative.[35] Stories are constructed around toys, they offer themselves as participants in a series of imaginary scenarios. This is associated with the idea that to 'toy' with something is to manipulate it, almost as an act of dalliance. Thus teddy bears, those most ubiquitous of modern western children's toys, are played with, dressed up, taken on journeys, slept with. The teddy bear is an American invention with a specific presidential association. While on a bear hunt in the Rocky Mountains in 1902, Theodore Roosevelt encountered a bear cub that had strayed into his camp. He let it go rather than shooting it and adopted it as a pet, which lead to a cartoon of the incident entitled 'Teddy's Bear'. On seeing this, a toy-maker, Morris Michtom, made a toy bear that became popular in his shop, and so he wrote to the president asking for permission to adopt the name Teddy Bear as his trademark. An answer quickly came back: 'Dear Mr. Michtom, I don't think my name is likely to be worth much in the bear business, but you are welcome to use it.'[36] As a toy, it has become a kind of inanimate pet.

Yet this more intimate manipulation of toys and dolls, both physically and as a device of fantasy, is not replicated in all countries where we might be inclined to deploy the English terms 'toy' or 'doll'. In Japanese the word for 'miniature' is *hinagata*, literally 'small form'. The word *hina* originally referred to chicks, but was adopted to refer to one of several kinds of doll produced for use in the doll festival (*hina asobi*), which is held on 3 March, the third day of the third month, every year. The practice arose in the Tokugawa period (1603–1868) and consisted of displaying a set of dolls in the corner of the main room in the house. Its origins lie with the imperial court, for the dolls represent the emperor and empress (see p. 151), together with their substantial retinue and court. The displays were often quite elaborate, with the dolls housed in a model palace and the room bedecked with blossoms. Today, they are often still arranged in tiers with the imperial figures at the top and the different grades of court in rows beneath. The dolls are donated to a family by the wife's parents, and can be acquired from one of many shops specializing in them. Interestingly, many of these shops are owned and run by members of the Shimazu clan, who have a historical reputation for their expertise in craft production and also often make the mannequins used in shop and museum displays.

In Kyoto the dolls are of two types, *gosho ningyo* and *hina ningyo*, and are intimately connected to the imperial court. *Gosho* means 'palace life' and refers to a rather dumpy form of doll, often with a moon-like face and sometimes shown with its legs splayed out, but always in a seated position. *Hina* dolls are distinguished by being dressed more formally in traditional imperial robes and are, again, seated. This has a practical aspect in that they are made for display and can more easily be disposed in their domestic display setting without risk of them falling over if they have a rounded base. However, their position also recalls the seated position of *darma*, the

position adopted by the deity who achieves a state of enlightenment by remaining in that pose for long periods.

This display of courtly dolls is exclusively observed in households where the family has a daughter. The equivalent festival for boys falls on the fifth day of the fifth month. In the past this day held a special significance for warriors, who would receive presents and wear special formal attire. If there was a boy in the household under the age of eight, a banner would be flown in the form of a carp, a fish that swims in the pools of temples and is regarded as possessing great strength and perseverance from its ability to swim upstream. Nowadays the observance of the festival in households possessing boys involves the display of miniature armour and helmets, again acquired for the family by the child's grandparents.

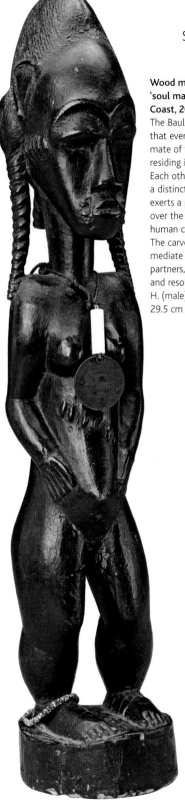

Wood male and female 'soul mates'. Baule, Ivory Coast, 20th century.
The Baule people believe that every person has a mate of the opposite sex residing in the spirit world. Each other-world mate has a distinctive character and exerts a powerful influence over the lives of their human counterparts.
The carved figures of them mediate between the two partners, receive offerings and resolve problems.
H. (male) 32 cm, (female) 29.5 cm

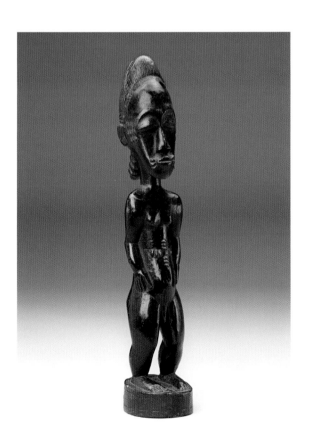

Wood doll figures (*akua'mma*). Asante (left) and Fante (above), Ghana, 20th century. Images such as these are normally used at the suggestion of the traditional priest and are carried by women on their back supported by a length of cloth as a real child would be. They are often referred to as 'fertility dolls', since their purpose is to aid conception and the successful birth of healthy children.
H. (left) 34.7 cm, (above) 22 cm

This activity already implies that the dolls are far from being just playthings. They are kept for display, not for children to manipulate and play with as they would with toys in the western sense. The complexity of the Japanese typology of dolls and their historical significance indicate that they serve a wide variety of symbolic and magical purposes, as indeed they do in many societies. That dolls may be perceived as animated is in part a function of the materials of which they are made. Thus in Shinto belief plants and trees are considered to be the home of *kami*, nature spirits or

gods, and figurative objects made from them thus possess a spiritual quality. This may often be protective and curative in effect, but if the dolls had been played with or otherwise suspected of having absorbed evil, they would be burnt at shrines.

The characterization of dolls as 'mere' playthings vies with the idea found in a number of contexts that they can materially affect the world of human affairs. As a category, dolls lie on the frontier between ritual and play; or, rather, all three categories – 'doll', 'ritual' and 'play' – may be thought of as forming an extended complex within the world of small things. To regard them in this way is to question the idea that dolls are 'merely' anything. Their characterization as frivolous distractions is far from expressing their burden of significance in wider cultural contexts. There is a point of intersection with the words 'doll' and 'idol', though the two actually have a separate etymology.[37] As Cameron and Ross have remarked in an innovative catalogue (and exhibition): 'Playing with dolls … is serious business'.[38]

As with the word 'maps', there is an elasticity in the use of the word 'doll'. A survey of what would in English be called 'dolls' confirms that manipulating small figures is both a playful and an intense matter in many cultures. One common area of usage is in association with marriage and the expectation of childbirth. In Renaissance Italy dolls, and even children, had a significant role at times of betrothal. Dolls might be wrapped up in real swaddling clothes by Florentine brides. They would be a welcome wedding gift, kept in the bedchamber and treated as if alive: washed, comforted and lavished with affection, the same kind of behaviour that a young girl might expend on a plaything in other contexts. Chubby little boy dolls in the guise of the Christ Child were a common part of a bride's trousseau, and real children had a role in engagement and wedding ceremonies.[39]

Among the Asante in Ghana, an *akua'ba* (plural *akua'mma*) – a small flat schematic figure with disc-like head and often carved with stumpy outstretched arms – is worn tucked into a wrapper, which holds it in place against a woman's back, should she have trouble conceiving children. This replicates the position in which a young child would actually be carried by its mother. It is generally explained that this encourages the divine intervention that would assure the process of conception and successful childbirth, and to some extent also acts as a surrogate for the yearned-for baby. The greater number of *akua'mma* have female features, which is variously explained by commentators as an expression of the wish for girls to help with housework, an actualization of the principles of matrilineal descent, or even a reference to the original myth in which the first *akua'ba* was carved for a woman (Akua), who eventually gave birth to a healthy and beautiful girl. Fante versions, from the coastal areas of Ghana, have a distinctive high rectangular head, but usually lack the protruding arms of other figures from the Akan areas of this part of West Africa.

The use of the figures among the Asante is the most fully documented.[40] The 'doll', once carved, goes through a ritual process, which is overseen by a priest. This effectively sacrilizes the object before it is used by a woman, and she herself would be obliged to observe a series of prescriptions and prohibitions lasting until she has

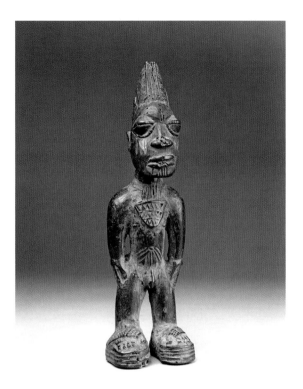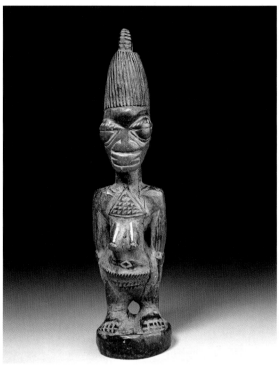

finally given birth. Indeed, if in the end she fails to bear a child, the *akua'ba* would not be handed to someone else when she passed childbearing age, but it would be likely to be buried with her when she herself finally passed away, presumably because its mission remained unaccomplished. But, when the *akua'ba* worked well, its influence was evident in the birth of well-proportioned babies, which in Asante terms meant well-formed, unblemished children with high foreheads. They conformed to the stereotype of the 'doll'. The successful *akua'ba* would be kept as an heirloom or might be displayed by the priest at his shrine as testament of his powers to inspire divine intervention in human affairs. Indeed, some figures in this general form appear to have been made only for use at shrines.

Doran Ross also notes an unusual Ghanaian account of another way in which the *akua'ba* substitutes for an absent child.[41] If a boy or girl should go missing, it was believed that they had been taken by dwarf spirits, who acted as attendants to a monstrous spirit that occupied the depths of virgin forest. In that event, an *akua'ba* might be carved and decorated and then left at the base of a large tree on the outskirts of the area of forest together with some mashed yam, eggs and some cowries or silver currency. The hope was that the figure would attract the captor spirits, who would begin eating the food and conceive a compulsion to possess the wooden child in preference to the living one. The missing child could then effect its escape and return to

Wood male and female figures (*ibeji*). Yoruba, Nigeria, 20th century. Although the birth of twins was once regarded as an aberration, they are considered by the Yoruba to be a great blessing and their loss a serious misfortune. A figure like one of these is carved for a lost twin and is treated with care and reverence as if it is the living child. H. (left) 29 cm, (right) 29.2 cm

its parents. In all these cases the point is not just that the small wooden figure sub-stitutes for a living child, but that it also crystallizes the passion to overcome the impediments to having a real child in front of you. It gives provisional form to what is formless both in the sense that it is not present and that it lacks physicality. It could be argued that it materializes desire.

Elisabeth Cameron documents a wide range of behaviours in relation to 'dolls' throughout sub-Saharan Africa, behaviours that well illustrate the porous nature of any distinction between play and ritual when taken out of its modern, western con-struction.[42] The Asante are far from alone in using dolls as mechanisms for ensuring fertility. Dolls are a common device in initiation rites for girls and also on occasion for boys. They may be dressed, fed, washed, put to bed and woken up. They may stand in for a deceased twin (as with *ibeji* figures among the Yoruba)[43] or they may materialize persons – spirit mates – from other worlds.[44] The purpose may be that of appeasing spirits, but equally the 'doll' may be conceived as possessing a 'personhood' in its own right, as Ravenhill tells us was constantly emphasized in his work among the Baule in Côte d'Ivoire. Here the figure is cared for in a thoroughly attentive way and repays its human partner by appearing as a spirit lover in sexually explicit dreams.[45] Cameron deploys the notion that the 'play world' is essentially one of make-believe in contrast to the 'real world'. Yet her underlying assumption is that the two intersect, that through creating change in the imaginary world, change becomes tangible in the real world.[46] She defines ritual activity as the mechanism for effecting these interchanges. All of this is part of the perception that small things are inherent-ly powerful.

Living dolls

Finally, then, what if, like the imaginary nursery of toys bursting into animated action when no one is watching, the dolls actually do move and apparently have the capac-ity for independent action? There is a story told of the philosopher René Descartes (1596–1650), who was invited on an ill-fated journey to Sweden by Queen Christina. He was to discourse with her and her courtiers on philosophical matters, but he went with some foreboding and did indeed die there some months later. He voyaged by sea, travelling, so his companions understood, with his young daughter Francine. He had had a daughter called Francine by a servant, and she had lived with him for part of her life until she succumbed to scarlet fever at the age of five, well before Descartes set out for Stockholm. On the journey the ship was buffeted by heavy storms. His companions came in search of Descartes and his daughter, who had yet to be seen by any of his fellow passengers. Descartes was not in his cabin, nor yet was his supposed daughter. However, on the way out of the empty cabin, the companions noticed a strange box, and when it was opened, a mysterious object was found within: a figure of a girl that seemed capable of movement and appeared in some sense to be alive.

157

What they had found was an automaton, a mechanical doll, which Descartes had constructed from bits of clockwork. When the captain saw this 'living doll' he immediately had it cast overboard, assuming that it must be some malign magical object capable of summoning up the sea storms with which the ship had been battling.

Susan Stewart talks of the terror of the doll that is an automaton: 'The dream of animation here is equally the terror caused by animation, the terror of the doll, for such movement would only cause the obliteration of the subject – the inhuman spectacle of a dream no longer in need of a dreamer.'[47] The responses to the automaton confirm this observation. Pierre Jacquet-Droz (1721–90) and his son Henri-Louis (1752–91) are credited with the invention at the remarkably early date of 1774 of two mechanical toys in the form of small boys, one of whom would draw passable sketches, while the second would dip a quill pen in a tiny ink well, shake it twice and inscribe the famous, but in this case distinctly challenging, words, 'I think therefore I am'. Even more provocatively, it is sometimes reported to have been so calibrated as to convey on occasion the troubling thought: 'I do not think, do I therefore not exist?'[48] This is the technician as philosophical joker. But these remarkable inventions were thereby exploiting that forbidden borderland between a mechanical creation and a living entity – the very stuff of Mary Shelley's Frankenstein and of innumerable subsequent horror films, of modern robotics and the extremities of contemporary nanotechnology.

In Europe, and elsewhere in the technologically sophisticated world, successful achievement on these esoteric peaks involved pushing at – and, seemingly, sometimes even beyond – such an impenetrable frontier. In Japan, from the eighteenth century, automata in the form of sword-wielding samurai capable of marching to and fro were created. In Europe the artistic and philosophical 'living dolls' of Jacquet-Droz were more than matched by the creations of the presiding genius of mechanical life, Jacques de Vaucanson (1709–82). It is entirely remarkable to make a metal toy able to simulate mechanically the muscular activity of drawing and writing, but Vaucanson sought to combine such wonders with the yet more extraordinary feat of mechanically simulating breathing and playing music. His vehicle was a flute player, a mechanical maestro that incorporated an immensely complex confection of pulleys, levers, valves and bellows based on the observation of the muscle movements by which man produced sounds. With these devices the operations of a metal tongue and the fingers could be controlled and coordinated, allowing the flute to be played, as it would be by a human musician, by modulating the passage of air through the tube. The resulting automaton could play twelve different tunes. A drummer and a pipe player followed, the piper being capable of moving his mechanical tongue more rapidly than a human musician and without developing the exhaustion that afflicts the human pipe player. All of this was achieved without subterfuge.

Vaucanson moved on to make a mechanical duck that could take food from the hand of its manipulator, swallow and then apparently digest and excrete it in a pellet-like form. His gallery of extraordinary animations held audiences enthralled for

generations; they included assemblies of the aristocratic and the scientifically mind-ed, as well as ordinary visitors. However, on fuller investigation the duck appeared not to have reproduced animal activity in its entirety – its digestive system turned out to contain a pellet that had been prepared in advance and was released in response to the (undigested) food slipping down the duck's neck.

There are overlaps between the creation of living dolls and magic. Indeed, one of the most recent studies of automata is subtitled *A Magical History*.[49] The reference is partly to the theatrically charged atmosphere that the display of the dolls engendered: a magical, wondrous world where make-believe vied with the improbable evidence of the eyes to create a fantastical reality. However, there are also overlaps between the mechanical skills required of the maker of automata and those of the disciplined sleight of hand of the illusionist. One such coincidence is biographical. Jean Eugène Robert-Houdin (1805–71), the father of modern magic from whom the escapologist Houdini took his name, was originally apprenticed as a watchmaker. He was suffi-

ciently skilled to have reputedly repaired Vaucanson's famous duck on the occasion of the Paris Exposition of 1844. However, he also learnt the techniques of the conjuror, possibly from a doctor who treated him after an accident. Although he was to open a shop in Paris specializing in clocks and mechanical toys, he recognized that automata offered the greatest prospects of eliding his technical and conjuring skills in a new and creative direction. The magical theatre he was to create included such combinations of mechanical wizardry and illusion as the 'Fantastic Orange Tree', an automaton that could not only bear metal fruit but also produce butterflies apparently bearing the handkerchief of one of the audience. He produced a 'Pastry Cook from the Palais Royal', which brought pastries from a miniature shop; a guardsman that shot rings from his gun to land on a glove balanced on a glass; and a miniature trapeze artist. Robert-Houdin also created his own entry for the Paris Exposition. It was an automaton that could write and that seemed to look rather like Robert-Houdin himself. Like the child of the technological humorist who made the Cartesian trickster, this *écrivant* would answer the question 'Who gave you life?' by inscribing, in a

Print by Balthasar Anton Dunker including three mechanical toys designed by Pierre Jacquet-Droz. German, 1775.
The three toy figures at the top represent a girl playing a harpsichord, a child drawing and another writing at a desk. All, as created by Jacquet-Droz, performed the physical actions of playing, drawing and writing with an accuracy of mechanical reproduction that made them all the more remarkable.
H. 40 cm, W. 51 cm

copy of Robert-Houdin's own handwriting, the name of his maker. This mechanical model had entered the repertoire of the phantasmagorical. Wordsworth in *The Prelude* talked of the lesser clockworks of his day as 'the marvellous craft of modern Merlins'; the automata of nineteenth-century Europe took the craft into Promethean dimensions. Appropriately, Robert-Houdin's self-portrait was subsequently bought and exhibited by the showman who brought Tom Thumb to nineteenth-century audiences, Phineas Taylor Barnum.[50]

Such technicians and illusionists liked to suggest, through the subtleties of their performances, a supernatural source to their powers. In a world already familiar with the achievements of the Industrial Revolution, where machines were capable of reproducing mechanically and rapidly forms of production that in previous generations had required arduous human labour, the human, doll-like qualities of these clockwork creations had a simple grace – particularly when compared to the satanic machines of the factory. They were ventriloquized, certainly, but once set to action, they appeared to perform with an independent, if predictable, will. Yet, they only hinted at the intervention of mysterious forces; their context was still one of public entertainment. A perceived proximity to the world of the supernatural was a mark of success, but it did not automatically convert admiration into a fear of the unknown. The frisson of suspended disbelief intervened to prevent the onset of any inevitable and widespread psychosis. This is the equivalent of the horror movie rather than the actual horror.

6. Small as Powerful

The flea exploring the female body is, in John Donne's poem of that name, not only a voyeur, it also bites. The inimitable Jonathan Swift also made the point, this time in poetical vein:

> *So naturalists observe, a flea*
> *Has smaller fleas that on him prey:*
> *And these have smaller still to bite 'em;*
> *And so proceed* ad infinitum.[1]

The image of little things that can have piercing, debilitating effects has a lengthy history in western thought. Before the invention of the microscope and the discovery of germs, the Greeks already had a well-tried line in poetic and sculpted reference to the phenomenon. Theocritus, in a characteristically short poem, talks of two herdsmen, one of whom, Battus, gets a small thorn stuck in his foot; the second, Corydon, goes on to reflect on how mighty beings can be struck down by tiny wounds. Likewise, Theocriticus is thought to be the possible author of an epigram in which Eros is said to have been stung by a bee. Eros himself was conceived as tiny and equally capable of inflicting stinging sensations in larger beings. In characterizing the differences between our experience of the small and the gigantic, Susan Stewart astutely observes: 'Whereas the miniature represents closure, interiority, the domestic, and the overly cultural, the gigantic represents infinity, exteriority, the public, and the overly natural.'[2] This is close to saying that the small is controlled, tamed, whereas the gigantic is gross and untrammelled. This is an apt description of the basic contrast noted in earlier chapters: when we talk of microcosms, we are referring to energies and their representations that are localized, as opposed to the unfettered forces of macrocosms loose in the cosmos. Yet, small things also 'get under your skin'. They are potent, irritating and sometimes malevolent. Their representation can be characterized as a technology of the aesthetic, but their control is also part of the ambivalence of what is loosely termed 'magic', the topic of this chapter.

Opposite
Bronze head of Jupiter. Romano-British, 2nd–3rd century AD.
See next page.

A selection of bronze objects from a Romano-British deposit. British (Felmingham Hall, Norfolk), 2nd–3rd century AD.

The objects here were all found together in a large pottery jar. They include a head of Jupiter, the goddess Minerva and a small bronze wheel associated with the Celtic deity Traranis. It is not clear what the circumstances of their burial might have been, and the lack of association with any skeletal remains has led to the conclusion that it is probably a temple hoard buried for ritual purposes in a pottery jar. However, it conforms to the tradition of placing small objects in burials, which is sufficiently general a practice that the interment of larger objects (such as the ship burial at Sutton Hoo or the terracotta army in China) stand out by their rarity.

H. (of largest piece/Jupiter) 15.5 cm

Empowered material

A discreet scene can sometimes be observed at tombs in central Madagascar, the home of the Merina. People may quietly and unobtrusively collect up a small hand-ful of soil from the entrance to a firmly closed stone structure, which is partly hidden underground but sufficiently raised above the surface to dot the bleak uplands with large rectangular rock or cement blocks. Inside, carefully arranged on shelves and individually wrapped in rough silk cloth and matting, are the remains of the dead of the area, who, however dispersed they may have become in life, are still reassembled in death in the same tomb: if in life they moved overseas or went to work in distant towns, in death they come to share the same address. The soil taken from around such a tomb will be secreted on the person, and the tomb may be one in which the person's own ancestors are buried. Or the soil may perhaps come from one of sever-al tombs that are particularly associated with travellers, for the soil packages are nowadays principally carried by those going on journeys. Taking small packets of soil is often interpreted as vaguely expressive of the wish to return to ancestral earth or, if going abroad, to once again alight on the distinctive red earth of *le grand isle*. But the significance of secreting soil on the person exceeds this reading of the act as sen-timental longing.

In Madagascar the concept of the ancestors (*razana*) is a fundamental point of reference, as has been thoroughly documented in the anthropological literature.[3] Blessings (*hasina*) flow from the dead to the living as a result of appropriate ritual actions, often focused on the physical habitation of the ancestors – that is, the tombs. Here the ancestors are invoked, and among the Merina the increasingly skeletal remains of the dead are periodically removed from their imposing communal sepul-chres, rewrapped in new burial cloth and matting, and, before being replaced, are taken on a riotous circuit round the tomb itself, and perhaps into the nearby village and surrounding rice fields. This honouring of the ancestors is the means by which the beneficial influence of the dead on the affairs of the living is secured.

The very fertility of the land, which enables the rice that sustains local commu-nities to grow, is attributed to the toil of the ancestors. It is they who, in previous generations, cut the terraces and established the often elaborate drainage systems sculpted into the landscape, which transfer and distribute rainwater in a carefully cal-ibrated manner down the hillsides, thereby maximizing production. The tombs them-selves are typically located in the midst of the rice fields, not in the centre of villages. And the community of the dead is maintained here: even people who have moved away from a region ultimately anticipate that their remains, too, will be added to those already residing in their ancestral tomb. They will thereby join the dead of the locality, their bones mingling with the earth not just in a conceptual but in a physi-cal sense, having been powdered by being rattled together in the rewrapping process. Soil collected from the vicinity of tombs is thus much more than a sentimental pack-et. It is a precious, charmed substance capable of maintaining blessings even when

the bearer is far removed from its physical source. It is more akin to the relics of medieval Europe – the bits and pieces derived from the saintly person's body or parts of their vestments held to sacrilize and protect – than they are to the souvenir, carried overseas like a family portrait placed in a wallet for remembrance.

It is notable that it is not just any earth that is carefully picked up and packaged, not just ancestral soil in a wider metaphorical sense (in no more would a visitor to Berlin at the time of the reunification of Germany have been satisfied with brick or mortar from any wall in the city). It is pieces taken from very specific sites with important associations that have significance. In the case of Madagascar the soil should be taken from the surroundings of tombs, the very place of the mingling of physical ancestral remains with the earth itself, the site of concentrated ancestral essence. Such soil is highly efficacious. Its properties are widely exploited, being incorporated into charms and magical devices worn on the body to empower the person. Thus it can also be protective in battle or skirmishing, and is capable of combating the dangers of malign spirits. This idea that small samples of substances taken from graves and other such special places might be used to empower objects, and offer mystical protection to those in contact with them, has a wider cultural pedigree. Evidence from the earliest pilgrim sites already documents what is equally a modern phenomenon: the carrying off of a whole range of materials and small images, known collectively in the Christian tradition as 'eulogia', which are held to have protective

Gold coin (obverse and reverse) known as 'Dr Johnson's touch-piece'. British, 1702.
For many centuries it was believed that the British monarch had the power to cure by touch. This developed in the sixteenth century into the practice of hanging a gold coin round the neck of the sufferer. This example is identified as one with which Queen Anne 'touched' the infant Samuel Johnson, later to become the author of the famous dictionary but then suffering from 'king's evil' (scrofula).
D. 2 cm

or prophylactic qualities. These, too, are most often for personal prophylaxis and are worn or carried close to the body they are intended to protect.

Throughout Muslim West Africa, and even among peoples who are not themselves Muslims, Quranic charms are often affixed to garments, to royal stools and state swords.[4] Thus non-Muslim chiefs in Ghana attach amulets in the form of scraps of paper with Quranic script or cabalistic signs sometimes reminiscent of Arabic script (and possibly written by scribes not familiar with Arabic) to the underside of seats or round the legs of royal chairs. They act as a form of protection for members of the court. Réne Bravmann reports that in the Nafana area of Ghana all important ritual areas within the royal palace will typically involve the deployment of protective Islamic charms; the lintels over the entrance to sleeping areas are hung with amulets that protect against potential disturbance while the ruler is asleep; and his bathing area is similarly hung with charms to ward off evil influences while he is naked and washing himself, a time when he is particularly susceptible to psychical danger.[5] Maskers will sometimes tie such charms to their masks as much to protect themselves when entering a domain of spirits by putting a powerfully charged artefact over their face. Likewise, hunters or warriors in the African Sahel in both Muslim and non-Muslim areas often use similar texts, which are encased in a leather pouch and tied to their gowns, to protect themselves against physical danger and exposure to witch-craft. The objects attached to such gowns often have a very personal reference – they

Bronze charm (obverse and reverse) in the form of a coin. China, Qing dynasty, 19th century. The scene refers to a legend in which the Emperor Huizong (a 12th-century ruler) had a vision of the god of the north, who was able to control evil forces and is depicted here standing on the back of a snake and a tortoise with a sword in his hand. The tortoise is associated with longevity and strength, and the sword with the victory over evil. D. 7.7 cm

Silver medallion. Baghdad, Iraq, AD 937. This commemorative medallion was struck, it is thought, to commemorate the re-establishment of order in the city of Baghdad following the arrival of the powerful Amir al-Ra'ik. It bears an arabesque motif on the reverse and a text from the Qur'an that reads in translation: 'Praise to God, who has put away sorrow from us, verily our Lord is forgiving, prone to reward.' D. 3.8 cm

are a kind of accumulation of small significant positive memories, known among the Bamana of Mali, for example, as *basi*, 'secret things'. A practice of making miniature religious books to be carried by emigrants, or those otherwise entering potentially dangerous situations, can sometimes take on a similar role. A small daily prayer book, the *Tefillah Mikal Hashana Katanah*, measuring $2\frac{8}{4}$ by $2\frac{1}{8}$ inches (7.3 x 5.4 cm) and printed in Hebrew, was specially made for Jews emigrating to the United States; it was intended to give the assurance of faith to those fleeing persecution in their homelands in the mid-nineteenth century. But, for Muslim soldiers fighting on the Allied side in the First World War, copies of the Quran published from 1900 onwards by David Bryce of Glasgow had particular significance. The books were printed in Arabic and measured 1 by $\frac{3}{4}$ inch (2.5 x 1.9 cm) at their smallest and came with metal lockets and an inset magnifying glass.[6] Muslim soldiers who were killed carrying them on their person at least died in the consolation of their faith.

Such portable texts are in exact relation to the larger entities of which they are models, but they are not considered any less effective because of their reduction in scale. Whether they should be considered charms or not is a moot point. Muslims do not readily recognize the carrying of Quranic texts as talismanic. In central Africa the issue has none of this uncertainty. The historian Wyatt MacGaffey discusses a portable form of magical construction among the Kongo peoples of central Africa that employs small figurines.[7] It is known as *nduda* and is considered to provide personal protection for warriors. The figurines have 'night guns' attached to them made of stalks of elephant grass packed with gunpowder together with other 'medicines'. An indigenous commentary accompanies the construction and explains the process:

The nkisi is a carved statue … If someone wants to compose the nkisi he goes with the nganga (ritual specialist) to the cemetery. When they arrive they make an enclosure of palm branches and begin to prepare medicines. The nganga and his apprentice put them into the statue and then fire off two shots. Then they leave

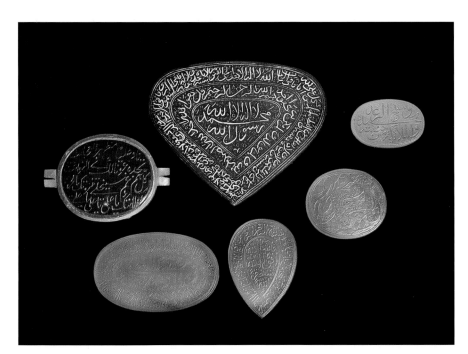

A group of Islamic amulets. 17th or 18th century.
The texts here incorporate Islamic inscriptions mostly drawn from the Qur'an and executed with the attention to calligraphic excellence appropriate to the words of the Prophet.

Cotton tunic. Probably from northern Nigeria, 20th century.
The distinctive feature of this gown is the mass of drawn inscriptions that cover its outer surface and are derived from Qur'anic texts. The inside of the garment has a series of small leather pouches attached (visible through the opening), which also contain verses taken from the words of the Prophet.
L. 89 cm

the nkisi on the grave and return to the village. The reason why the nkisi is left is that it leads people to believe that the ghosts themselves complete the medicine packet.[8]

With the sides of their eyes and their foreheads appropriately marked by the *nganga* and armed with the *nkisi-nduda*, the warriors are protected from wounding.

As with other classes of *minkisi*, magical substances are applied to empower them in performing a wide range of intercessory activities, from identifying thieves and curing illness (or causing it) to countering sorcery and securing oaths. The substances that animate the objects include earth, herbs, leaves and relics – indeed, without them the carvings to which they are applied are lifeless and purposeless. The materials applied are all in fragmentary form – scrapings, powder or ashes – and include nets, cords, minerals, plants, seeds, fruits, small animals such as toads, teeth, claws or the heads of poisonous snakes. Each of the different elements has a specific application: to bring good fortune and blessings, to cure headache, to resuscitate, to cause harm to others. But, as with soil from tombs in Madagascar, the associations of each of these substances brought together on magical devices are more than pharmacological and far more than sentimental. Their efficacy derives directly from the significance of the materials of which they are a fragment. Since the advent of missionary activity and colonial government the overt use of *minkisi* has ceased. But this has not led to the cessation of private acts, similar to those in Madagascar, of secreting little packages of protective materials on the person. Indeed, students reportedly sometimes 'medicate' their pens with substances that yield a magical potency before taking examinations.[9]

The history of the place of reliquaries in the western Christian tradition has similar implications. The sanctity of churches throughout the Christian world has been enhanced by the presence of reliquaries, parts of saintly bodies separated from their living hosts after death and distributed to congregations in wider Christendom, whether by arrangement or by sanctioned theft (*sacra furta*). Relics of saints or other divine figures in the form of bones, other parts of the body, clothing or materials specific to particular sanctified people were often kept in special reliquaries in churches – indeed, they still are. From the early years of Christendom the possession of relics was a precondition of the consecration of churches. The interdict was sufficiently prescriptive that more mortal relics than the bodily remains of appropriate saints could realistically have generated were divided and relocated to different churches. Just as *minkisi* contain empowering substances, so shrines and altarpieces often have small cavities or compartments built into them in which the relics of associated saints reside. One example, the early fifteenth-century Holy Thorn reliquary, was originally in the collection of Jean, Duc de Berry, and now forms part of the Waddesdon Bequest in the British Museum.[10] The reliquary is presented in the form of a heavily jewelled case with scenes of the apostles and the Resurrection on the front surrounding a glass-fronted cavity. Inside is a long sharp spine, visible behind its protective glazing

Gold reliquary pendant of the Holy Thorn (shown open and closed). French, c.1340. The Crown of Thorns was one of the most treasured sacred relics of the Byzantine empire kept in Constantinople. In the 13th century it was taken to France and housed in the specially commissioned church of Sainte-Chapelle. In successive centuries occasional thorns were detached from the original and presented as special gifts; they then found their way into treasuries elsewhere and were placed in elaborate reliquaries, like this example in the form of a personal pendant. L. 3.8 cm

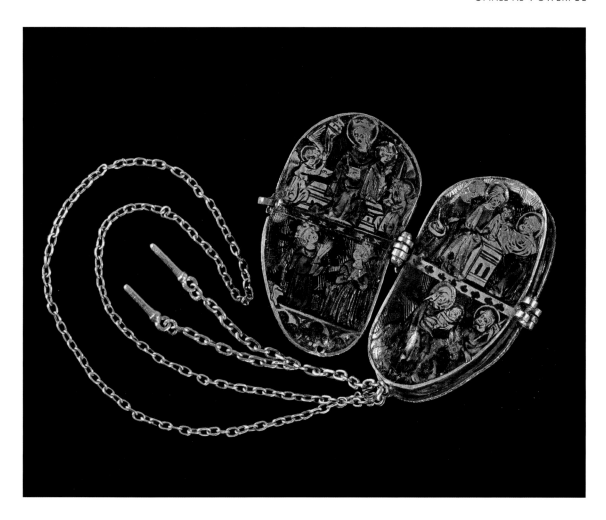

and said to derive from Christ's Crown of Thorns. However, at the back, hidden behind small, hinged doors, there is also a compartment that, though now empty, was clearly designed to contain other concealed relics. The images on the outside of the doors are of St Michael and St Christopher, though whether it is the ecclesiastical significance of these two saints to which reference is made or whether it is their own actual relics that were once contained within is no longer clear.

The art historian David Freedberg, whose interest is in the relationship between viewer and image, draws a distinction between relics and other kinds of religious imagery that may be displayed in chapels.[11] In addition to relics, figurative images of saints are also incorporated into shrines or altars. The two are usually treated as distinct by commentators and art historians in terms of the behaviours associated with each. The point Freedman makes is that relics have efficacy by definition, while other kinds of sculpted images only have it as inherent potential. The latter receive their

efficacy through being consecrated or by inclusion in shrines. Sculpted images that lack concealed relics are in a sense always playing catch-up in terms of their effectiveness. 'Few if any relics need to be consecrated in order to make them effective: very many images do – at least in order to make them effective in specific and particular ways.'[12] Freedberg is at pains to distinguish the status of each class of object. The figural image is different from the relic precisely because it is carved and shaped into a representational form. Its supernatural efficacy is to be distinguished from what we might call the raw power of the relic, which is quite specific in its application. The relic has this or that known effect and implication, and no other. It is focused, intense, and not diffuse or manipulable in its application and significance. By contrast, figural sculpture can be diverted to serve different purposes. It is consecrated, washed, anointed and given a specific identity appropriate to particular ends, rather than possessing it from the start.

However, there are occasions when the two are met in a single image. Thus in the 1160s the church of Sainte-Marie-Madeleine at Vézelay was destroyed by fire. But a figure of the Virgin miraculously survived more or less intact except for some blackening of the surface, and proved capable of restoration. In the process 'a most secret little door between the shoulders' was discovered not by careful inspection but by tapping the figure and recognizing from variations in sound that parts of it were hollow. Inside was found a mass of small relics, each with labels such as part of Mary, the Mother of God; a bone from the body of John the Baptist and others from the Apostles Peter, Paul and Andrew; and part of the thumb of St James.[13] The discovery of this otherwise unknown saintly ossuary explained the power of the image to resist the flames beyond that achieved by consecrating an image alone. It contained material elements derived directly from divine beings. But in the end the point about the statue of Vézelay is the combination of the two forms of magical device in one assemblage.

The Vézelay figure is, in Freedberg's analysis, the exception rather than the rule. For him the distinction between the relic and the figure is clear and decisive. He grants each a different 'ontological' status. The relic is as it is; the figure, however, may be inoperative without some action to make it efficacious in particular ways. Without consecration to invest figures with particular qualities, they may still be regarded from other perspectives and elicit different responses: they may, for instance, have aesthetic aspects independent of any wider mystical significance that they may subsequently acquire. In this they are quite distinct from the *minkisi*, which, though figurative, are only made to be empowered and for no other reason. Without the addition of the magical substances to empower them, they are inert, meaningless – lacking 'personhood'.[14] It is for this reason that one of the most evocative descriptions of *minkisi* and related phenomena in Africa is that they are 'containers', even if they are figural. So, as in the case of relics, materials added to an object give it direction and personality; it is empowered magically, mystically and ontologically. Whatever is the case with Romanesque or medieval religious statuary, the addition of fragmentary

matter with powerful associations is sufficient to give an object attitude and direction. In the same way bringing a small package of soil from a Merina tomb into direct contact with the body is a method of assuring a continuance of ancestral blessings in distant places. Contact with the body or with inert objects animates and empowers such substances. Concentration of materials, plus intimacy of contact, manifests potency.

Magical gems

The talismanic properties of materials are nowhere more evident than in the case of precious stones. Indeed, what is often considered as a branch of the decorative arts – the Renaissance rediscovery of the art of the cameo and the intaglio, or the Elizabethan tradition of the painted portrait miniature – may owe its origins in part to more ancient magico-medical practice in the Mediterranean area and subsequently in other parts of medieval Europe. Plato, in the *Timaeus* (to which we have referred in relation to ideas of the body as cosmos), also talked of the process of animating images through consecrating them with secret marks and inscriptions. Such secret marks were concealed on an image in the form of an engraved gem or other inscribed fragment, in order that an image could gain the power of independent action and prophecy. The material itself should be that associated with particular gods, and its appropriate placement could endow an image with animating aspects of the soul of the divine.

In the late Roman period, as Christianity developed as a state religion, such theurgy began to take on a feeling of the heretical. Yet, in the area of personal magico-medical practice, it was tolerated for as long as it was for protective purposes rather than for witchcraft. Constantine in fact issued a law in AD 318 explicitly allowing the uttering of spells in curative medicine, a verbal version of secret magical inscription. Scarabs and Graeco-Egyptian magical papyri were reused, as they had the mysterious patination of ancient usage. Chalcedony scarabs from the fourth century BC offered protection to Romans as they had to Egyptians 800 years earlier. Gem-cutters were also employed in the Christian era to fashion talismanic stones for use within the Roman empire. Most seem to have been carved in the eastern Mediterranean and often invoke Egyptian gods, but using the Greek language. Both the material and the imagery were prescribed. Chalcedony, from which scarabs were carved, was credited with bringing joy, intelligence and victory, and with protecting against shipwreck. A gem in haematite, the material used most frequently as a cure for backache, shows a bent figure reaping the harvest with a bill-hook. On the reverse is an inscription indicating that the gem is a help for difficulties with 'the hips'. A basalt stone with an engraving of the god Chnoumis is an appropriate prophylactic in cases of stomachache. His magical mark and name appear on the reverse with his praise-titles round the rim – he is referred to as 'giant-killer' or as 'breaker of all things'.[15]

A group of ancient Egyptian amulets. Various periods ranging from the Middle to the Late Kingdom, c.2000 BC to after 600 BC.

Egyptian amulets were intended for use by both the living and the dead. They were regarded as protective devices to deflect potential dangers and also as mechanisms to endow the individual with specific desired characteristics such as strength or fierceness. Amulets were in different materials and colours – here: gold and silver, faience, and turquoise (below); faience and obsidian (right); and gold (far right).

Their form was also related to their purpose. Of those illustrated, the bangle and eye below were intended for use by the living. The bangle has a multitude of images ranging from turtles and hares to eyes and pillars. The turtle, though associated with evil, is shown immobile, and thus harmless; the hare survives in the desert and is thus a powerful evocation of life force. The coloured faience, *wedjat* eye refers to an amuletic eye that was given by the god Horus to Osiris and restored him to life. It was subsequently accorded regenerative powers.

The emphasis in funerary amulets is often on qualities of endurance, stability and regeneration. The pillar amulet (*djed*), for instance, is associated with the backbone of Osiris and would be strung round the torso chest or neck of a mummy. The two fingers are made of obsidian, a hard stone that was held to endure for eternity. It was placed near the incision through which the embalmer removed the internal organs to symbolically seal the body against penetration by malign forces. The human-headed 'heart' scarab set in gold was placed on the chest to ensure that the heart, the source of intelligence, remained intact. Each of the four animal or bird-headed figures represents one of the sons of Horus and each is protective of different internal organs. Their use is associated with a period when these organs were removed, mummified and then returned to the body. Finally, the string of gold amulets includes trussed ducks and lotus leaves, each evoking the idea of resurrection.

D. (bangle) 8 cm; H. (*wedjat* eye) 5.1 cm, W. 6.3 cm; H. (pillar) 10 cm; L. (scarab) 3.8 cm and W. 2.5 cm; *Opposite:* L. (of largest Horus figure) 14.6 cm; L. (fingers) 8.5 cm; L. (chain) 15.5 cm

Some overlap with Christian imagery did occur, though without the specific associations of Egyptian-Platonist theurgy. An early example on a larger scale than small gems, and from the Carolingian period (dated approximately AD 867–77), is the Saint-Denis crystal, named after the Abbey of Saint-Denis in Paris from which it may have originated. It is made of rock crystal carved as a convex oval with a flat underside on which is engraved an image of Christ on the Cross with two weeping figures and cabalistic signs. At the bottom is a swirl that may be a serpent. By the sixteenth century this combination – the Brazen Serpent and Christ on the Cross – was known from medals where their combination was regarded as talismanic against the plague. Sometimes parallel biblical texts from the Book of Numbers and St John's Gospel would be inscribed to enforce the connection.[16] Rock crystal itself was carried held against the body into medieval times as a protection against general fevers. There is, then, reason to think that this conjunction of material and image is both declaratory of Christian worship and inherently powerful.

Small 'jewels' concealed on the body were hardly to be regarded as merely decorative (because unseen), but equally, given this enhanced significance, jewellery flamboyantly displayed on the body may not only be a matter of ostentation alone either. In medieval times rock crystal and other precious and semi-precious stones continued to be incorporated into settings by jewellers. Often opaque rock crystal acted as a device to place over small reliquaries and religious images, so-called *fondi d'oro*

Above left
Engraved crystal. Thought to be from the Abbey of Saint-Denis, Paris, France, Carolingian period, c. AD 867–77. H. 15.5 cm

Above
'Magical' glass bead. Early Anglo-Saxon, 6th century AD. This bead was found in a woman's grave along with other objects that had an apparently amuletic function: a ring of deer antler, an iron purse-bar and amber beads. Their precise significance is unknown. The beads, it is suggested, may be associated with soothsaying or with divination. D. 4.4 cm

(scratched gold foil with colours underneath to bring out an image), or even over inscribed fragments of parchment. Crystal obviously provided a cover for impermanent materials, a preferred alternative to glass at the time. Yet in Ole Worm's reliquary now in the National Museum of Denmarl, believed to date from 1230, the rock crystal itself is the primary material and the miniature that it shields has been added as an afterthought.[17] The crystal as material is an integral part of the reliquary and contributory to its symbolic and magico-'religious' (in this case) significance in a way that manufactured glass could not be. Sometimes crystal itself would have been framed with other smaller precious stones. The combination of the stone and the image it covered lent many such settings, conventionally thought of as purely decorative, a distinctly talismanic quality.

During the Renaissance period in Italy another conjunction developed. Jewellers, goldsmiths and gem-dealers were often one and the same person. Like many artists, goldsmiths became deeply involved in the business of examining and authenticating ancient gems for the elite families for whom they were among the most sought-after possessions. The discussion of the Renaissance thirst for such precious items is usually couched in terms of their place as 'objects of virtue', things that represent the wisdom of the ancients and encapsulate the time-honoured virtues. Much visual imagery associated with weddings, for instance, is intended to create an identity of purpose between children and married women. A whole series of devotional images was given

A group of magical gems. Mediterranean area, 2nd–7th centuries AD. Engraved precious and semi-precious stones from the late Roman period were accorded particular curative powers in parallel with the adoption of Christianity as a state religion. Their imagery usually recalls the gods whose powers are sought, the most common being Yahweh, or Jehovah. Of those illustrated here, the black basalt image on the right shows the god Chnoumis, whose particular domain was the cure of stomachache. His titles (engraved on the reverse) include 'giant-killer' and 'breaker of all things'. L. (Chnoumis gem) 3.1 cm, W. 2 cm

Rock crystal intaglio by Giovanni Bernardi di Castelbolognese after Michelangelo's 'Tityus'. Italian, c.1533–5.
The subject of Tityus being devoured by a vulture is very closely derived from Michelangelo drawings and would have been made for one of several possible patrons. Like the makers of micro-mosaics in a later century, the carvers of gems were prized for the faithfulness of their reproductions in that medium rather than for their own independent creative flair. The combination of a classical scene accurately portrayed and the material used gave the resulting setting its significance and value.
L. 5.8 cm

to women on becoming married, both to inspire them and to be worn as charms to encourage conception and childbirth. Among the most common were medallions stamped with the Lamb of God, Agnus Dei. Pope Urban V declared in 1366: 'This Agnus … destroys sin … and augments virtue. It at once preserves the pregnant woman, and delivers her of her child.'[18] The first such medallions were in wax and later ones were also in silver and gold.

What, however, was the process by which the charm enchanted the young wife? One answer is that looking upon the image itself could inspire divine intervention in the process of conception. The popular saying, 'what she sees, she makes',[19] suggests that surrounding a woman with appropriate imagery had a general talismanic effect. At the very least we might say that gazing upon a thing of undoubted virtue and beauty can only have had positive moral and aesthetic results. In a sense, this is an extension of the idea that objects of antiquity can inspire. Yet, we might wonder if this engagement with the objects of antiquity is purely conceptual, only to do with the perfection of the moral status of the rich owner. What is described about the impact of such objects on Renaissance brides is similar to Hindu ideas of *darshan*, the devotional effect of exchanging glances with an image of divinity in a temple or, in a domestic setting, with a picture of the god set up in a house shrine. But in the Indian case the exchange is with an image that has staring eyes, where the devotee receives divine blessing and in turn the god receives the devotional attention of the worship-

per. With a jewelled object or an Agnus Dei image mutual eye contact is not the issue, so the intersubjectivity achieved in *darshan* is more restricted.[20] Is the aura of such works, then, attributable to them being invested with a more material, talismanic aspect? If an 'object of virtue' is by definition charming, might it also be regarded as charmed?

There is some reason to think that this might be the case. The archaic usage of the word 'virtue' was in reference to the operative power within a supernatural or divine being. The leading families of Renaissance Italy, the Visconti and the Sforza dukes in Milan, the Estes and Gonzagas in Ferrara and Mantua, or the Medicis in Florence, were certainly willing to pay huge sums of money for authenticated ancient gems: Piero de' Medici is reported to have remarked that an engraved gemstone was 'worth more than gold itself'.[21] They became treasured family heirlooms. Gemstones were worth more than gold and indeed silver, because it was thought that they had an additional quality: a design that had been divinely created by nature itself. The gem engraver's skill was in drawing out and revealing an inherent design, making visible what divine nature had locked up in hard precious gemstones. Engraved rock crystal seemed to be the carving 'of light itself'.[22] We also know from various sources that jewels might be embedded in devotional images to generate an efficacy of prayer, an idea that, as we have seen, was already to be found in Plato.[23] And when they came from excavations, as many did, there was also the possibility that they might be *telesmata*, mysterious objects originally buried beneath buildings to assure the prosperity and longevity of their occupants; Virgil was commonly supposed to have buried a picture of a city in a vessel at the founding of Naples.[24] Gemstones, then, may be conceived as having an inherent empowered property, a residue of divine or mystical action awaiting revelation and direction at the behest of the jeweller.

Finally, we should note the overlaps between jewellers and miniaturists or limners in terms of their shared professional background and skill. The sources of the miniature have often been presented as either larger paintings rendered in small format or, in the case of the Persian miniaturists, as dependent on the size of book plates and other forms of book illustration. However, in contrast to either of these sources, the oval form of jewelled, talismanic settings and the professional overlaps of miniaturists and jewellers suggest a link to the locket and the gem setting, in which case the enchantment attributed to the miniature may have a double sense.

Medicines

If small is powerful, small is also dangerous. The instrument that opened up this disarming observation to the western scientific world was the microscope. The frontiers between the seen and the unseen were to be renegotiated. As Hooke demonstrated and illustrated (see pp. 37–46), microcosms hidden in previously unseen things were to prove every bit as complex as the macrocosm to be observed in the night sky.

Writing in the mid-seventeenth century, Blaise Pascal remarked of the sights revealed under the lens of a microscope:

> *Let him see therein an infinity of universes, each of which has its firmament, its planets, its earth, in the same proportion as the visible world; in each earth, animals, and in the last mites, in which he will find again all that the first had, finding still in these others the same thing without end and without cessation. Let him lose himself in wonders as amazing in their littleness as the others in their vastness.*[25]

The world of small turned out to be immense, as it already was in many non-western conceptions.

But the world that began to be revealed not only afforded a whole new perspective on the wonders of nature, it also led, in the hands of Louis Pasteur (1822–95) and others, to the discovery of a more sinister world, that of the microbe. Pasteur's unequivocal identification of the bacterial causes of anthrax translated small things into potential hidden enemies, unseen contaminants quite at odds with the Alice-in-Wonderland lens on the world that the microscope as a plaything and didactic toy seemed to promise. These minuscule living organisms were no longer just a reproduction in miniature of a nursery world of non-threatening beauty. Here was proof of the existence of germs and bacteria, of organisms otherwise unseen, capable of secretly incubating disease and ultimately death. Germ theory, as it developed in the late nineteenth century, has come to dominate our perception of the environment and of the happenings in our own bodies. Germs have even become the stuff of the most nightmarish forms of warfare and terrorism.

The idea that appropriate substances, condensed and concentrated, possess a focused essence that is inherently powerful has of course had a profound application in the history of pharmacology. The ingested powdered remains from Persian and Egyptian mummies have been credited with profound medical effects since at least medieval times. However, the first compressed tablet drugs – or 'pills', as we would now say – emerged as a commercial proposition in the second half of the nineteenth century. Silas Melville Burroughs, co-founder of one of the most successful pharmaceutical companies the world has seen, wrote on them as the subject of his graduation essay from Philadelphia College of Pharmacy in 1877.[26] Their development and production formed the basis of the company that he created with his more famous fellow student and business associate, Henry (later Sir Henry) Wellcome, whose name continues to be associated with one of the largest medical research trusts in the world. The original 'pills' in this form were first patented in 1843 by an English pharmacologist, William Brockedon, under the less than euphonious title of 'Shaping Pills, Lozenges and Black Lead by Pressure in Dies'. His method of production was somewhat rough and ready and involved a mould and a mallet. Pills were introduced into the United States in 1854, when an earlier graduate from Philadelphia College,

Jacob Dunton, built a machine that anticipated future mass production. He marketed his products in 1869 and registered his invention under patent in 1876, though any guarantee of the quantities that might be produced was questioned and the assurance of quality proved fallible. By 1887 Burroughs Wellcome & Co. had produced a machine capable of manufacturing 600 pills a minute. The compressed tablet re-crossed the Atlantic and its production on a commercial scale revolutionized the approach to public health and the whole social and cultural context within which medicine was administered.

In the words of Joseph Amato, 'The pill, a tablet of fine dust, was contemporary medicine's Communion wafer'.[27] These were products that, appropriately prescribed, could in many circumstances thereafter be beneficially self-administered. They were to become small enough to be swallowed and they were to be delivered in sufficiently reliable a form for their constituents to have a predictable medical effect that could be matched to the condition to be treated. Wellcome, the entrepreneur and showman of the two, began the search for a better name than Brockedon or subsequent pharmaceutical entrepreneurs had come up with. His brainchild was to take on a wider etymological history, for the word he invented – 'tabloid' – was transposed to the world of newspapers and publications in a small format with a more populist approach and appeal than their more serious stablemates, 'the broadsheets', which until recently in Britain were also of larger format. In registering the name – a happy combination of the word 'tablet' and 'ovoid' – Burroughs Wellcome arrived at a winning description. Use of this name by competitors to describe their product would only court legal redress, as one company found to its immense cost. Wellcome's standard biographer quotes the professional journal *The Pharmaceutical Era* on the subject to good effect:

> First they [Burroughs, Wellcome] had something to sell, something that was wanted. English medicine was labouring in the slough of big bottles, big doses, and nauseous drugs. A revolution had already taken place in favour of the elegancies of Hahnemann, but homeopathic medicines had proved useless for people with anything the matter with them. 'Tabloids' hit the happy mean. They provided an allopathic dose in a convenient and palatable form.[28]

The emphasis is on size – size and efficacy. Small is powerful and effective. Were it a large and indigestible product, the same gloss could hardly have been promoted. The revolution lay in the creation of a remedy that would not only cure the body of its ailments but was in proportion to the scale of the human frame and its internal organs; it could be ingested and passed through the bodies' arteries and tracts delivering a concentrated benign regime. The tabloid was medicine-as-magic.

181

7. Private Pleasures

In the preface to a fifteenth-century theological work, *De Visione Dei*, Nicholas of Cusa expounds on the qualities and impact of Jan van Eyck's picture *Portrait of Christ* (1440):

> *This picture you should put up in some place – say the north wall – and you, brothers should stand around it at equal distances from it. Look at it: and each of you will experience that from whatever side you look, it will seem to look at you alone. To the brother who stands in the east it will seem to look eastward, to him in the south, southward, and to him in the west, westward. Therefore at first you will all be amazed at how it gazes at all and each of you; for the imagination of him who stands in the east cannot at all grasp how the gaze of the icon should be turned in another direction, namely west or south … And because he knows the icon is fixed he will wonder at the change of the unchangeable gaze.*[1]

In his discussion of the responses to western images in general, David Freedberg cites this passage to show that the clichéd assessment that the eyes of a good picture follow you round the room is not to be dismissed as low-level appreciation of art but has a basis in genuine experience. Indeed, it is an entirely appropriate, desirable quality of a divine image that it should possess an all-seeing, transcendent aspect. And in the most successful images the magnetic effect of the eyes makes it effectively impossible to inadvertently evade the exchange of gaze. The result can be unsettling, challenging. These are not eyes that stare vacantly and invite nonchalance in response, they engage the viewer and anticipate electrified attention. Although none of these images are necessarily miniatures, the encounter with them has the same existential potential as that with small things. When we experience them we do so uniquely, one to one. As noted earlier, exceptional powers of 'sightedness' are a significant feature in the armoury of those who manipulate small things for magical or divinatory purposes. Other examples suggest that the conditions and experience of seeing miniature things, rather than questions of scale alone, are critical.

Above

Gold enamelled pendant jewel. Spanish, late 16th century.
This jewel is set with emeralds, amethysts and garnets and has the form of an enormous fish being ridden by a warrior, thought perhaps to represent an Aztec.
L. 10.2 cm

Opposite

Enamelled gold locket by Henri Toutin. French, 1637.
Henri Toutin is credited with pioneering a technique for applying an opaque enamelled-gold ground, which was painted onto small pieces of jewellery, watch cases and small boxes. The result was a series of exquisite virtuoso pieces destined for the courts of Europe. The image here is of a naval battle with, on the back, a military encounter.
L. 3.6 cm

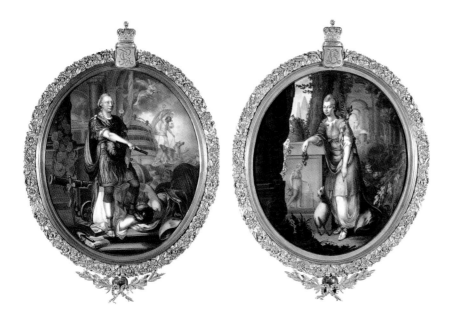

Courtly dalliance

In the restricted world of the Elizabethan court, miniatures were often kept locked away in cabinets in private rooms. What required concentrated, monastic circumstances to create in the first place, was also something that, to a large extent, would only be viewed privately. Queen Elizabeth herself is known to have kept her collection of miniatures in the innermost quarters of her own living area within the royal palace. Our earliest report of the circumstances in which the collection was kept comes from Sir James Melville. In 1564, as Mary Queen of Scots' envoy, he was admitted to the inner sanctum, where he saw within the royal cabinet 'divers little pictures wrapt within paper, and their names written with her own hand upon the papers'.[2] Again, as with cabinets of curiosity and the characters in some doll's houses, there is a curatorial aspect to the keeping of miniatures. Later, in 1598, a German visitor, Paul Hertzner, also described the cabinet within the royal bedchamber. He talks of 'a little chest ornamented all over with pearls, in which the Queen keeps her bracelets, earrings and other things of especial value'.[3] Many were also kept in grand bejewelled boxes.

Elizabethan miniatures were not displayed in public, nor hung in dining halls or reception spaces like larger formal pictures, but were kept discreetly in the private chambers of royalty and courtiers. Lord Herbert of Cherbury recounts seeing Lady Ayres in her bedroom in quiet, singular contemplation of an image of himself by Hilliard that he had given to her. 'Coming one day into her chamber,' he says, 'I saw her through the curtains lying upon her bed with a wax candle in one hand and the

Enamel portraits of King George III and Queen Charlotte by William Hopkins Craft. British, 1773.
Royal patronage was a major encouragement to the arts of the miniature. Miniature painted portraits were supplemented by medals and enamels. This example is not technically a miniature. However, its interest arises from taking the technique of enamelling explicitly created for the execution of miniatures into a larger format. They are allegorical in style, King George being cast as a Roman warrior and Queen Charlotte as his classical consort.
L. 33 cm, W. 28 cm

Gold ring with onyx cameo of Elizabeth I. British, late 16th century. This is one of a series of approximately thirty cameo portraits of Elizabeth I that were created in the late 16th century. They were given as marks of royal favour and subsequently worn by recipients as symbols of allegiance.
D. 2.5 cm

picture … in the other.'⁴ What is described is what we might think of as the erotic. In contrast to public behaviour, the face of the other is contemplated in private and becomes, as it were, a part of the life of the imagination, distinct from the outward formalities of the courtship process. Contemplation of the miniature permits an imaginative possession of the other. It portends the potential for obsession.

Thus, the limning was a primary agent in the amatory practice of the Elizabethan court. And, as such, miniatures contain their measure of secret references. The poses are often allegorical: a hand placed suggestively against the heart or raised in enigmatic gesture, hair tousled, clothes slightly ruffled. In one a hand emerges from a cloud and grasps the hand of the subject. The colours used, the choice of garment, jewellery and other costume accessories in which to be portrayed, or the inscriptions sometimes added may all have had personal meanings for the sitter and for the person to whom the miniature was to be given. The image was part of the transactions of the game of courtly dalliance, and as such had many and complex layers of allusion, which might only be known to a limited number of people extending little beyond the limner, the subject and perhaps a recipient. At a distance of time their intended meaning can be distinctly ambiguous. A famous limning by Nicholas Hilliard, *Young Man among Roses* (1585–95), now in the Victoria and Albert Museum, bears the Latin inscription *Dat poenas laudata fides* (My praised faith procures my pain), suggesting that the image is about the dilemma of a faithful lover who suffers the discomfort of the thorns at the same time as he appreciates the beauty of the buds. However the source is Lucan and refers to a plea that Pompey should be assassinated; thus it could equally be interpreted in quite the opposite way as a warning not to

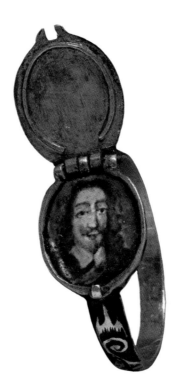

Left
Gold memorial ring for Charles I. British, about 1650.
Charles I was executed by hanging in ambiguous circumstances on 30 January 1649. He left behind many secret supporters of the Royalist cause who found covert ways to express their loyalties. Commemorative jewellery – whether rings, lockets or clasps – that included references to his reign were among the most widely, if discreetly, dispersed. This example is in the form of an oval ring with a hinged lid set with a diamond on an enamel ground. The image of Charles I within is also enamelled. His queen, Henrietta Maria, circulated such commemorative imagery to supporters in recognition of their support and anticipation of the eventual restoration of the monarchy.
D. 1.8 cm

Opposite below
Silver brooch. Slav or nomadic from a hoard found in the Ukraine, late 6th or early 7th century.
The imagery on this brooch shows a human head at the top with peacocks to the sides, ears of grain and an animal mask terminal. It is assumed that the brooch was one of a pair that would have been used as dress fasteners by high-status women.
L. 13.1 cm

persist loyally against the odds.[5] Such confusion over the intended interpretation typifies discussion of many miniatures of the period, not because they have an unstable meaning, but because, at this distance of time and without direct interpretation by those involved in its original, we, like any contemporaneous viewer who might have been permitted to look at it, are not 'in' on the secret. It has a depth that is not perceptible to casual, uninformed looking.

Miniature portraits were also worn of course. The images might be of the sovereign herself (or later himself) or of a loved one. They might be hung or pinned to clothing. A favourite device was the so-called 'picture-box', a kind of locket that might contain either a miniature portrait or a cut stone and needed to be opened for the contents to be viewed. Although displayed, they were still not flaunted. Thus, set in its box or its jewelled surround, the limning was meant to be viewed 'in hand near unto the eye', as Hilliard put it. The experience of focusing on the miniature detaches the viewer from the surroundings and gives that sense of a privileged and personalized perspective. People cannot crowd round to look at the miniature. To that extent there is something of the peephole about them. In another context Baudelaire talked of 'greedy eyes … glued to the peephole of the stereoscope, as though they were skylights of the infinite'. In similar vein a number of miniature books in the nineteenth and early twentieth centuries focused on erotica, reproducing, for instance, the poems of Alexis Piron (1689–1773), *Ode à Priape* and *Le chapitre des Cordeliers*, with appropriate illustration. In these respects the miniature purveys a sense of a teasing, illicit pleasure.

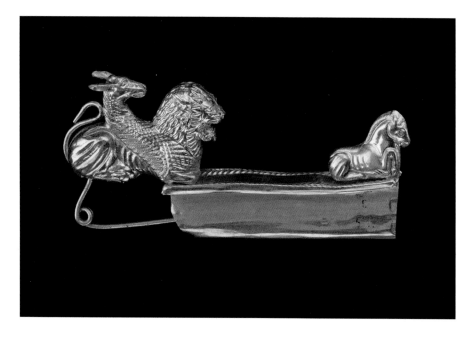

Left
**Gold brooch. Etruscan,
525–500 BC.**
Gold brooches of this type
were popular pieces of
discreet costume jewellery
in Italy towards the end of
the sixth century BC. Often
they were simple bow
shapes. Here, however, the
brooch is decorated with
a chimaera composed of
the head of a winged lion
and the body of a goat.
Its open mouth appears
to threaten the foal at rest
at the other end of the
brooch.
L. 6.8 cm

Where it was worn could also be meaningful, especially if it was the disposition of the queen's own accessories that was at issue. Graham Reynolds quotes an excellent example of some of the currents of flattery and intrigue that were at work:

> *Lady Derby wore about her neck and in her bosom a portrait. The Queen, espying it, inquired about it, but her ladyship was anxious to conceal it. The Queen insisted on having it, and discovering it to be the portrait of young Cecil, she snatched it away, and tying it upon her shoe, walked long with it; afterwards she pinned it on her elbow, and wore it some time there. Secretary Cecil hearing of this, composed some verses and got them set to music; this music the Queen insisted on hearing. In his verses Cecil sang that he repined not, though Her Majesty was pleased to grace others. He contented himself with the favour she had given him, by wearing his portrait on her feet and her elbow!*[6]

The limning was not appended to Elizabethan gowns as surface decoration nor as a register of trophies or amatory conquests, for all that Elizabeth had Hilliard produce portrait miniatures while in France of at least one potential consort, François, Duc de Alençon, the third son of Catherine de Medici, with whom she contemplated marriage. Worn, or held in the hand in contemplation, the miniature had a whole bodily context, which was part of the perception that it could be owned, not just as property but as a focus of personal and emotional entanglement.

The discreet charm of the *netsuke*

Japanese *netsuke* (see pp. 13–14) also have a bodily context. Like Elizabethan miniatures they would be held in the hand, turned and fondled, all encouraged by their size, shape and surface; and they too were worn. However, while the miniature portraits of sixteenth- and seventeenth-century Europe were always recognized as having inherent value, *netsuke* were not especially prized at the imperial court and have received, until recently, only limited recognition. Despite the Japanese delight in, and exploration of the miniature in many areas of artistic production, Japanese colleagues talk of only having become aware of *netsuke* through seeing exhibitions and catalogues originating outside Japan in the second half of the twentieth century, rather than through any attention inside the Japanese archipelago. Even today *netsuke* are not at all as well known in Japan as their pre-eminence in the world of miniature creations elsewhere would imply. Although a great many of them were produced during a period of intense artistic innovation lasting over several centuries, they were in fact rather mundane objects.

As we have already seen, *netsuke* had their allotted place on Japanese garments: as a toggle used to attach various containers on pocket-less kimonos. The term itself already hints at this context of use; it comes from *ne*, 'a root', and *tsuke*, 'to fasten'. The *netsuke* was used to hold in place a number of different types of container, which, in association with clothing that lacked places to keep things, needed to be suspended if they were to be carried conveniently. These included, at various times, medicine cases, tinder boxes, purses, seals, writing materials, small gourds and, when it became popular, pouches for tobacco. In practice, a length of stick passed through loops and attached to a girdle would have sufficed. That said, as with so many small objects created by Japanese artisans and artists, their humble function renders them no less an aesthetic challenge. Some of these containers were themselves highly decorative; an ornamental toggle was clearly an appropriate complement to the larger decorative items that they suspended.

Netsuke were small, subtle, carefully observed. They were largely made of wood or ivory, although examples of lacquer on wood, or of lacquer built up in layers and then carved, are common. Other materials used included porcelain, nuts, seeds and occasionally animal and bird skulls. Despite their miniaturized scale, the lifelike qualities of the portrayal were a matter of artistic pride: frogs had to look as if they were ready to hop, hermits had to appear as if they had been subject to the physical and spiritual disciplines of their reclusive life. Yet, the decoration was more visibly ostentatious on the larger, suspended boxes that they held in place, notably on *inrō*, the lacquered containers originally made to carry seals and, later, powdered medicinal herbs.[7] The *netsuke* has, by comparison, a quality of discreetness, if not of absolute secrecy. Most were difficult to see at a distance, having dimensions of little more than an inch. Yet, if not overtly displayed, the evolution of the *netsuke* was, like the Elizabethan miniature, enhanced by courtly practices during the Tokugawa period of roughly the same time.

Opposite
Wood and ivory *netsuke* by Kagetoshi. Japan, Edo period, 19th century. Kagetoshi's speciality was landscapes, especially those containing pavilions and palaces. Some of these appear to rise out of the sea with waves and shells. Here the palace is evocatively built on bubbles blown by a clam, symbolizing the impermanence and illusory nature of the world.
W. 4 cm

Below
Wood *netsuke* by Hōjitsu. Japan, Edo period, 19th century.
This *netsuke* shows beetles crawling over a sandal. The artist, Hōjitsu (died 1872), was recognized as the best carver of his day and used the miniature format to demonstrate his skills.
L. 5 cm

Left
Wood *netsuke*. Japan, Edo period, early 19th century.
Netsuke often show delicate subjects from the natural world. This well-observed example portrays a wasp alighting on a nest.
L. 3.8 cm

The third of the Tokugawa *shōgun* leaders, Tokugawa Ieyasu, is principally remembered as the person responsible for moving the capital from Kyoto to Edo (the modern Tokyo) after he assumed outright control over most of Japan in 1600. By then his predecessors had encouraged the emergence of an assertive, successful mercantile class who, with the feudal lords, had established a flourishing interest in Japanese arts and crafts. With the move to Edo, however, the independent authority of the feudal lords was essentially restricted after an edict made them reside one year in every two in Edo itself with their large retinues, and obliged their wives and families to set up residence there permanently. The demand for artisanal products was thereby re-centred to some degree on Edo. However, the bureaucracy of the new capital extended to control over ostentatious display, styles of clothing, and amusements, dampening down what had been an effervescent popular culture. Unobtrusive arenas for the display of wealth and taste were sought that would not offend against shogunate edicts, but would nonetheless serve to underline prosperity. *Netsuke* was the ideal vehicle: luxurious, charming and, above all, modest in scale. It was unlikely to offend through overt ostentation.[8]

From this base the demand for *netsuke* to support tobacco pouches escalated enormously as the practice of smoking spread to all classes of society. Rather than being specially commissioned as an accompaniment to an ornate *inrō*, they were increasingly made expressly for commercial purposes and sold ready-made without direct patronage. There was a corresponding expansion in the range of subjects portrayed. The basic distinctions in Japanese are between flat

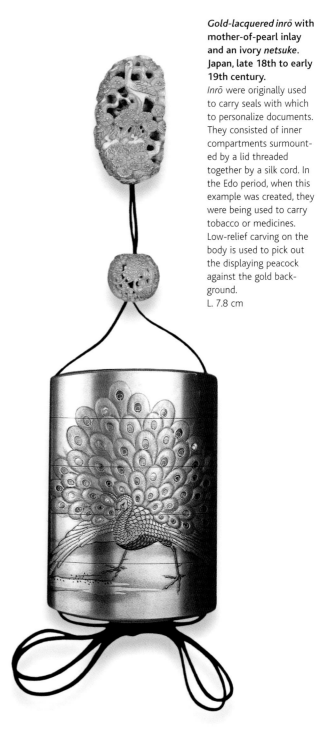

Gold-lacquered *inrō* with mother-of-pearl inlay and an ivory *netsuke*. Japan, late 18th to early 19th century.
Inrō were originally used to carry seals with which to personalize documents. They consisted of inner compartments surmounted by a lid threaded together by a silk cord. In the Edo period, when this example was created, they were being used to carry tobacco or medicines. Low-relief carving on the body is used to pick out the displaying peacock against the gold background.
L. 7.8 cm

Two lacquered *inrō*. Japan, 18th century (left) and late 16th century (right).
Both examples are furnished with four inner compartments to contain different materials. That on the left is decorated in gold and black and depicts shellfish. On the right chrysanthemums and boats on a lake are picked out in low relief against a black-lacquered background.
L. (left) 7.7 cm, (right) 9 cm

button-like *netsuke, manju* (meaning 'bean-curd cake', a reference to its shape) or *kagambitu* (a metallic version), and *katabori*, the commonest type of miniature sculpted forms made to be viewed from all sides, though shaped in accordance with its functional constraints. A taste for the odd was established early: among the first *katabori* seem to be those carved in figurative form showing Chinese and Dutch people from the Osaka area and often observed in a light-hearted, comic manner. With this went a passion for carving scenes from Chinese tradition – the hermits and recluses already mentioned in the discussion of Chinese gardens above (pp. 85–90), scenes from Chinese legend, Han-dynasty heroic figures, mythical lion-like creatures, and the exemplars of Chinese virtue known as the 'Twenty-four paragons of filial piety'.[9] Japanese stories and legends offered an even richer resource to the carver of figurative *netsuke*, including saintly, historical and legendary figures, illustrations from folk tales, and a suitable panoply of gods and demons. Well-observed natural subjects were also popular themes, especially animals with connections to the zodiac, nuts and plants. Scenes from everyday life, sometimes with a quirky aspect, abound, and occasionally they include an erotic element. Finally, masks were a speciality of a group of artists who all took the surname Deme, the name of the master

of the art of mask-*netsuke*, Deme Kezan, although this did not necessarily indicate that all were descended from him. His full-sized masks were famous among seventeenth-century supporters of the *Nō* drama, and were copied in miniature versions in the centuries that followed. Rendering the powerful grotesqueness of the mask in miniature was an especially challenging artistic task.

The range of these subjects thus provides a miniature panorama of the concerns and experience of Japanese society across several hundred years.[10] And, although stories and legends were the immediate source of many subjects, a similarly promiscuous range of symbolical references (like those of Asante gold weights – see below) can also be found, and many have no single, stable meaning. A toad, for example, was a popular subject, but it had a variety of possible interpretations. One story concerns a poisonous toad that could only be caught by suspending gold coins on a hook, which attracted and ultimately entrapped it. A moral about the lure of money is thus implied. But the toad is also seen as attracting rain-bearing clouds and has an association with the arrival of spring. Finally, a toad is often sculpted sitting on the side of an old bucket, which is a commentary on transience. The toad in its well is constantly in danger of being scooped up in a bucket, but ultimately the bucket grows old and develops holes, rendering it useless; it holds no further fear for the toad.[11] Like many other *netsuke* subjects, the toad's ability to straddle various worlds is thus invoked: as an amphibian, it can exploit the symbolic switches between attraction and repulsion, between water and earth, as well as the succession of the seasons, and permanence and impermanence.

Wood *netsuke*. Japan, Edo period, 18th–19th century.
The subject of this *netsuke* is a Dutchman, a representative of the only westerners who were permitted residence in Japan from 1639 – and even then only in restricted areas. Here, he is shown carrying a cockerel, one of the domestic animals they raised.
H. 13 cm

Ivory figure. Japan, Edo period, late 19th century.
The figure is of a *rakan*, one of the original disciples of the Buddha who were credited with supernatural powers. In this case the *rakan* is accompanied by a dragon and holds a Buddhist shrine or reliquary. Chinese influence is evident in Japanese depictions of such subjects, as in the choice of topics for *netsuke*.
H. 52 cm

The first *netsuke* artists made these miniature forms as a diversion from their more serious professional preoccupations. They were otherwise the sculptors of Buddhist shrine imagery, mask-makers, the carvers of dolls, makers of musical instruments, lacquer artists, metalworkers – even dentists. Indeed, although nearly 50 per cent of the *netsuke* in large collections are likely to be signed, and schools and ateliers with their own styles developed, the profession never ranked as a major creative enterprise. Many did attain a measure of esteem as workers in miniature and became known as *netsuke-shi* ('makers of *netsuke*'), and a few artists were recognized with honorific titles, notably in the eighteenth century Yoshimura Shuzan in Osaka and Hara Shugetsu I in Edo-Tokyo, who received the title of *hogen*. But these were the exceptions, for the making of *netsuke* was a popular art that escaped the restrictive attention paid to other aspects of behaviour, decorum and decoration. Indeed, it worked in reverse: tobacco, when it became widely available and popular, was one of the principal items suspended on a *netsuke* and used by all classes; but for the samurai the use of tobacco in public was forbidden, and the *netsuke* was effectively rendered redundant in one of its primary roles among the other echelons of the Japanese hierarchy. As the demand for toggles spread throughout society, so towards the end of the nineteenth century mass production took over and the sculptural integrity of the earlier *netsuke* waned. Indeed, the ultimate demise of the *netsuke* was linked to three developments: this debasement of the original form, the introduction of western clothing with the convenience of pockets, and finally the arrival of cigarettes, which made tobacco pouches unnecessary. Many *netsuke* were subsequently acquired by visitors to Japan and taken overseas.

Because of this history Japanese scholars have paid relatively little attention to *netsuke*. Since the carving of *netsuke* was regarded as a minor art and received virtually no royal patronage, the national museums, whose holdings are based around

Opposite, left
Ivory *netsuke*. Japan, 18th century.
The subject here is one of the *sennin*, the immortals of Chinese legend. They are often portrayed as being haggard, with ribs showing and perhaps, as here, with a thin beard, as is appropriate to those who, like hermits, occupy the remote heights of mountains.
H. 11.1 cm

Left
Ivory *netsuke*. Japan, 18th–19th century.
This group of foxes recalls a series of associations in Japanese mythology. Most identify the fox with magical powers, often to the disadvantage of human beings. In this case it has been suggested that the foxes are emissaries of the god of the harvest and thus a harbinger of good fortune.
H. 4.5 cm

the imperial collections and traditions, have limited numbers of examples.[12] The British Museum, by contrast, has a collection of over three thousand *netsuke* and held a major exhibition of its holdings in 1976; on a recent visit to the National Museum in Kyoto none were on display. Indeed, to the extent that they are collected in Japan, it is largely those created since the second half of the twentieth century that have been acquired and preserved; by then the functional purposes of *netsuke* were subverted and they became more like miniature sculptures (*okimonio*). The context may no longer have been a practical one, but the artistic challenges remained compelling.

Similarly, while much of the carving of the modern sculptural *netsuke* continues to be in Japan, some foreign sculptors have also gained a considerable reputation for their skill and dedication, the British jeweller-turned-*netsuke-shi*, Guy Shaw (1951–2003), being among the most celebrated. He began to start carving *netsuke* after having been inspired by a collection in his own family and having seen that of

Above

Wood *netsuke*. Japan, 18th–19th century.
This image illustrates an episode in the story of two Japanese fishermen, Ashinaga ('Long Legs') and Tenaga ('Long Arms'). They combined to catch an octopus, but Ashinaga's long legs got entangled with the tentacles of their prey and they are shown here wrestling to free him. H. 13 cm

195

a neighbour.[13] The miniature has been seen as an ultimate creative challenge, and modern miniaturists have frequently sought to test their powers of solitary perfectionism by pushing the delicacy of their pieces to the limits, both in terms of reduction in size and subject, such as, for example, minuscule ants attached to nuts by minute spindly legs. The deliberate choice of difficult materials is also a part of that rigorous and testing approach. Shaw applied his skills to fossilized walrus tusk, mammoth tusk imported from the Siberian permafrost, hippopotamus and cave-bear teeth, stag antler and even fossilized dinosaur dung (which polishes up to a veritable rainbow of colour). By definition the art of the miniaturist is a difficult one. One of Shaw's more remarkable works reflects well the artistic challenge of the miniature sculptural tradition, and the extent to which it has provided a format in which the exercise of skill – the requirement of creating at once tactile and visual quality – is to the fore. Called *Love Letters*, the piece portrays a bundle of correspondence tied together with ribbon and at the point when it is about to burst into flames – already browned and curling up at the edges. Like micro-miniaturists, modern makers of

Pipes and smoking sets. Japan, 19th century.
Tobacco probably arrived in Japan in the 16th century. It gave rise to a decorative material culture in the Japanese style with special cases for pipes and boxes for the tobacco itself. The *netsuke* helped suspend them. The demise of the *netsuke* as a functional object was linked to the introduction of cigarettes and a decrease in the wearing of kimonos.
L. (of pipe case) 26.4 cm

netsuke are attracted to the child-like and the sentimental. In terms of subject, the outer limits of what it is possible to achieve technically and artistically is also here exploited as the moment of transition, when something that exists as a locus of emotional experience ceases to be.

Miniatures and proverbs

Most of the objects that we have been discussing achieve acts of condensation by largely visual and representational means. In each case the contention is that they achieve a meaning that belies their reduction of scale in the process of being condensed. The 'pleasure' of the miniature is partly, perhaps, the recognition of its appositeness as a representation of something much larger. However, the effect is not always just visual. Some *netsuke* make reference to myth and to moral tales as their subject matter. And some language forms are themselves condensations of meaning, notably proverbial sayings. The most fully analysed example of such linguistic association is found in the gold weights of the Asante of Ghana, which are sometimes referred to as 'proverb weights'.

Asante gold weights were made of brass by the lost-wax process (see pp. 14–17), and have been used since at least the fifteenth or sixteenth century for determining the weight of gold dust, which was ascertained in its powdered state rather than being cast into solid form. By the eighteenth century gold dust had become the exclusive Asante currency and remained so until the start of the last century.[14] Thus, anyone engaged in trade was obliged to own or to have access to a set of weights: gold dust was by no means used only in major enterprises but was the medium of exchange even in minor market trade. Weights were thus an essential element in the economy for three or four hundred years until other currencies came into use during the colonial period. The size of these weights has been a matter of some discussion,[15] but they do seem to have conformed to a common system and could be adjusted by filing elements off to reduce the weight or by adding solder to increase it. In any case the weights were checked against each other, though that has not obviated the suspicion that senior chiefs might have succeeded in using heavier weights in their transactions unchallenged.

The form of the weights shows great variety. Many exploit geometric designs, and it has been tentatively suggested that these derive from the Saharan trade and owe their inspiration to the Islamic world; that they represent a numerical system; or even that they correspond to a cryptographic scheme that fell into disuse.[16] The discussion at least raises the question of whether the imagery was entirely fortuitous or had underlying meaning as some have speculated.[17] In practice, though, only the swastika design of some weights has any supporting history of this sort. It is widely held to have an origin in Islamic trade and to have had amuletic properties. One source records a practice of sacrificing chickens over swastika-shaped weights to enhance

197

prosperity and acquire more gold dust,[18] and elsewhere there is evidence that images of chickens were also sometimes marked on such weights. Some general sense that such non-representational designs had vague magical properties may be sustainable. Certainly drawings and stamped designs on cloth seem, among the non-literate Asante of the time, to have been equated with the incorporation of Quranic script onto gowns as a protective device among Muslims to their north. It is not, therefore, that the designs had some hieroglyphic meaning to the Asante, but rather that glyph-like designs were accorded more general cabbalistic significance.

If we can go no further with the geometric weights, representational imagery opens up a wider perspective on the interpretation of weight motifs. These come in an astonishing range, which is witness to the exploratory creativity of this tradition of brass-casting in miniature. The most comprehensive discussions of the subject of gold weights, by M.D. McLeod and by Timothy Garrard,[19] examine both the areas of Asante experience that have been regarded as appropriate to represent in weights and those that appear to have been avoided. Thus, domestic objects and tools, such as axes, adzes, bill hooks, knives, hammers, bellows, lamps, scoops, grinders, ladles, gaming boards and stools, are included, but hearths, forges and dwellings are not present in many thousands of examples that are known. Among the animals, antelope, elephant, leopard, catfish, sawfish, amphibians, hornbills, chickens and cocks are found, alongside porcupines, lizards, snakes, baboons, monkeys, tortoises, snails and chameleons; domesticated animals, mice, rats, crows, vultures, ducks and turkeys are largely absent. Everyday events – agricultural activity, men with guns or other equipment, women suckling babies or pounding food – are popular, but children, carvers, blacksmiths, and people dancing or engaged in more intimate acts are rare. Weights representing aspects of the political and military system are numerous, as are those depicting chiefly regalia (from state swords to flywhisks, royal stools and chairs), warriors and their weapons, drums and horns, and executioners holding severed heads, but funerals, corpses and offerings to ancestral stools have proved taboo. Europeans and European goods – locks, keys and flagons – are copied in miniature, but oddly carriages did not make it into the brass-casters' repertoire. In addition, a large number of weights were directly cast from nature. These included seeds, small fruits, shells, crab and fowl claws, insect heads and beetles, all of which share the property that, when encased in a mould and subjected to heat, they turn to powder. This allows the resulting cavity to be filled with molten metal and their shape to be accurately reconstituted in permanent form: a process playfully referred to as the 'lost beetle' technique.[20] If claws can be cast, there are no doubt many other possibilities that, wide as the corpus undoubtedly is, were not exploited.

Although these examples illustrate a virtual microcosm of Asante life and experience, that is not the point of this discussion. McLeod shows that there is a consistency in what is represented and what is not: if there is innovation, it is within a particular canon, some elements of which can be identified. One is that in some domains there seems to be a preference for things that lie beyond the immediate surrounds of

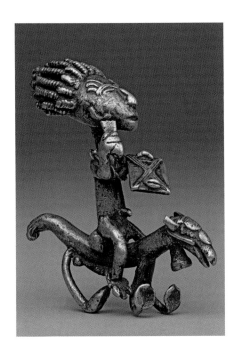

Brass weights for measuring gold dust. Asante, Ghana, 20th century.
Figurative images were only part of the wide repertoire of Asante brass-casters when creating weights to determine the quantity of gold dust. Those illustrated here indicate three subjects: a horse and rider is an image of power, the drummer is a scene from everyday life, and the backward-looking *sankofa* bird refers to a proverb indicating that it is never too late to undo the errors of the past.
H. (far left) 11 cm, (left) 7 cm, (below) 5.5 cm

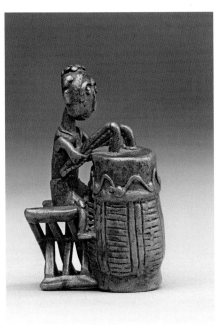

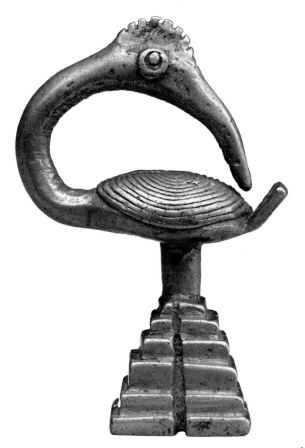

the village. As far as animals are concerned, there is a preference for wild ones over those of the home or the field, for animals that live on or beyond the fringes of human society over those that are dependent upon it. Likewise the exclusions of certain ritual behaviour or private and polluting activities can be related to reluctance to portray subjects that are too sacred or too offensive. The explanation of those that are 'in' and those that are 'out' is thus suggestive, if not conclusive. However, another element, which does not necessarily determine the choice of subject but is one that expands its indigenous interpretation, is its assessment in proverbial terms.

There are a number of weights whose form suggests that they were deliberately and explicitly created to represent particular well-known popular sayings. The most quoted example is of the weight type that shows two crocodiles in a cross form so that they share one belly. This refers to the saying that, although having a common stomach, their heads still compete to swallow food – a warning that it is futile to try and grab for yourself what is for the common good of all. A weight that shows a particular type of bird, the *sankofa*, looking backwards refers to the saying that it is never too late to try and undo the errors of the past; while a casting of an antelope with impossibly long horns recalls the phrase 'had I only known', meaning that, like growing long and unwieldy horns, regrets after the event are hopeless. In these instances the eccentricity of the portrayal already suggests that there is more going on than meets the eye.

There is some evidence that weights bearing such clear proverbial interpretations might be used to send messages, thereby extending their transactional context beyond the intricacies of trade. In communications between chiefs direct contact was often inappropriate and the will of the chief was often conveyed by spokesmen (*okyeame*), who would also speak on the ruler's behalf at public assemblies as the vehicle for expressing chiefly judgement. Such orators often carried staffs with particular images carved on them as a part of their regalia, confirming the authenticity and authority of the messages that they were bearing on behalf of the chief. Sometimes, however, rather than relying on spoken messages alone, gold weights seem to have been subtly used to support the burden of their communication. Although doubt has been cast on the regularity of the practice, there is evidence that it did occur. A native testimony from the turn of the twentieth century shows how it worked:

> As a white man sends a letter, so do we send these weights to one another. The Crab's Claw. As you know, the crab is a very tenacious animal, and what he once holds with his claw he will never let go: even though it becomes severed from the body, it will still hold on, until crushed to atoms. If I were to send this to another chief, who had done me an injury, he would at once know what I meant, without a long palaver, and if he meant to compensate me, send some suitable weight in return, if not, another crab's claw, then that meant that we would have to fight.[21]

In this way the gold weights acted rather like the pot lids of the Woyo in the Democratic Republic of Congo, which were equally imbued with proverbial references. The choice of which lid to put over food could give a whole other dimension to the process of providing food. It could for instance convey pleasure or displeasure; a jilted or disregarded wife could subtly embarrass a husband in front of others; and flirtatious intentions could be advanced.[22]

Yet, for weights (or pot lids) to perform this role, there can be no indeterminacy in their interpretation. The fact that relatively few have such explicit associations is one reason why a wider role as message-bearers is somewhat questionable. But this does not exhaust the oral context of weights. Indeed, in focusing on the weights that illustrate proverbial sayings, there is a risk of portraying as a stable linguistic form a mode of speech that is by its very nature mobile and innovative. The use of proverbial speech is itself an art form, where the ability to construct allusive expressions linking colourful statements together to give a multi-layered communication was an admired quality, as it is in many predominantly oral societies. The Asante say that 'we speak to the wise man in proverbs, not in plain language' or, again, 'when the fool is told a proverb, the meaning of it has to be explained to him'.[23] This could be taken to argue for a different perspective, for a view that the weights have been a point of departure for the linguistic transactions of everyday discourse, rather than for the commercial transactions of the marketplace alone. Weights invite and initiate proverbial description, rather than illustrate or prescribe. Thus, when the anthropologist/ethnographer R.S. Rattray was documenting Asante history and culture in the 1920s, he found that some of the recorded sayings of the past were still known to older people but that younger informants no longer used or knew them. Indeed, when shown weights, they came up with their own new associations, although by Rattray's time the use of weights and of gold dust as currency had ceased.

Likewise, we would expect there to be regional variations in popular sayings and thus of association with weight types, and for some to be known and used in some places but not in others. One interpretation of the image of the crab's claw was quoted above. The literature gives a series of others: for instance, 'for its large claw the crab is feared' (meaning a man is respected for his power rather than his person) or 'take the claw and eat the meat without cracking it'.[24] Thus any single weight might occasion multiple proverbial associations; those with only one, when the very eccentricity of their form has narrowed down and stabilized the association, would seem to be the exception rather than the norm. As the images multiplied dramatically over the three or four centuries of their production, the speech to which they gave rise likewise unfolded and changed with time. In a sense, self-contained miniature things are the ideal vehicles for this kind of promiscuous relationship with language. Asante gold weights are routes into larger narratives. They produce a double inflection, whereby a reduction in dimension is associated with an exaggeration of content.

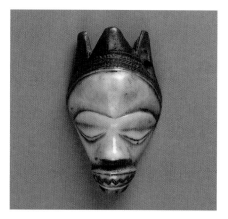

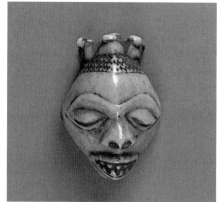

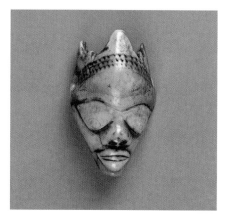

Miniature ivory masks. Pende, Democratic Republic of Congo, late 19th century.
The Pende peoples use full-scale masks at initiation ceremonies for boys. One of the 'secrets' boys learn as they transform into adult men is that of masquerade, for until then they, in common with women, will have understood that masks are ancestral emanations without the human agency that makes them move, challenge and entertain those watching them in performance. Both as a mark of their initiated status and no doubt with protective purpose, small ivory and wood masks are carved, which may be worn by initiated men next to the body as a pendant.
L. (top left) 6.4 cm, (top right) 5 cm, (above) 6.4 cm, (right) 5 cm

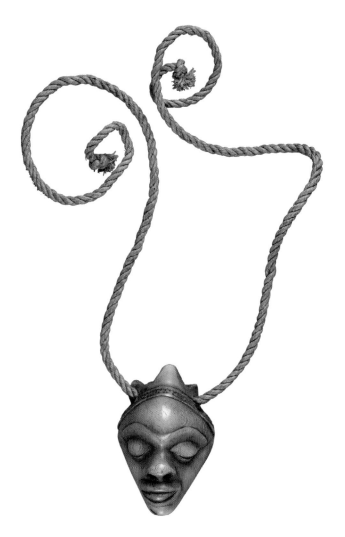

Miniature wood masks. Ivory Coast, 20th century.
As artefacts, masks are usually neither small nor secret. They are made to be viewed in performance and most are either at the human scale of the face or they exaggerate and enlarge the proportions of the body. A practice associated with the peoples of parts of Liberia and Ivory Coast in West Africa is that of making miniature masks whose size has given rise to the name 'passport masks'. The process of making small masks for the tourist market, where portability is at a premium, is well established. However, although the idea of the 'passport' as a document of voyaging accurately sums up the commercial context of much of this production, in the case of the so-called 'passport masks' the association is inappropriate. They were originally made by the Dan, Nguere and Mano peoples for local purposes, not for a global market.

Such miniature masks share an identity with their larger prototypes whose function is at once to entertain, to protect and to organize communities for public works. The miniature mask possesses a similar range of versatility, but it is directed towards personal ends rather than public means. In reduced form it becomes a privately owned thing. Often a diviner suggests that one is carried or worn, and an association with the body or with personal possessions is the essential element in ensuring its efficacy: its powers are directed and intimate. Thus it may be recommended to be taken on journeys or carried if some hazardous venture is intended; the tiniest of masks may be hung in a small concealing bag on a baby's body to protect it from adversity; and when women move to their husband's compound, although they may not otherwise have contact with masks, they may take a small mask with them which, like a trousseau, will be kept among the most private of possessions.
L. (left) 22 cm, (right) 15 cm

The secret and the esoteric

In addition to differences in the relationship of the viewer to the object, the miniature, in contrast to the gigantic, has two other distinctive aspects: one is that it may readily be lost, and a second, related characteristic is that it may be kept not just discreetly but in total secrecy. The shift from something that is experienced as personal to it being considered a private, secret possession is, in a sense, merely technical. Anyone looking at the van Eyck *Portrait of Christ* in its present museum location may experience its magnetic gaze as if it is made for them alone, even if it is a picture in public ownership and seen on a regular basis by innumerable other sets of eyes. It is not hidden away or reserved for exclusive viewing, yet it is experienced on an individual basis. The Elizabethan miniature might be kept privately but was also displayed on the body; it existed in the realms of both the private and the public. If someone should pick up a miniature object, they will have the impression that the image is in that moment experienced by them alone, that they possess it, regardless of how it is actually owned.

Yet miniature things may, to all intents and purposes, have no public biography at all, for they may be readily concealed and kept secret. Consider the response to the measures taken by the Bourbon government after Napoleon's defeat at Waterloo in 1815 and subsequent exile to St Helena. In the same year the French parliament adopted a law criminalizing any verbal or written endorsement of Napoleon. Strict censorship laws were introduced that forbade any pictorial representation that could be regarded as libellous or as threatening the existing government. These laws of sedition were interpreted as extending to any thought, utterance or object that might be held to indicate support for the so-called 'usurper'. The result, however, was not the successful suppression of the memory of Napoleon but the emergence of, in effect, a Napoleonic cult. Between 1815 and 1830 a veritable industry in miniaturizing objects with Napoleonic associations emerged. Thousands of coins and medals, and hundreds of thousands of busts and small statues, were in circulation across France. In November 1819 a Parisian street trader admitted to the police that he had sold 8,000 busts of Napoleon in the previous four days.[25] Coins lampooning the restored monarchy were in wide circulation. One, in circulation in south and south-west France in the late 1820s, showed Charles X with a noose around his neck. Any technology capable of producing multiples was widely employed. Engravings were immensely popular and plaster moulds were in wide use. In 1823 a French order was placed at a foundry in Württemberg for 12,000 small busts of Napoleon.[26] Confectionery was widely produced with Napoleonic imagery stamped on it. When it came to destroying the offending objects, such purges were often conducted by the official

Gold and diamond box encasing a miniature portrait of Napoleon signed by J.-B.-J. Duchesne de Gisors. French, 1812.
This small box was given by Napoleon to the sculptor Anne Seymour Damer in appreciation of a bust he received from her of Charles James Fox, the British Whig statesman – an interesting continuation of the practice of courtly dalliance associated with earlier European courtly behaviour.
L. 8.3 cm

hangman. Thus was initiated a vast underground trade in images of Napoleon, a trade that, it might be argued, would not have been so extensive or remarkable if it had not had to be underground. Because of the illegality of circulating images of Napoleon, many entrepreneurs reverted to miniaturization to make this material culture of sedition less overt. Thus, Marcily of Paris published *La Lanterne magique* around 1825. It consisted of a series of small illustrated frames measuring just over 2 inches (5 cm) in dimension. Into these were inserted small coloured illustrations, which when held in front of the light revealed further 'magically staged' subjects. One frame showed a soldier kneeling before a tomb. With the appropriate illustration inserted, Napoleon could be seen rising from the dead.[27]

If this was all part of a widespread clandestine cult, the creation of miniature imagery has also been implicated in the shadowy world of spying. Espionage, for instance, was among the potential uses of microphotography suggested when John Benjamin Dancer successfully invented a method of microscopic photography in the 1850s. His forte was the production in miniature of a montage of faces of the famous, usually encompassed within an oval or circular frame. Dancer produced catalogues of his work that boasted images of up to '155 Portraits of Eminent Persons' on a single slide, 'The Lord's Prayer in a Pinhole' and 'The Eleventh Commandment [and for that matter, the National Anthem] in the eye of a needle'. Sir David Brewster, Professor of Physics at St Andrews University in Scotland, suggested in an article on the 'micrometer' in the eighth edition of the *Encyclopaedia Britannica* that 'Microscopic copies of dispatches and valuable papers and plans might be transmitted by post, and secrets might be placed in spaces not larger than a full stop or a small blot of ink'. And, indeed, something of the sort did occur shortly afterwards. Brewster took examples of Dancer's work with him when he went on a visit to France in 1857, where they were seen by the French photographer Prudent Dagron. The technique attracted impressive attention and in 1870, when Paris was besieged, Dagron used microphotography to convey messages by carrier pigeon to the outside world.[28]

The miniature as the container of specialist or esoteric knowledge is further evidenced by the kinds of topics that were ubiquitous among the publishers of miniature books. Almanacs and calendars were among the most numerous topics of eighteenth- and nineteenth-century publishers in this format. Indeed, the *London Almanack* was the most continuously published miniature book on record, having been in regular production for over two hundred years from its first publication in 1690. The contents included such essential information as listings of kings and queens, details of the Cabinet and the Lord Mayors of London, the rate of stamp duty, high tides and the eclipses of the sun and moon. It is not that such information is 'secret', but arguably its value is increased by the limited access to it implied by its presentation in a format that is personal to the owner of each miniature volume. As Bondy notes about the interest in miniature books: 'Their very portability marries them more intimately to their owners and permits easy and frequent reference to their contents whenever desired.'[29] The more restricted is access to this knowledge,

the more valued does it become. The Bible (or Thumb Bibles as the genre was called), prayer books, dictionaries and encyclopaedias are hardly either private or, because of their bulk and the volume of information they contain, the natural topic of the miniature. Complete versions were produced – one of the complete Bible, for instance, is dated to 1901. But selections from much larger works, pared down to essential verities, offer a privileged route to enlightenment, nonetheless. Their value is enhanced by their compression, by the removal of the unnecessary or the frivolous and the concentration on the nuggets they contain. And it is not just religious texts that are in question. As gifts for their clients, Geisha girls in Japan had available to them miniature versions of the telephone directory giving the phone numbers of theatres, actors, dance teachers, wrestlers, and useful taxi rank and restaurant numbers in Tokyo and Yokohama[30] – examples of what are called in Japanese *Mame-Hon*, or bean-sized books, to which a museum at Fujieda near Tokyo is devoted.

The small scale of such works and their sense of exclusive access and possession did not obviate some becoming major publishing successes. Thus David Bryce of Glasgow, a prolific publisher of miniature books in the late nineteenth century, noted:

> *Instead of developing works of a larger kind, I descended to the miniature, mite and midget size, producing a little dictionary, the smallest in the world, in a locket accompanied by a magnifying glass. I had many a scoff and jeer as to the absurdity of the production, nevertheless it appealed to Mr. Pearson of the notable weekly, who gave me a first order of 3,000 copies and its sales are now over 100,000.[31]*

Some books, however, take the format in the other direction and bring together information distinguished by its irrelevance, the miniaturization giving the information a spurious significance that it does not otherwise deserve. For instance, in 1891 a compendium of such facts as the number of words, letters and verses that occur in the Bible was published in Grimsby by Ernest A. Robinson under the title *The Mite*. It is said to be the smallest book ever published in English using movable type. This book was among those selected for Queen Mary's famous doll's house library.[32]

Objects of desire

The combination of creating things so small that they are barely readable – to be incorporated into a model house that is too small to admit of human access – well expresses the captivating allure that the miniature is capable of generating. On the one hand, doll's houses create a functionless space, for which of us can sit down in a minuscule library chair to read a book whose print is so tiny that it is unreadable? Yet miniatures nonetheless replicate functionality: we recognize that it would be possible – were we of such diminished scale as to clamber into the doll's house ourselves, and

Left
Gold ring containing the words of the Lord's Prayer. British, 1676.
This ring is remarkable for the text of the Lord's Prayer, some sixty-six words written in minute lettering on a disc of paper barely 1 cm in diameter. There is even room for the signature of the calligrapher: 'William Mason Writing Master in the Minories, April 2, Anno Domini, 1676.' The text itself is all but invisible to the naked eye, but the assurance of its presence lent the ring both
curiosity and prophylactic properties.
D. 2.2 cm

Right
Ivory ship inset in an ivory ring with a gold rim, by G. Stephany and J. Dresch. British, c.1790.
It is thought that this small ring may have been given as a sailor's keepsake. It has been suggested that a miniature sailing ship was kept as a personal manifesto associated with the phrase 'such is life', referring to the unavoidable absences of sailors from their home ports.
L. 3.4 cm

with (paradoxically) sufficiently enlarged visual acuity – to accommodate ourselves comfortably in the imaginative world created for Queen Mary. We can play with the contents of doll's houses, rearrange them, create narratives around them, but we cannot ourselves occupy such a house. John Elsner, in an interesting discussion of Sir John Soane's collection of model buildings, notes that our experience of models and of the real things are of a different order. We experience real buildings by entering them, by exploring their inner sanctums directly for ourselves and taking in their contents. The architecture contains us. Yet, in the form of models, miniature buildings contain things we can no longer explore directly. We are forever on the outside and experience their interiority only as inaccessible places. This, Elsner suggests, is a condition of them being objects of desire.[33] Like the ever receding spaces inside MacCruisken's nested boxes, we are forever denied ultimate access to their interiority and the secrets they may contain.

What is true of model buildings also holds for other kinds of object. Small things are not just experienced passively, they challenge us. We may ignore them because their minute size does not impose itself upon us, but once we are aware of them, they have the capacity to become magnetic. If we began with a discussion of the general and accessible perception of the miniature as an aesthetic domain, we conclude with the observation that small things resist final possession. We may, of course, own a miniature, have it available for ourselves alone as a personal object, perhaps conceal it on our person as a protective device of some kind, but its capacity for continuing enchantment lies in its ability to evade complete comprehension.

Epilogue

At various places in this book the image of the Ark in the sense of a place or a ship (*tebah* in Hebrew) has been invoked. Noah's Ark contained the possibility of reproduction following the great flood. It is an apt metaphor for the experience of exile. As also discussed, the word 'ark' has been adopted to describe a museum and its ambitions to create 'representative' collections, as it had to contain the stock of living things from which the world could be repopulated anew. Yet the term has another sense in English: the ark as a holy vessel, the container of the Ten Commandments (*eduth* in Hebrew) vouchsafed to Moses. In the Ethiopian Orthodox Church the inner sanctum of the altar space, the Holy of Holies, is occupied by a *tabot*, an authorized representation of the original Ark of the Covenant in the form of a small wood or stone tablet. There is no subterfuge here. The original Ark is believed by Ethiopian Christians to rest in Aksum, the ecclesiastical capital, where it remains in the care of a resident priest in the Church of St Mary of Zion surrounded by high iron railings. Without the presence of these tablets derived from the original, a church is not a church and the mass cannot be celebrated.

Within the church building the massive spaces in which the general laity stands give way to the choir to which the most aged of the congregation and the novitiate are admitted. In the curtained space beyond, to which only the priesthood has access, hidden beneath a veil, are the altar and the indispensable *tabot*. What is most holy is also most secret. Knowing it is there obviates the need to see it is there. It is not a presence which requires objective evidence of its existence before it can become a source of faith. Faith itself is witness to holy presence. Indeed, in these instances, holy things can only be 'seen' by priests, by those (paradoxically) who have least need to see them, for their certainty of the existence of such unseen things is the greatest. This conception draws together many aspects of the miniature and of the use of the idea of 'small worlds' in culture that this extended ethnographic essay has suggested: that the most important, symbolically motivated or powerful may be the least in scale; that the miniature occupies a contained space; that it may be controlled, possessed; but, yet, that it has at its heart an inherent mystery which may be a matter of aesthetics or, as here, of hidden verities.

If seeing is believing, then *not* seeing may be even more so.[1] Where our eyes can no longer penetrate, or can barely distinguish the outlines of things, sight gives way to insight – and to the disconcerting thought that we ourselves may live within a microcosm of someone else's construction. And, finally, this perhaps is why the exploration of the world in miniature is the subject of so many imaginative constructions.

Notes

Chapter 1
Small is Beautiful
1 Lévi-Strauss 1966, p. 23.
2 Onians 1979, p. 121.
3 Swift 2003, p. 119.
4 Burke 1826, p. 237.
5 O'Brien 1993, all foregoing quotations from p.72.
6 O'Brien 1993, p. 75.
7 Ibid.
8 O'Brien 1993, p. 76.
9 O'Brien 1993, pp. 76–7.
10 Bondy 1981, p. 20.
11 Bondy 1981, p. 157.
12 As quoted in Bondy 1981, p. 95.
13 Clegg 2003, pp. 209–10.
14 Penny 1993, p. 21.
15 Jahss 1979, pp. 239–46, for a discussion of the properties of the different materials in which *netsuke* are made.
16 McLeod 1981, pp. 80–1.
17 For a discussion of the Oxus Treasure as a whole see Curtis 1997. See also Curtis 2000, ch. 7.
18 Mack 1986, pp. 91–2; see also Oberle 1979, pp. 94 ff.
19 Rugoff n.d., p. 19.
20 Rugoff n.d., p. 36.
21 Interviewed on BBC Radio 4, 11 February 2004.
22 Colding 1953, p. 10.
23 The discussion here is based on an exhibition at the Royal Academy of Arts, London, and its associated catalogue, Kren and McKendrick 2003; for a perceptive review article see Luckett 2004.
24 Edmond 1983, p. 44.
25 Quoted in Mowitt 2003.
26 William Shakespeare, *Twelfth Night*, Act 3, scene 4, line 203.
27 Pope-Hennessy 1949, p. 17.
28 See Canby 1993, ch. 1.
29 Canby 1993, p. 24.
30 Ibid.; Rogers 1993.
31 Mitter 2001, p. 114.
32 Abu'l Fazl, as quoted in Mitter 2001, pp. 116–17.
33 Ibid.
34 Gabriel 2000, p. 25 n. 3.
35 Gabriel 2000, p. 15; Rudoe 2000, pp. 28, 32–3.
36 Rudoe 2000, p. 27.
37 As quoted in Rudoe 2000, p. 36 .
38 Bachelard 1969, p. 150.
39 See Bennett and Mandelbrote 1998, p. 69.

40 As quoted in Danto 1994, p. 377.
41 Bennett *et al.* 2003.
42 Inwood 2003, p. 157. It is also interesting to note that Wren himself was reportedly of very small stature.
43 Cooper 2003, pp. 28–49.
44 Hooke could be awkward, but, of his ground-breaking relationships with some of the great figures of his age, only that with Isaac Newton, a younger scientist, proved more contentious. Hooke sought to refute Newton's classic observation that white light results from an amalgam of coloured light, suggesting that he had himself already enunciated principles sufficient for its explanation. From this a lengthy feud developed. Hooke was jealous of his own experimental observations and claimed their implications as his own original insight when he had not fully explored them. Things came to a head over the competing claims of copyright for the idea of universal gravitation. When Newton famously remarked, 'if I have seen further it is by standing on the shoulders of Giants', he did not have Hooke in mind.
45 Bennett 2003, p. 94.
46 Aubrey 1898, pp. 409–16.
47 Aubrey 1898, p. 409.
48 Aubrey 1898, p. 410.
49 Ibid. Samuel Cowper is Samuel Cooper, a nephew of John Hoskins who inspired the young Hooke in the direction of miniaturist illustration.
50 Harwood 1989, p. 123.
51 Harwood 1989, pp. 128–30.
52 Griffiths 1998, p. 276.
53 Griffiths 1998, p. 23.
54 Harwood 1989, p. 121.
55 As quoted in Inwood 2003, p. 72.
56 Danto 1994, pp. 376–87.
57 Danto 1994, p. 377.
58 Danto 1994, p. 379.
59 Allin 1998.
60 Barley 1991, p. 120.
61 Harwood 1989, p. 136.
62 As quoted in Bennett 2003, p. 88.
63 Gell 1998, p. 69.

Chapter 2
The Colossal and the Diminutive
1 Colding 1953, p. 17.
2 Swift 2003, pp. 47–8.
3 Swift 2003, pp. 50–51.
4 Swift 2003, pp. 57–8.
5 The kind of thing, of course, that

real travellers and showmen increasingly did in the nineteenth century – see Altick 1978.
6 Swift 2003, p. 77.
7 Swift 2003, p.88.
8 Swift 2003, p. 89.
9 Ibid.
10 Burke 1826, pp. 267–8.
11 Wilson 2000, p. 183. I am grateful to Heather Crabtree for drawing this and subsequent references on Nazi architectural programmes to my attention.
12 Burke 1826, p. 237.
13 Ibid.
14 Bachelard 1969, p. 155.
15 As quoted in both Onians 1979, p. 125, and Beard and Henderson 2001, p. 197.
16 As quoted in Benjamin 1996, p. 108.
17 Beard and Henderson 2001, p. 199.
18 Williams and Ogden 1994, pp. 37–46.
19 Williams and Ogden 1994, pp. 30–1.
20 As quoted in Williams and Ogden 1994, p. 44; see also p. 76.
21 See Fagg 1970 and Waterfield 2000.
22 Matthews 1985.
23 Blurton 1992, pp. 126–7.
24 Pieper and Thomsen 1979, p.10.
25 Jones and Mitchell 1979
26 Kulke 1979, p. 19.
27 One of the fullest accounts describes a cart festival that occurs at the Vaishnavite temple town of Srirangam in south India (Pieper and Thomsen, 1979). Here three festival months are celebrated with a series of processions, some of which involve carrying floats while others are full-scale cart processions. That the cart is a direct analogue of the temple itself is clear. Thus, in terms of decoration the iconographic programme deployed on one such cart makes reference to the architecture of the temple, its associated cycle of legends and the deity it celebrates. On the uppermost levels, embroidered on textiles, is the central image of Raganatha resting on a snake, recalling the principal deity of the temple, whose image is kept there in the inner sanctum. The structure of the cart incorporates the pillars and the dome of the temple. It is also decorated with flowers and fruit, like the sanctuary within the temple. Thus, the cart itself is a quite explicit replication of the architecture of the temple. The instructions for the building of

temples are laid down in ancient texts (*vastushastras*), which, if not followed attentively, will not provide a building in which deities will be content to dwell. In replicating this architecture on a wheeled structure, the cart is thereby rendered an appropriate vehicle for the deity. This common identity is affirmed in the nomenclature: the *ratha*, like the temple itself, bears the name of the principal deity associated with it. Finally, the activities of the devotees in relation to the cart are those that are otherwise reserved for the temple itself. The cart, for instance, stops at midday when on its cumbersome progression and is effectively 'closed' for a period, as is the temple itself at the same hour. It may only be approached with bare feet, and once it has completed its circumambulation but before the image of the deity is returned to the temple, the devotees mount the steps and are able to make eye contact with the image in what is called *darshan*, the act of exchanging glances with the deity, something otherwise regarded as the culmination of a temple visit.

28 Pieper and Thomsen 1979, p. 10.
29 Blurton 1992, p. 47.
30 Arnold 2003, p. 74.
31 Arnold 2003, p. 75.
32 Bennett and Mandelbrote 1998.
33 As quoted in Leith-Ross 1984, p. 15.
34 MacGregor 1983; Leith-Ross 1984.
35 Arnold 2003.
36 As quoted in Leith-Ross,1984, p. 14.
37 Pomain 1990, p. 71.
38 Pomain 1990, p.78.
39 See Greenhalgh 1988; also Harvey 1996.
40 Baudrillard 1994, p. 172.
41 Eco 1987.
42 See Stewart 1984, ch. 5. One of the first sources to which I turned in researching the topic of the miniature was Susan Stewart's perceptive book, *On Longing: Narratives of the Miniature, the Gigantic, the Souvenir, the Collection*. It is more concerned with literature than visual culture, and with the whole field of scale and the experience of it rather than focused only on small things. Yet on a number of occasions I found I had drafted some section of text only to discover that a similar theme or instance was also persuasively

discussed by Stewart, so replete is the book in range of reference and apposite example.
43 As quoted in Elsner 1994, p. 164.
44 Jordanova 2004, p. 449.

Chapter 3
Visualizing Small Worlds
1 As quoted in Hughes 1990, p. 225.
2 Ibid.
3 This thought underlies the discussion in Mack 2003.
4 Hughes 1990, p. 226.
5 Hughes 1990, p. 227.
6 Mack 2003, pp. 15–20. See also Yates 1992.
7 Naumann and Obalk 2000, p. 197.
8 Green 2000, p. 79.
9 Naumann and Obalk 2000.
10 As quoted in Tomkins 1997, p. 316.
11 As quoted in Goody 1993, p. 86.
12 Goody 1993, pp. 4–5.
13 Goody 1993, pp. 102–3.
14 Thomas 1983, pp. 234–8.
15 Rawson 1992, pp. 207–8.
16 Clunas 1996, p. 98.
17 Rawson 1992, p. 207.
18 Goody 1993, p. 348.
19 As quoted in Goody 1993, p. 367.
20 Clunas 1996, pp. 100–1.
21 Clark 2001.
22 Hendry 1997; see also Hendry 1993.
23 Hendry 1997, p. 86.
24 Hendry 1997, p. 87.
25 As quoted in McEwan and van de Guchte 1992, p. 364.
26 As quoted in Dransart 2000, p. 85.
27 Compare, for example, Harvey 1991, illustrations 12 and 62.
28 Edson 1994, pp.118–25; Harvey 1992; Vaughan 1958.
29 Edson 1997, pp. 62–3.
30 Edson 1997, p. 15.
31 Edson 1997, pp. 39–40.
32 See Kline 2001, fig 1.8.
33 Kline 2001, p. 2.
34 Kline 2001, p 10.
35 Kline 2001, pp. 34–5, and figs 1.19a and b.
36 Kline 2001, p. 47.
37 Kline 2001, p. 12.
38 Edson 1997, ch. 8.
39 For a convenient summary of the patterns of pilgrimage in the world's religions see Coleman and Elsner 1995.

Chapter 4
Seeing Hidden Things
1 Thurston and Attwater 1956, vol. III, pp. 580–5.
2 Nettleton 1989, p. 72.

3 Nettleton 2000, pp. 188–9.
4 Olupona 2004, p. 109.
5 Bastin 1995.
6 Jordán 2000; also Jordán 1994.
7 Jordán, 2000, p. 138.
8 As quoted from a native source, Kavuna Simon, in MacGaffey 1993, p. 21.
9 Thompson 1981, pp. 108–9.
10 Devisch 2000; also Devisch 2004.
11 Devisch 2004, p. 26.
12 Nooter Roberts 2000, p. 71.
13 Devisch 2000, pp. 123–6.
14 As quoted in Lyon 2004, p. 131.
15 Lyon 2004, p. 122.
16 All quoted in Lyon 2004, p. 123.
17 Fridman 2004.
18 Nooter, 1993.
19 Roberts 1993, p. 66.
20 Roberts 1993, p. 72.
21 Lagamma 2000, p. 145.
22 Stroeken 1993, p. 34.
23 MacGaffey 1993, p. 44.
24 MacGaffey 1993, p. 52.
25 As quoted in MacGaffey 1993, p.65.
26 MacGaffey 1993, p.59.
27 Lyon, 2004, p. 127.
28 Lyon, 2004, p. 128.
29 See also Stewart 1984, ch. 4.

Chapter 5
Small Bodies
1 The poem in question is William Empson's 'Homage to the British Museum', whose opening lines are: 'There is a supreme God in the ethnological section, / A hollow toad shape, faced with a blank shield.'
2 Moore 1981, p. 83, where he remarks that 'the excitement of this piece comes from its sense of life-force, with all those small figures springing from the parent figure.'
3 See Hooper 2006, cat. nos 191–3, 195, 198, 199.
4 Hooper 2006, cat. nos 116, 117.
5 For instance, see Thomas 1995, p. 166.
6 Gell 1998, pp. 137–9. Hooper (2006), we might note, is less inclined to speculate than either Gell (1998) or Thomas (1995) and prefers to stay with what can be asserted from a strict reading of the historical evidence.
8 As quoted in Barkan 1975, pp. 10–11.
9 Williams 1837.
10 As quoted by Gell 1998, p. 137 n. 4.
11 The specifically Christian elaboration of this perspective is the analogy that emerged between the

idea of the body of Christ and the idea of the Church, both architecturally and in the sense of a community of the faithful. If man was the pinnacle of God's creations, so the establishment of the Church was the greatest of man's works, a creation in celebration of the body of the crucified Christ. The rediscovery in the Renaissance of the work of Vitruvius – notably his *De architectura* (*c.*27 BC) – was a particular source of inspiration in applying the proportions of the body to the design of ecclesiastical buildings.

12 Castner 2002, p. 16.
13 Harner 1973.
14 Harner 1973, p. 135.
15 Harner 1973, pp. 143–9.
16 McEwan and van de Guchte 1992. See also Dransart 2000 and Lleras-Pérez 2000.
17 As quoted in McEwan and van de Guchte 1992, pp. 361–2.
18 As quoted in McEwan and van de Guchte 1992, p. 363
19 Dransart 2000, p. 86.
20 Dransart 2000, p. 80.
21 Dransart 2000, p. 85.
22 Lleras-Pérez 2000, p. 113.
23 Wood 2000.
24 Stewart 1984, p. 43.
25 Bondy 1981, p. 22.
26 Bondy 1981, p. 62.
27 Pasierbska 2002, p. 4.
28 The writer G.K. Chesteron judged toy theatres 'the best of all toys'.
29 Swift 2003, p. 99.
30 Swift 2003, p. 100.
31 Ibid.
32 Swift 2003, p. 111.
33 Swift 2003, pp. 111–12.
34 Gordon 1953, pp. 19–20.
35 Stewart 1984, p. 56.
36 Gordon 1953, p. 152.
37 Indeed, the history of the vocabulary in English for referring to these small objects already expresses the breadth of meaning that they summon up. The word 'doll' is a relatively recent innovation. The first reference found by the compilers of the OED dates from 1560, where it appears as a diminutive of 'Dorothy' and is related to the term 'moll', meaning either a female pet or a mistress; by the nineteenth century it came to have the fuller sense of a pretty but vacuous woman, a sense that it retains – otherwise a 'bimbo' in modern parlance. As a verb, the word 'toy' also has a similar flirtatious, manipulative connotation. However, at the start of the eighteenth century the word 'doll' had already acquired the parallel meaning of a girl's toy baby, and this came to predominate as it gradually took over the shared meaning of the word 'puppet', which in the sixteenth century had the multiple meanings of a disreputable woman, a marionette and a child's plaything. 'Doll', of course, remains *poupée* in French (and puppet is *marionette*), *puppe* in German and (for completeness) *pupa* in the original Latin. The original overlap of meaning between something played with innocently and something manipulated with intent remains a part of its total context.
38 Cameron 1996, p. 11.
39 Syson and Thornton 2001, p. 61.
40 For example in McLeod 1981 and also in Ross 1996.
41 Ross 1996, pp. 44–5.
42 Cameron 1996.
43 Houlberg 1973.
44 Ravenhill 1993.
45 Ravenhill 1993, p. 36.
46 Cameron 1996, p. 27.
47 Stewart 1984, p. 172.
48 Wood 2000, p. 7.
49 Wood 2000.
50 Wood 2000, p. 172.

Chapter 6
Small as Powerful

1 From *Poetry: A Rhapsody* (1733), as cited in Amato 2001, p. 64.
2 Stewart 1984, p. 70.
3 As discussed in Mack 1986, and in the literature listed in the accompanying bibliography.
4 Bravmann 1974, pp. 12–13.
5 Bravmann 1974, p. 90.
6 Bondy 1981, pp. 109–10.
7 MacGaffey 1991, pp. 107–9.
8 MacGaffey 1991, p. 109.
9 MacGaffey 1993, p. 29.
10 As discussed in Mack 2003, pp. 122–3.
11 Freedberg 1989, pp. 93–8.
12 Freedberg 1989, p. 97.
13 Freedberg 1989, p. 94.
14 MacGaffey, 1990, pp. 45–61.
15 Caygill 1999, p. 198.
16 Colding 1953, p. 97.
17 Colding 1953, pp. 43–4, 51.
18 As quoted in Syson and Thornton 2001, p. 63.
19 Ibid.
20 Mack 2003, p. 131; see also Gell 1998, pp. 116–21.
21 As quoted in Syson and Thornton 2001, p. 183.
22 Syson and Thornton 2001, p. 176.
23 Syson and Thornton 2001, p. 61.
24 Burckhardt 1928, p. 533.
25 As quoted in Amato 2001 p. 63.
26 Rhodes James 1994, p. 71.
27 Amato 2001, p. 122.
28 Rhodes James 1994, p. 193.

Chapter 7
Private Pleasures

1 Freedberg 1989, p. 52.
2 Edmond 1983, p. 23.
3 See Mack 1986, Part 2, and the associated bibliography.
4 Strong 1975, p. 16.
5 Reynolds 1980, p. 13.
6 Reynolds 1971, p. 19.
7 Jahss 1971.
8 Earle 1980, p. 4.
9 Ryerson 1958, pp. 27–9.
10 For accessible summaries see Ryerson 1958; Earle 1980, pp. 8–10; Jahss 1971, p. 246.
11 Jahss 1971, pp. 247–8.
12 The Tokyo National Museum, indeed, was known from 1889 to 1952 as the Tokyo Imperial Household Museum (*Tokyo Teishitsu Hakubutukan*).
13 Anon. 2003.
14 McLeod 1981, p. 122.
15 McLeod 1981, pp. 123–4; Garrard 1980, pp. 332–6.
16 Garrard 1980, p. 197.
17 Meyerowitz 1951.
18 As quoted in Garrard 1980, p. 197.
19 McLeod 1981, ch. 8 (see also McLeod 1971); and Garrard 1980, ch. 6.
20 McLeod 1981, p. 125.
21 As quoted in Garrard 1980, p. 202.
22 Cornet 1980.
23 Garrard 1980, p. 203.
24 McLeod 1981, p. 125; Garrard 1980, p. 207.
25 Hazareesingh 2004, p. 80.
26 Hazareesingh 2004, p. 74.
27 Bondy 1981, p. 160.
28 Benjamin 1996, p. 104.
29 Bondy 1981, p. 201.
30 Bondy 1981, p. 162.
31 As quoted in Bondy 1981, p.103.
32 See Stewart-Wilson 1988.
33 Elsner 1994.

Epilogue

1 To echo the title of an insightful essay: Roberts 1993.

Bibliography

Allin, Michael. 1998. *Zarafa*. London.

Altick, Richard D. 1978. *The Shows of London*. Cambridge, MA.

Amato, Joseph A. 2001. *Dust: A History of the Small and the Invisible*. Berkeley.

Anderson, R.G.W., M.L. Caygill, A.G. MacGregor and L. Syson. 2003. *Enlightening the British: Knowledge, Discovery and the Museum in the Eighteenth Century*. London.

Andrews, C.A.R. 1981. *Catalogue of Egyptian Antiquities in the British Museum VI: Jewellery*. London.

Andrews, C.A.R. 1994. *Amulets of Ancient Egypt*. London.

Andrews, C.A.R. 1996. *Ancient Egyptian Jewellery*. London.

Anon. 1869. 'Giants and Dwarfs'. *Harper's New Monthly Magazine*, July, xxxix, pp. 202–211.

Anon. 2003. Obituary: 'Guy Shaw'. *The Times*, 27 October, p.29.

Ardern, L.L. 1960. *John Benjamin Dancer*. Occasional Papers No. 2, Library Association, London.

Arnold, Ken. 2003. 'Skulls, Mummies and Unicorns' Horns: Medical chemistry in early English museums'. In Anderson *et al.* 2003, pp. 74–80.

Arnold, Ken and Danielle Olsen (eds). 2003. *Medicine Man: The Forgotten Museum of Henry Wellcome*. London.

Aubrey, John. 1898. *'Brief Lives', Chiefly of Contemporaries, Set down by John Aubrey, between the Years 1669 & 1696*. Edited from the author's mss by Andrew Clark. Oxford.

Auerbach, Erich. 1961. *Nicholas Hilliard*. London.

Avent. R. 1975. *Anglo-Saxon Garnet Inlaid Disc and Composite Brooches*. British Archaeological Reports, Oxford.

Bachelard, Gaston. (1958) 1969. *The Poetics of Space*. Trans. Maria Jolas. Boston.

Baillet, Adrien. (1691) 1946. *Vie de Monsieur Descartes*. 4th edn, Paris.

Barkan, Leonard. 1975. *Nature's Work of Art: The Human Body as the Image of the World*. New Haven.

Barker, R. and L. Smith. 1976. *Netsuke: The Miniature Sculpture of Japan*. London.

Barley, Nigel. 1991. *The Duke of Puddle Dock: Travels in the Footsteps of Stamford Raffles*. London.

Bartman, E. 1992. *Ancient Sculptural Copies in Miniature*. Columbia Studies in the Classical Tradition. Leiden.

Bastin, Marie-Louise. 1995. 'Divination Figures'. In Phillips 1995, pp. 208–9.

Baten, Lea. 1992. *Japanese Folk Toys: The Playful Arts*. Tokyo.

Baten, Lea. 1996. 'Ornamental Japanese Dolls'. In Jane Turner (ed.), *The Dictionary of Art*. London.

Baudelaire, Charles. (1859) 1955. 'On Photography'. In J. Mayne (trans.), *Charles Baudelaire: The Mirror of Art*. London.

Baudrillard, Jean. (1981) 1994. *Simulacra and Simulation*. Ann Arbor.

Beard, Mary and John Henderson. 2001. *Classical Art: From Greece to Rome*. Oxford.

Ben-Amos, Paula Girshick. 1995. *The Art of Benin*. Rev. edn. London.

Benjamin, Marina. 1996. 'Sliding Scales: Microphotography and the Victorian Obsession with the Miniscule'. In Francis Spufford and Jenny Uglow (eds), *Cultural Babbage*. London.

Bennett, Jim. 2003. 'Hooke's Instruments'. In Bennett *et al.* 2003, pp. 63–104.

Bennett, Jim and Scott Mandelbrote. 1998. *The Garden, the Ark, the Tower, the Temple: Biblical Metaphors of Knowledge in Early Modern Europe*. Oxford.

Bennett, Jim, Michael Cooper, Michael Hunter and Lisa Jardine. 2003. *London's Leonardo: The Life and Work of Robert Hooke*. Oxford.

Benson, Arthur. 1924. *The Book of the Queen's Dolls' House*. London.

Bloch Maurice. 2005. 'Where did Anthropology go wrong?' In Maurice Bloch, *Essays in Cultural Transmission*. Oxford, pp. 1–19.

Blurton, T. Richard. 1992. *Hindu Art*. London.

Bondy, Louis W. 1981. *Miniature Books: Their History from the Beginnings to the Present Day*. London.

Bravmann, René. 1974. *Islam and Tribal Arts in West Africa*. Cambridge.

Briggs, Asa. 1988. *Victorian Things*. London.

Burckhardt, Jacob. (1878) 1928. *The Civilisation of the Renaissance in Italy*. Trans. S.G.C Middlemore. London.

Burke, Edmund. 1826. 'A Philosophical Enquiry into the Origin of Ideas of the Sublime and Beautiful'. In *The Works of the Right Honourable Edmund Burke*. London, vol. I, pp. 81–322.

Cameron, Elisabeth, with a contribution by Doran H. Ross. 1996. *Isn't s/he a doll? Play and Ritual in African Sculpture*. Los Angeles.

Canby, Sheila. 1993. *Persian Painting*. London.

Castner, James Lee. 2002. *Shrunken Heads: Tsantsa Trophies and Human Exotica*. Gainesville.

Caygill, Marjorie. 1999. *The British Museum A–Z Companion*. London.

Caygill, Marjorie and John Cherry (eds). 1997. *A.W. Franks: Nineteenth Century Collecting and the British Museum*. London.

Chakrabarty, Anjan. 1996. *Indian Miniature Painting*. New Delhi.

Clark, Timothy. 2001. *100 views of Mount Fuji*. London.

Clark, William, Jan Golinski and Simon Schaffer (eds). 1999. *The Sciences in Enlightened Europe*. Chicago.

Clegg, Brian. 2003. *A Brief History of Infinity: The Quest to Think the Unthinkable*. London.

Clunas, Craig. 1996. *Fruitful Sites: Garden Culture in Ming Dynasty China*. London.

Colding, Torben Holck. 1953. *Aspects of Miniature Painting, its Origins and Development*. Copenhagen.

Coleman, Simon and John Elsner. 1995. *Pilgrimage, Past and Present in World Religions*. London.

Cooper, Michael. 2003. 'Hooke's Career'. In Bennett *et al.* 2003, pp. 1–61.

Cornet, Joseph. 1980. 'Pictographies Woyo'. *Quaderni Poro*, vol. 2.

Curtis, John. 1997. 'Franks and the Oxus Treasure'. In Caygill and Cherry 1997, pp. 231–49.

Curtis, John. 2000 (1989). *Ancient Persia*. London.

Daiken, Leslie. 1953. *Childrens' Toys throughout the Ages*. London.

Dalton, O.M. 1909. *Catalogue of the Ivory Carvings of the Christian Era … in the Department of British and Mediaeval Antiquities and Ethnography of the British Museum*. London.

Danto, Arthur. 1994. 'Aesthetics and Art Criticism'. In Arthur Danto, *Embodied Meanings: Critical Essays & Aesthetic Mediations*. New York, pp. 376–87.

Dark, Phillip. 1973. *An Introduction to Benin Art and Technology*. Oxford.

De Chadarevian, Soraya and Nick Hopwood (eds) 2004. *Models: The Third Dimension of Science*. Stanford, CA.

Devisch, René. 2000. 'The Slit-drum in body imagery in mediumistic divination among the Yaka'. In Pemberton 2000, pp. 116–33.

Devisch, René. 2004. 'Yaka divination: Acting out the Memory of Society's Life-spring'. In Winkelman and Peek 2004, pp. 243–64.

D'Isreali, Isaac. 1924. *Curiosities of Literature*. London.

Dransart, Penny. 2000. 'Clothed Metal and the Iconography of Human Form among the Incas'. In McEwan 2000, pp. 76–91.

Earle, Joe. 1980. *An Introduction to Netsuke*. London.

Earle, John. (1628) 1933. *Microcosmography, or, A Piece of the World Discovered in Essays and Characters*. Ed. Harold Osborne. London.

Eaton, Faith. 1990. *The Miniature House*. London.

Eco, Umberto. 1987. *Travels in Hyperreality: Essays*. Trans. William Weaver. London.

Edmond, Mary. 1983. *Hilliard and Oliver: The Lives and Works of Two Great Miniaturists*. London.

Edson, Evelyn. 1997. *Mapping Time and Space: How Medieval Mapmakers Viewed their World*. London. Studies in Map History, vol. 1.

Elliot, R.W.V. 1989. *Runes: An Introduction*. Manchester.

Elsner, John. 1994. 'A Collector's Model of Desire: The House and Museum of Sir John Soane'. In John Elsner and Roger Cardinal (eds), *The Cultures of Collecting*, Cambridge, MA, pp. 153–76.

Fagg, William. 1970. *Miniature Wood Carvings of Africa*. With a foreword by Joseph Herman. Bath.

Fischer, Eberhart and Hans Himmelheber. 1984. *The Arts of the Dan in West Africa*. Trans. A. Biddlee. Zurich.

Freedberg, David. 1989. *The Power of Images: Studies in the History and Theory of Response*. Chicago.

Fridman, Eva J.N. 2004. 'Ways of Knowing and Healing: Shamanism in the Republics of Tuva and Buryatia in Post-Soviet Russia'. In Winkelman and Peek 2004, pp. 139–66.

Gabriel, Jeanete Hanisee. 2000. *The Gilbert Collection: Micromosaics*. London.

Garrard, Timothy F. 1980. *Akan Weights and the Gold Trade*. London.

Gell, A. 1998. *Art and Agency: An Anthropological Theory*. Oxford.

Gere, C. et al. 1984. *The Art of the Jeweller: A Catalogue of the Hull Grundy Gift to the British Museum*. 2 vols. London.

Glubok, Shirley. 1984. *Dolls' Houses: Life in Miniature*. New York.

Goody, Jack. 1993. *The Culture of Flowers*. Cambridge.

Gordon, Lesley. 1953. *Peepshow into Paradise: A History of Children's Toys*. London.

Graburn, Nelson. 1976. *Ethnic and Tourist Arts: Cultural Expressions from the Fourth World*. Berkeley.

Green, Christopher. 2000. *Art in France, 1900–1940*. New Haven and London.

Greenhalgh, Paul. 1988. *Ephemeral Vistas: The 'Expositions Universelles', Great Exhibitions and World's Fairs, 1851–1939*. Manchester.

Griffiths, Antony. 1998. *The Print in Stuart Britain, 1603–1689*. London.

Harbison, Robert. 1977. *Eccentric Spaces*. New York.

Harley, J.B. and David Woodward (eds). 1987. *The History of Cartography: Vol. 1, Cartography in Prehistoric, Ancient and Medieval Europe and the Mediterranean*. Chicago.

Harner, Michael J. 1973. *The Jivaro, People of the Scared Waterfalls*. Garden City, NY.

Harris, Victor. 1987. *Netsuke: The Hull Grundy Collection in the British Museum*. London.

Harvey, P.D.A. 1987 'Medieval Maps: An Introduction'. In Harley and Woodward 1987, pp. 283–5.

Harvey, P.D.A. 1991. *Medieval Maps*. London.

Harvey, P.D.A. 1992. 'Matthew Paris's Maps of Britain'. In Peter Cross and Simon Lloyd (eds), *Thirteenth Century England IV*. Woodbridge.

Harvey, Penelope. 1996. *Hybrids of Modernity: Anthropology, the Nation State and the Universal Exhibition*. London and New York.

Harwood, John T. 1989. 'Rhetoric and Graphics in *Micrographia*'. In Hunter and Schaffer 1989, pp. 119–47.

Hawkins E. 1885. *Medallic Illustrations of the History of Great Britain and Ireland*. London.

Hau'ofa, Epeli. 1993. 'Our Sea of Islands'. In Eric Waddell, Vijay Naidu and Epeli Hau'ofa, *A New Oceania: Rediscovering our Sea of Islands*. Suva, Fiji.

Hay, J. 1986. *Kernels of Energy, Bones of Earth: The Rock in Chinese Art*. New York.

Hazareesingh, Sudhir. 2004. *The Legend of Napoleon*. London.

Hazlitt, William Carew. 1896. *The Coin Collector*. London.

Henderson, James Dougald. 1930. *Miniature Books*. Leipzig.

Hendry, Joy. 1993. *Wrapping Culture: Politeness, Presentation and Power in Japan and other Societies*. Oxford.

Hendry, Joy. 1997. 'Nature Tamed: Gardens as a Microcosm of Japan's View of the World'. In Pamela J. Asquith and Arne Kalland, *Japanese Images of Nature*. London, pp. 83–105.

Hendry, Joy. 2000. *The Orient Strikes Back: A Global View of Cultural Display*. Oxford.

Hill. C.F. 1930. *A Corpus of Italian Medals of the Renaissance before Cellini*. London.

Hilliard, Nicholas. (1597–1603) 1952. *A Treatise concerning the Arte of Limning*. Ed. R.K.R. Thornton and T.G.S. Cain. Manchester.

Holas, B. 1952. *Les masques Kono*. Paris.

Hooke, Robert. (1665) 1961. *Micrographia: Or Some Physiological Descriptions of Minute Bodies Made by Magnifying Glasses with Observations and Enquiries thereupon*. New York.

Hooper, Steven. 2006. *Pacific Encounters: Art and Divinity in Polynesia, 1760–1860*. London.

Houlberg, Marilyn H. 1973. 'Ibeji Images of the Yoruba'. *African Arts*, 7, 1, pp. 20–7.

Hughes, Robert. 1990. *Nothing if not Critical: Selected Essays on Art and Artists*. London.

Hunter, Michael and Simon Schaffer (eds). 1989. *Robert Hooke: New Studies*. Woodbridge.

Impey, Oliver and Arthus MacGregor (eds). 1985. *The Origins of Museums: The Cabinets of Curiosities in Sixteenth- and Seventeenth-Century Europe*. Oxford.

Inwood, Stephen. 2003 *The Man who Knew too much: The Strange and Inventive Life of Robert Hooke 1635–1703*. London.

Jahss, Melvin and Betty. 1971. *Inro and other Miniature Forms of Japanese Lacquer Art*. London.

Jardine, Lisa. 2002. *On a Grander Scale: The Outstanding Career of Sir Christopher Wren*. London.

Johns, C. 1996. *The Jewellery of Roman Britain: Celtic and Classical Traditions*. London.

Jones, D and G Mitchell (eds) 1979. *Mobile Architecture in Asia: Ceremonial Chariots, Floats and Carriages*. Art and Archaeology Research Papers 16. London.

Jordán, Manuel. 1994. 'Heavy Stuff and Heavy Staffs from Chokwe, and related peoples of Angola, Zaire and Zambia'. In Allen F. Roberts (ed.), *Staffs of Life, Rods, Staffs, Scepters and Wands from the Coudron Collection of African Art*. Iowa City.

Jordán, Manuel. 2000. 'Art and Divination among Chokwe, Lunda Luvale and other related peoples of Northwestern Zambia'. In Pemberton 2000, pp. 134–43.

Jordanova, Ludmilla. 2004. 'Material Models as Visual Culture'. In De Chadarevian *et al.* 2004, pp. 443–51.

Kline, Naomi Reed. 2001. *Maps of Medieval Thought: The Hereford Paradigm*. Woodbridge.

Kren, Thomas and Scot McKendrick (eds). 2003. *Illuminating the Renaissance: The Triumph of Flemish Manuscript Painting in Europe*. London.

Kulke, Hermann. 1979. 'Rathas and Rajas: The Car Festival at Puri'. In Jones and Mitchell 1979, pp. 19–26.

Kwint, Marius. 2005. 'Scale and its Losses'. In Rudd 2005, pp. 16–23.

Lagamma, A. 2000. 'Divination as a fundamental organizing principle in Equatorial Africa'. In Pemberton 2000, pp. 144–54.

Leith-Ross, Prudence. 1984. *The John Tradescants: Gardeners to the Rose and Lily Queen*. London.

Lévi-Strauss, Claude. 1966. *The Savage Mind*. London.

Lleras-Pérez, Roberto. 2000. 'The Iconography and Symbolism of Metallic Votive Offerings in the Eastern Cordillera, Colombia'. In McEwan 2000, pp. 112–31.

Long, Basil. 1966. *British Miniaturists 1520–1860*. London.

Luckett, Richard. 2004. 'A holy private function. Flemish illumination and the waning of the miniature ages'. *Times Literary Supplement*, 9 January, pp. 16–17.

Lyon, William. 2004. 'Divination in North American Indian Shamanic Healing'. In Winkelman and Peek 2004, pp. 121–38.

McClinton, Katherine. 1970. *Antiques in Miniature*. New York.

McEwan, Colin (ed.). 2000. *Precolumbian Gold: Technology, Style and Iconography*. London.

McEwan, Colin and Maarten van de Guchte. 1992. 'Ancestral Time and Sacred Space in Inca State Ritual'. In Richard Townsend (ed.), *The Ancient Americas: Art from Sacred Landscapes*. Chicago, pp. 359–71.

MacGaffey, Wyatt. 1988. 'Complexity, astonishment and power: the visual vocabulary of Kongo minkisi'. *Journal of Southern African Studies* 14, pp. 188–203.

MacGaffey, Wyatt. 1990. 'The personhood of ritual objects: Kongo minkisi.' *Ethnofoor* 3, pp. 45–61.

MacGaffey, Wyatt. 1991. *Art and Healing of the Bakongo Commented by themselves: Minkisi from the Laman Collection*. Stockholm and Bloomington.

MacGaffey, Wyatt. 1993. 'The Eyes of Understanding: Kongo Minkisi'. In Wyatt MacGaffey and Michael Harris, *Astonishment and Power*. Washington, DC, pp. 21–103.

MacGaffey, Wyatt. 2000. 'The Cultural Tradition of the African Forests'. In Pemberton 2000, pp. 13–24.

MacGregor, Arthur (ed.). 1983. *Tradescant's Rarities: Essays on the Foundation of the Ashmolean Museum, 1693, with a Catalogue of Surviving Early Collections*. Oxford.

Mack, John. 1986. *Madagascar: Island of the Ancestors*. London.

Mack, John n.d. [1991] *Emil Torday and the Art of the Congo, 1900–1909*. London.

Mack, John. 2003. *The Museum of the Mind: Art and Memory in World Cultures*. London.

McLeod, M.D. 1971. 'Goldweights of Asante'. *African Arts*, Autumn.

McLeod, M.D. 1976. 'Verbal Elements in West African Art'. *Quaderni Poro*, pp. 85–102.

McLeod, M.D. 1981. *The Asante*. London.

MacNamara, E. 1990. *The Etruscans*. London.

Matthews, Oliver. 1985. 'Interview with Joseph Herman'. *Antique Collector*, September, pp. 83–5.

Meaney, A.L. 1981. *Anglo-Saxon Amulets and Curing Stones*. BAR British Series 96. Oxford.

Meinertzhagen, Frederick. 1956. *The Art of the Netsuke Carver*. London.

Meyerowitz, E.L.R. 1951. *The Sacred State of the Akan*. London.

Mitchiner, M. 1998. *Indian Tokens: Popular Religious and Secular Art from the Ancient Period to the Present Day*. London.

Mitter, Partha. 2001. *Indian Art*. Oxford.

Moore, Henry. 1981. *Henry Moore at the British Museum*. London.

Moorey, P.R.S. 2003. *Idols of the People: Miniature Images of Clay in the Ancient Near East*. Oxford.

Mowitt, John. 2003. 'Miniature, making Short Work'. *Journal of Visual Culture* 2 (2), pp. 269–71.

Munn, G. 1984. *Castellani and Giuliano: Revivalist Jewellers of the Nineteenth Century*. London.

Murdoch, John, Jim Murrell, Patrick J. Noon and Roy Strong. 1981. *The English Miniature*. New Haven and London.

Naumann, Francis M. and Hector Obalk. 2000. *Affectt Marcel: The Selected Correspondence of Marcel Duchamp*. London.

Nettleton, Anitra. 1989. 'The Crocodile does not leave its pool: Venda Court Arts'. In A. Nettleton and D.W. Hammond-Tooke, *Art from Southern Africa: From Tradition to Township*. Johannesburg, pp. 67–83.

Nettleton, Anitra. 2000. 'Divining Bowl'. In John Mack (ed.). 2000. *Africa: Arts and Cultures*. London, pp. 188–9.

Nooter, Mary H. 1993. *Secrecy: African Art that Conceals and Reveals*. New York.

Nooter Roberts, Mary. 2000. 'Setting meaning before the eyes'. In Pemberton 2000, pp. 63–82.

Norgate, Edward. 1919. *Miniatura or the Art of Limning*. Ed. Martin Hardie. Oxford.

Oberle, Philippe. 1979. *Provinces Malgaches*. Tananarive.

O'Brien, Flann. (1967) 1993. *The Third Policeman*. London.

O'Donnell, Georgene. 1943. *Miniaturia: The World of Tiny Things*. Chicago.

Olupona, Jacob. 2004. 'Owner of the Day and Regulator of the Universe: Ifa divination and healing among the Yoruba of southwestern Nigeria'. In Winkelman and Peek 2004, pp. 103–20.

Onians, John. 1979. *Art and Thought in the Hellenistic Age: The Greek World View 350–50 BC*. London.

Page, Nick. 2001. *Lord Minimus: The Extraordinary Life of Britain's Smallest Man*. London.

Paris, Matthew. 1852–4. *Matthew Paris's English History*. Trans. J.A. Giles. London.

Pasierbska, Halina. 2002. *Dolls' Houses*. Princes Risborough.

Pemberton III, John (ed.) 2000. *Insight and Artistry in African Divination*. Washington.

Penny, Nicholas. 1993. *The Materials of Sculpture*. New Haven and London.

Phillips, Ruth B. 1998. *Trading Identities: The Souvenir in Native North American Art from the Northeast, 1700–1900*. Seattle, London and Montreal.

Phillips, Tom (ed.). 1995. *Africa: The Art of a Continent*. Munich.

Pieper, Jan. 1979. 'A Note on South Indian Ceremonial Floats'. In Jones and Mitchell 1979, pp. 47–50.

Pieper, Jan and Margaret Thomsen. 1979. 'South Indian Ceremonial Chariots'. In Jones and Mitchell 1979, pp. 1–10.

Pinch, G. 1994. *Magic in Ancient Egypt*. London.

Pomain, Krysztof. 1990. *Collectors and Curiosities: Paris and Venice, 1500–1800*. Cambridge.

Pope-Hennessy, John. 1949. *A Lecture on Nicholas Hilliard*. London.

Propert, J.L. 1887. *A History of Miniature Art with Notes on Collections and Collectors*. London.

Ravenhill, Phillip. 1993. *Dreaming the Other World: Figurative Art of the Baule, Côte d'Ivoire*. Washington, DC.

Rawson, Jessica (ed.). 1992. *The British Museum Book of Chinese Art*. London.

Reilly, R. 1989. *Wedgewood*. London

Reynolds Graham. 1971. *Nicholas Hilliard and Isaac Oliver*. 2nd edn. London.

Reynolds, Graham. 1980. *Wallace Collection: Catalogue of Miniatures*. London.

Reynolds, Graham. 1988. *The English Portraits Miniature*. Rev. edn. Cambridge.

Roberts, Allen F. 1993. 'Insight, or *Not* seeing is Believing'. In Nooter 1993, pp. 65–80.

Rhodes James, Robert. 1994. *Henry Wellcome*. London.

Rodis-Lewis, Geneviève. 1998. *Descartes: His Life and Thought*. Trans. Jane Marie Todd. Ithaca and London.

Rogers. J.M. 1993. *Mughal Miniatures*. London.

Ross, Doran H. 1996. 'Akua's Child and other relatives: New mythologies for Old Dolls'. In Cameron 1996, pp. 42–57.

Rudd, Natalie. 2005. *Size Matters: Exploring Scale in the Arts Council Collection*. London.

Rudoe, Judy. 2000. '*Mosaico in Piccolo*: Craftsmanship and Virtuosity in Miniature Mosaics'. In Gabriel 2000, pp. 17–45.

Rugoff, Ralph. n.d. *The Eye of the Needle: The Unique World of Microminiatures of Hagop Sandaldjian*. Los Angeles.

Ryerson, Egerton. 1958. *The Netsuke of Japan: Legends, History, Folklore and Customs*. London.

Scher, S.K. (ed.) 1994. *The Currency of Fame: Portrait Medals of the Renaissance*. New York.

Schwab, G. 1947. 'Tribes of the Liberian hinterland'. *Papers of the Peabody Museum*, Cambridge, MA.

Sekules, Veronica. 2001. *Medieval Art*. Oxford.

Speaight, George. 1969. *A History of the English Toy Theatre*. London.

Stein, R.A. 1990. *The World in Miniature: Container Gardens and Dwellings in Far Eastern Thought*. Trans. P. Brooke. Stanford.

Stewart, Susan. 1984. *On Longing: Narratives of the Miniature, the Gigantic, the Souvenir, the Collection*. Blatimore and London.

Stewart-Wilson, Mary. 1988. *Queen Mary's Doll's House*. London.

Stroeken, Koen. 1993. 'In search of the Real. The Healing Contingency of Sukuma Divination'. In Nooter 1993, pp. 29–54.

Strong, Roy. 1963. *Portraits of Queen Elizabeth I*. Oxford.

Strong, Roy. 1975. *Nicholas Hilliard*. Folio Miniatures. London.

Strong Roy. 1983. *Artists of the Tudor Court: The Portrait Miniature Rediscovered 1520–1620*. London.

Summers, David. 2003. *Real Spaces: World Art History and the Rise of Western Modernism*. London.

Swift, Jonathan. (1726) 2003 *Gulliver's Travels*. London.

Syson, Luke and Dora Thornton. 2001. *Objects of Virtue: Art in Renaissance Italy*. London.

Tait, H. 1976. *Jewellery through 7000 Years*. London.

Tait, H. and C. Gere. 1978. *The Jeweller's Art: An Introduction to the Hull Grundy Gift to the British Museum*. London.

Taylor, J.H. 1999. *Studies in Egyptian Antiquities: A Tribute to T.G.H. James*. British Museum Occasional Paper 123. London.

Thomas, Keith. 1983. *Man and the Natural World: Changing Attitudes in England 1500–1800*. London.

Thomas, Nicholas. 1995. *Oceanic Art*. London.

Thomas, Nicholas. 1997. *In Oceania: Visions, Artifacts, Histories*. Durham, NC.

Thompson, Robert Faris. 1981. *The Four Moments of the Sun: Kongo Art in Two Worlds*. Washington, DC.

Thurston, Herbert and Donald Attwater (eds). 1956 *Butler's Lives of the Saints*. 4 vols. Notre Dame, NI.

Tomkins, Calvin. 1997. *Duchamp: A Biography*. London.

Torday, Emil, 1925. *On the Trail of the Bushongo*. London.

Turcan, Robert. 1996. *The Cults of the Roman Empire*. Oxford.

Ueda Reikichi. 1961. *The Netsuke Handbook of Ueda Reikichi*. Adapted from the Japanese by Raymond Bushell. Rutland, VT, and Tokyo.

Vainker, S.J. 1991. *Chinese Pottery and Porcelain: From Prehistory to the Present*. London.

Vaughan, Richard. 1958. *Matthew Paris*. Cambridge.

Vitruvius (Marcus Vitruvius Pollio). 1955 (c.27 BC). *De Architectura*. Trans. Frank Granger. Cambridge, MA.

Waterfield, Hermione. 2000. *Joseph Herman Sale*. Christie's catalogue, 12 December. Amsterdam.

Williams, Dyfri and Jack Ogden. 1994. *Greek Gold: Jewellery of the Classical World*. London.

Williams, J. 1997. *Money: A History*. London.

Williams, Revd J. 1837. *A Narrative of Missionary Enterprise in the South Sea Islands*. London.

Wilson, Colin St. John. 2000. *Architectural Reflections: Studies in the Philosophy and Practice of Architecture*. Manchester.

Wilson, David. 2002. *The British Museum: A History*. London.

Wilson, Mary S. 1988. *Queen Mary's Dolls' House*. London.

Winkelman, Michael and Philip Peek. 2004. *Divination and Healing: Potent Vision*. Tucson.

Winter, Carl. 1943. *Elizabethan Miniatures*. London.

Wittgenstein, Ludwig. 1953. *Philosophical Investigations*. Trans. G.E.M. Anscombe. Oxford.

Wittkower, Rudolf. 1967. *Architectural Principles in the Age of Humanism*. London.

Wood, Gaby. 2000. *Living Dolls: A Magical History of the Quest for Mechanical Life*. London.

Woodward, David. 1987. 'Medieval *Mappaemundi*'. In Harley and Woodward 1987, pp. 286–372.

Yates, Frances. 1992. *The Art of Memory*. London.

Yonge, Charlotte. *The History of Sir Thomas Thumb*. Edinburgh.

Index